What Ever Happened to the U.S. Congress's Portraits of Louis XVI and Marie-Antoinette?

What Ever Happened to the U.S. Congress's Portraits of Louis XVI and Marie-Antoinette?

Retracing the Events that Led to
the Conflagration of the Capitol
and the Loss of the Pictures
on 24–25 August 1814

T. Lawrence Larkin

American Philosophical Society Press
Philadelphia

Transactions of the
American Philosophical Society
Held at Philadelphia
for Promoting Useful Knowledge
Volume 110, Part 5

ISBN: 978-1-60618-105-8
Ebook ISBN: 978-1-60618-110-2
U.S. ISSN: 0065-9746

Library of Congress Cataloging-in-Publication Data

Names: Larkin, T. Lawrence, author.
Title: What ever happened to the U.S. Congress's portraits of Louis XVI and
 Marie-Antoinette? : retracing the events that led to the conflagration
 of the Capitol and the loss of the pictures on 24-25 august 1814 / T.
 Lawrence Larkin.
Description: Philadelphia : American Philosophical Society Press, [2021] |
 Series: Transactions of the American Philosophical Society, 0065-9746 ;
 volume 110, part 5 | Includes bibliographical references and index.
Identifiers: LCCN 2021030433 (print) | LCCN 2021030434 (ebook) | ISBN
 9781606181058 (paperback) | ISBN 9781606181102 (ebook)
Subjects: LCSH: Louis XVI, King of France, 1754-1793--Portraits. | Marie
 Antoinette, Queen, consort of Louis XVI, King of France,
 1755-1793—Portraits. | United States. Congress—Art collections. |
 United States—History—War of 1812—Art and the war.
Classification: LCC N7628.L59 L37 2021 (print) | LCC N7628.L59 (ebook) |
 DDC 944.04/1092—dc23
LC record available at https://lccn.loc.gov/2021030433
LC ebook record available at https://lccn.loc.gov/2021030434

Preface

There are some books that come about as a result of a hypothesis and method, others that spring from a desire to follow an argumentative thread to its logical conclusion, and others still where the subject is so obscure as to warrant expansion into allied fields. In the last case, I am reminded of Henri Focillon's advice to his art history students that a work of art should be appreciated as a creative expression suspended within a process of formal development and as a point of conceptual intersection with other developments in culture, politics, society, economics, etc., all striving to reach fruition—only this time the work of art is absent, and the nexus of human developments must speak for it. Just how does the foliage continue to indicate the spider web that the storm blew away? By revealing its stress points and slight deviations? By serving as a support for future araneidan weaves?

This volume in the *Transactions* series has long been in the works without me being completely conscious of it—in the sense that I have followed every lead while balancing commitments to teaching at the university, research of other topics, and service to the community. To impose some structure on the hunt for data and invest it with the air of methodical development, I should admit that my interest in the U.S. Congress's state portraits of Louis XVI and Marie-Antoinette was stimulated while conducting research on royal diplomatic gifts at the Archives du Ministère des affaires étrangères, Paris, in the winter of 1997–98 on the advice of Xavier Salmon, then Curator of Eighteenth-Century Paintings at the Musée national du château de Versailles. The foreign ministry's *Registre général des présents du roi* indicated that during Louis XVI's reign, single portraits of the king were frequently distributed to French ambassadors and foreign heads of state, but paired portraits of the king and consort were rare dispensations. That one of the few pairs should be sent to a Congress so recently habituated to a citizenry venting their political-economic frustrations on full-length portraits of George III seemed incredible. That the portrait of Louis XVI should have been supplied by Antoine-François Callet instead of the royal household's preferred Joseph-Siffred Duplessis and that the portrait of Marie-Antoinette should have been supplied by Élisabeth Vigée Le Brun, usually reserved for the queen's personal use, were also remarkable. Here was clear evidence that the French monarchs realized the unusual potential of the United States as an independent nation with the right to forge defensive and economic ties with governments of its own choosing. It remained to confirm the formal appearance of the missing copies sent to America, for which the advice of Joseph Baillio at Wildenstein & Company, New York City, on the queen's portrait proved helpful.

Having invested Congress's state portraits of Louis XVI and Marie-Antoinette with an unimpeachable origin and visual profile, I determined to pursue the circumstances and motives for Versailles dispatching them to Philadelphia. In the spring of 2000, I received a research fellowship from Donald R. Kennon, Director of the U.S. Capitol Historical Society, so that I could travel to Washington, D.C.,

and peruse the archives for evidence of the first of four "contextualized moments" for the portraits, namely, the initial period between Congress's formal request for the portraits in 1779 and the French chargé d'affaires' presentation of them in 1784. Pamela Scott, then lecturer at Cornell University, facilitated exposure to the art collections of the White House and the prints and photos of the Library of Congress, and Barbara Wolanin, Curator of the Capitol, provided access to the Office of the Architect of the Capitol, Senate, and House curators and staff. It soon became apparent that the initial impulse for the delegates' request for portraits of their royal allies at the height of the War of Independence was advised by Benjamin Franklin, then serving as minister plenipotentiary to the court of Versailles, and advanced by republican moderates who met in the Pennsylvania State House, Philadelphia. Karie Diethorn, Curator of Independence National Historical Park, furnished documents relating to the royal portraits' tenure at Congress Hall. Articulating the nexus of at least four developments—in French, British, and American state portraiture, Louis XVI's and Congress's respective foreign policy platforms, Charles Gravier de Vergennes' and John Jay's wily negotiations, and factional (radical, moderate, loyalist) interests within the legislature—presented a real challenge. The invaluable counsel of Amy Earls, Managing Editor of *Winterthur Portfolio*, and anonymous readers ensured that the argument of Louis XVI's and Congress's respective strategic motives in gifting and receiving the portraits was clearly articulated in my article published in the spring of 2010. Even so, the appearance of such traditional, authoritarian portrait imagery in a republican deliberative chamber seemed inappropriate to me until Ellen G. Miles, Curator of Painting and Sculpture at the Smithsonian's National Portrait Gallery, kindly pointed me in the direction of Gilbert Stuart, who was able to gratify the pretensions of Federalists with a portrait lexicon adapted from British and French models in the grand manner.

I was motivated by the approaching bicentennial of the disappearance of Congress's portraits of Louis XVI and Marie-Antoinette from the Capitol in Washington, D.C., in August 1814 to finally address the problem of what had happened to them. I approached Roland Celette, Cultural Attaché at the French Embassy, and Brandon Brame Fortune, Chief Curator of American Painting, at the National Portrait Gallery, about organizing an international symposium, Political Portraiture in the United States and France during the Revolutionary and Federal Eras, ca. 1776–1814. As the organizing scholar of the event, I secured program grants from the Terra Foundation for American Art, the Henry Luce Foundation, and the Samuel H. Kress Foundation and worked with distinguished scholars Fortune, Salmon, Philippe Bordes, Amy Freund, and Margaretta Lovell to provide a public forum to explore themes on the state portrait, portrait ateliers, diplomatic gifts, republican identity, family identity, and body metaphors in city planning. With what issues would the public connect with the most? My own paper attempted to address the last of the four "contextualized moments" for the royal portraits, that is, the period between Congress's installation of them in the Capitol in 1800 and British forces' destruction of the edifice in 1814. Concentrating on the spatial configuration of the Senate wing and the quarrel between Federalists and Republicans over the viability of an alliance with France, I stopped short of providing a definitive answer on their fate, which some attendees found frustrating. With a sabbatical release in 2015–16, I was able to edit the conference anthology, *Politics & Portraits in the United States & France during the Age of Revolution,*

so that it could be published by Smithsonian Institution Scholarly Press under the direction of Ginger Strader Minkiewicz in the spring of 2019.

Near the end of the sabbatical, I gathered documents from the Archives du Ministères des affaires étrangères in La Courneuve and the National Archives in Washington, D.C., to propose what had happened to the state portraits on the night of 24–25 August 1814, but this cursory and fragmentary history failed to solve the mystery or to make a contribution to the literature on the War of 1812 and the history of iconoclasm during the American Revolution. Mary MacDonald, Director of Publications at the American Philosophical Society, and five readers helped this project along by generously sharing expertise on political and economic history as well as visual and material culture that might elucidate the investments at stake by the time the British marched on Washington, D.C. The diplomatic papers showed that the war against military strongholds provided great cover for all sorts of crimes perpetrated on cities and that phrases could be turned ambiguously to cover battlefield humiliation and material loss. I concluded that the best way to approach the problem was to lay out the evidence to support two scenarios for their disappearance and then see how well each scenario intersected with the larger contexts of British deployment of royal portraits throughout North America and British ransacking of republican buildings in the Chesapeake. Studying colonialism critiques and battle reenactments was a challenging slog for a historian whose research is usually motivated by the appeal of a portrait and could only have been achieved over two summers in which American and French revolutionary holidays were observed and widespread social unrest tested the resilience of the republics. Which of the two scenarios seems more convincing the reader will, no doubt, in time convey with diplomatic tact or partisan zeal.

<div style="text-align:right">

T. Lawrence Larkin
Belgrade, 2020

</div>

In gratitude to the Hon. Leon E. Panetta
for selecting my portrait of Louis XVI and Marie-Antoinette
to represent California's 16th district in the House Offices, Washington, D.C.,

1985

Table of Contents

List of Illustrations

Introduction

George Munger's ink and watercolor rendering of the U.S. Capitol as viewed from the southeast (figure 1) pretends to show the grim, demoralizing effects of British troops' occupation, looting, and arson of government buildings on an American citizenry who contemplate, explore, and shore up the ruins during the final months of the War of 1812. Broken windows and charred casements suggest that the commodiously planned and lavishly fitted interiors of the House of Representatives and Senate have been completely gutted, leaving only cracked stones and smoldering timbers. Laborers equipped with a cart, shovel, and pick arrive at the unfinished rotunda to remove unwanted debris from the structure, while an array of stones and planks deposited on the lawn signal that salvage and disposal efforts have been underway for some time. Gentlemen with frockcoats, hats, and canes somewhere in between take in the awesome spectacle, perhaps attempting to come to terms with the folly of palatial structures or the vulnerability of young republics, while a woman with a large basket pauses to attend them and two more men stride along the façade of the building to assess the extent of repairs needed. These folk of different classes and occupations seem to share a desire to remember what was lost, to preserve what remains, and to furbish anew, achieving a sense of dialogue as a community and continuity as a nation.

The loss of Congress's state portraits of Louis XVI and Marie-Antoinette, displayed on the main floor of the Senate wing at right, surely had different import for each generation and political faction who had seen them. From the vantage point of the veteran of the American Revolution, the loss of the royal portraits threatened to erode collective memory that the French monarchy had been the first to ally with the American republic (i.e., had been the first to recognize, to subsidize, and to trade with the United States as a full-fledged member of the international community) and that the First Republic and Consulate had through their erratic behavior (e.g., periodic seizures of American merchant vessels and declarations to revive an empire in Louisiana and the Caribbean) effectively forced Congress to develop an independent foreign policy platform and to pass bills intended to protect trade and territorial interests. For the Democratic-Republican citizen who supported successive Jefferson and Madison administrations, the displacement of the royal portraits from the Senate Chamber to a committee room, followed by their disappearance during British occupation of the Capitol, signaled the end of Federalist influence over the legislature and a decisive break with the trappings of gentry as a prerequisite for high office. One could argue that other state portraits, equally grandiose in their claims of executive authority vested in a mythic individual (e.g., George Washington, Theodore Roosevelt), have long since taken their place, leaving the scholarly researcher of American art and history to discover sporadic references to them in ledgers and documents at the National Archives.

For more than a century, concerned citizens and their elected representatives have written to the Architect or Curator of the Capitol to inquire about the

1

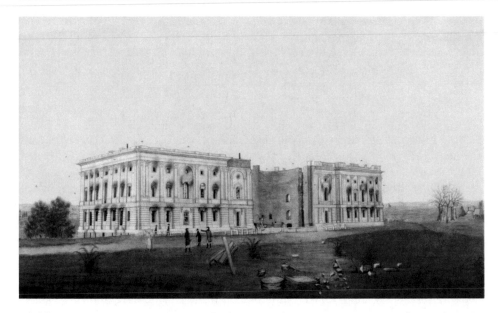

Figure 1. George Munger, *The U.S. Capitol after Burning by the British* (detail), 1814. Ink and watercolor on paper, 59 × 50 cm. Prints and Photographs Division, Library of Congress, Washington, D.C., Public Domain.

appearance and whereabouts of the French state portraits.[1] The explanation most commonly offered is that Benjamin Franklin conceived the idea of a gift as part of a diplomatic outreach initiative at the beginning of his tenure as minister in Paris, the Second Continental Congress formally requested the pictures at the height of the War of Independence, and Louis XVI granted them as a testament of his regard for the fledgling republic after the signing of the Treaty of Paris.[2] They were carted to Congress's various meeting places in New York City, Philadelphia, and Washington, D.C., and vanished during British occupation of the capital and the chaotic aftermath in late August 1814, and no credible accounts of them have emerged since then. National recollection of the former existence of the images has been stirred, and renewed efforts to locate or replace them have been launched, on important occasions when Americans have sacrificed or celebrated in common cause with the French. Although Democratic legislators were the first to introduce a bill authorizing "the purchase of certain portraits to replace those presented by the French Government and destroyed in the burning of the Capitol" in early 1885, presumably as a gesture of gratitude to parallel the completion of the Statue of Liberty, Republicans took time to inquire about research and reclamation efforts in the mid-1920s as American politicians and diplomats were reflecting

[1] For public and Congressional correspondence on the portraits, see "Works of Art Destroyed by Fire: Portraits of Louis XVI and Marie-Antoinette" file, Curatorial Department, Office of the Architect of the Capitol, Washington, D.C. (gratitude is herewith expressed to Dr. Barbara Wolanin).

[2] See T. Lawrence Larkin, "A 'Gift' Strategically Solicited and Magnanimously Conferred: The American Congress, the French Monarchy, and the State Portraits of Louis XVI and Marie-Antoinette," *Winterthur Portfolio* 44, no. 1 (Spring 2010): 31–75.

on the long-term consequences of the Treaty of Versailles.[3] Indeed, the earliest scholarly assessments of the royal portraits were born of the latter impulse: in an essay published as part of the proceedings of the Massachusetts Historical Society in 1925–1926, Harvard legal scholar Charles Warren credited mid-nineteenth-century "sightings" of the portraits as evidence that they probably survived British occupation of Washington, D.C., to languish in storage; in his survey of the Capitol art collections published in 1927, curator Charles Fairman re-evaluated piece-meal documents and concluded that they were almost certainly looted or burned.[4] Since neither researcher could offer unimpeachable evidence that the pictures had been destroyed or had survived, the matter was left to speculation and continues to try the patience of curators and archivists. What can the fragmentary record of Congress's deliberations and motions offer in the way of indications of the preservation or destruction of the portraits of Louis XVI and Marie-Antoinette, and with them the national exercise of party politics in the pursuit of international alliances?

I cannot claim to have located an eye-witness account of the theft and/or destruction of the state portraits, a secret bill of sale pointing to their transfer to a rampaging general or unscrupulous merchant, or a neglected storage vault rumored to contain forgotten treasures; however, I have reviewed an ever-expanding corpus of images, plans, letters, journals, and documents conserved at the Western Reserve Historical Society, Cleveland; the Library of Congress, the Capitol, and the National Archives, Washington, D.C.; and the Archives du Ministère des Affaires Étrangères, La Courneuve. These suggest that since the eighteenth century there was a tradition of displaying state portraits to assert political claims in North America, a revival of the practice of spolia on defeated countries in Western Europe, both of which have some bearing on the thieving and incendiary warfare waged across the Great Lakes and the Chesapeake Bay, culminating in the destruction of public buildings in Washington, D.C. Official documents and war histories shed light not only on the strategic interests of governments, parties, and generals but also on how the portraits may have fared as objects of desire or danger.

This essay will accomplish four specific tasks: it will establish the origins, location, and function of British and French state portraits in North America and the West Indies from the 1760s to 1820s and relevance to the American republic;

[3] See George H. Pendleton, Senate Bill 2591, 27 January 1885, in "Portraits of Louis XVI and Marie-Antoinette" dossier, December 1960, National Archives, Washington, D.C. (gratitude is herewith expressed to William H. Davis); Isaac M. Jordan, House of Representatives Bill 8166, 2 February 1885, in "Works of Art Destroyed by Fire: Portraits of Louis XVI and Marie-Antoinette" file, Curatorial Department, Office of the Architect of the Capitol, Washington, D.C.; the proposal was eventually dropped, possibly because Pendleton's and Jordan's terms expired before sufficient support could be found or because art historians had not yet identified the original portrait types. Also see Richard Wayne Parker to Elliot Woods, 14 March 1923, in "Portraits of Louis XVI and Marie-Antoinette" dossier, December 1960, National Archives, Washington, D.C.; Simeon D. Fess to Charles E. Fairman, 13 April 1926, cited in Fairman to Fess, 14 April 1926, in "Works of Art Destroyed by Fire: Portraits of Louis XVI and Marie-Antoinette" file, Curatorial Department, Office of the Architect of the Capitol, Washington, D.C..

[4] Charles Warren, "What Has Become of the Portraits of Louis XVI and Marie Antoinette, Belonging to Congress?" *Massachusetts Historical Society Proceedings* 59 (October 1925–June 1926): 45–85; Charles E. Fairman, *Art and Artists of the Capitol of the United States of America* (Washington, D.C.: Government Printing Office, 1927), 22–25.

it will identify a new phase of looting and burning as strategies integral to British and French warfare in Western Europe in the 1800s and assert ramifications to British–American hostilities in the Great Lakes and Chesapeake Bay regions in 1812–1814; it will propose that both the perceived rivalry of portrait subjects and established practice of appropriating and annihilating public buildings and images came to bear on the British invasion, looting and burning of the Capitol in Washington, D.C., on the night of 24–25 August 1814; finally, it will weigh the fragmentary bodies of evidence in terms of their usefulness in presenting two arguments: one in support of destruction, and the other in support of theft, of the French portraits.

What will emerge is a sense of the following: the British foreign ministry saturated the colonial governorships with paired portraits of George III and Charlotte over a sixty-year period to suggest proprietorship of the colonies and to encourage loyalty to the crown while the French preferred to gift a single portrait of Louis XV or Louis XVI to a foreign head of state or governing body in a manner that promised to yield a particular strategic benefit; British and American militia employed looting and firing of military forts and public buildings ideally, private homes and farms collaterally, as a strategy to profit from, punish, deplete, and demoralize the other, a practice fairly evenly matched in thrust and counter-thrust along the Canadian border but used with relative impunity by the British in the Chesapeake; Vice-Admiral George Cockburn nursed a long-term ambition to capture and destroy the government buildings at the national capital of Washington, D.C., in retaliation for the looting and burning of the colonial assembly building at York, the brutal excesses of which were checked somewhat by General Robert Ross; French ambassador Louis Barbe Charles Sérurier came to terms with local African American accounts of the vandalism of the royal portraits, an act of political iconoclasm, at the same time American patents superintendent William Thornton concluded from the evidence of empty frames that the portraits were stolen, for which there were several suspected culprits.

By moving from European production of political portraits to North American points of political conflict, to the U.S. government's abandonment of its capital, to the Senate's loss of cultural artifacts, I am able to propose a larger question of how vulnerable state portraiture could be to revolutionary change and imperial quarrels. The portrait could be not only identified with a particular individual, political faction, or government building but also associated with the origins, development, and expansion of a nation to a point where its existence as a historical claim clashed with that of a rival nation.

Royal Portraits in North America and the West Indies

It is important at the outset to sketch the administrative structures that facilitated the development of state portraits in Britain and France and their distribution to North America and the West Indies in the fifty years or so following the Seven Years' War (1756–63). British and French sovereigns could commission their state portraits to be presented to any number of relations, ministers, ambassadors, foreign dignitaries, and colonial governors as a sign of delegated power or strategic alliance. From the British foreign minister's point of view, it was logical that a governor or council appointed to preside over a heterogeneous body of colonials (especially those in the newly acquired provinces of Nova Scotia, Quebec, and the Floridas) would require a portrait of the Hanoverian monarch arrayed in robes of state as an economical sign of his mandate. From the French minister's point of view, it was reasonable to regard a governor-general or lieutenant governor's vulnerable or temporary standing within the few remaining colonies (in the Caribbean and Nova Scotia) as inadequate to justify the delivery of an elaborate portrait of the Bourbon king attired in coronation robes or Bonaparte absorbed in civil and military concerns, which made their occurrence noteworthy.

George III appointed Scottish painter Allan Ramsay to the post of Principal Painter in 1761, and within a year and a half he completed the principal portrait models of the king and his consort, Charlotte of Mecklenburg-Strelitz (figures 2 and 3).[5] Although both portraits display the same gold-ivory-dusty blue coronation apparel, a table covered with red velvet and supporting regalia, monumental plinth and column, swag of pink drapery with ropes and tassels, and arabesque carpet in shades of red, blue, and green, the figures of the sovereigns are largely independent in pose, the king refreshingly at ease with one hand resting on the table and the other on his hip, and the queen aridly erect and symbolically reaching for the diadem. Both sovereigns were sketched from life, although the king seems animated by his relaxed

[5] Alastair Smart, *Allan Ramsay: A Complete Catalogue of His Paintings*, ed. John Ingamells (New Haven and London: Yale University Press, 1999), 88–90 (no. 85), 111–120 (no. 192). When the Hanoverian monarch desired a state portrait, he asked his Principal Painter in Ordinary (e.g., Ramsay) to produce a charcoal sketch or oil model of himself and/or the consort at full length, and the work being judged satisfactory, the artist would establish a studio in London and contract with assistants (e.g., David Martin and Philip Reinagle) to handle the production of copies; the painter would carry out work on the face and hands and leave the business of draperies and furnishings to others; he would communicate with the royal joiner to ensure that the frame was designed and fit appropriately; the status of the patron and the amount he or she was willing to pay determined the extent of the artist's direct involvement in the picture(s). Jacob Simon, "Frame Studies II. Allan Ramsay and Picture Frames," *The Burlington Magazine* 136, no. 1096 (July 1994): 453, states that Ramsay, in addition to receiving direct orders from the royal family and the Lord Chamberlain, kept his own accounts of courtiers and corporations who came directly to him to obtain copies.

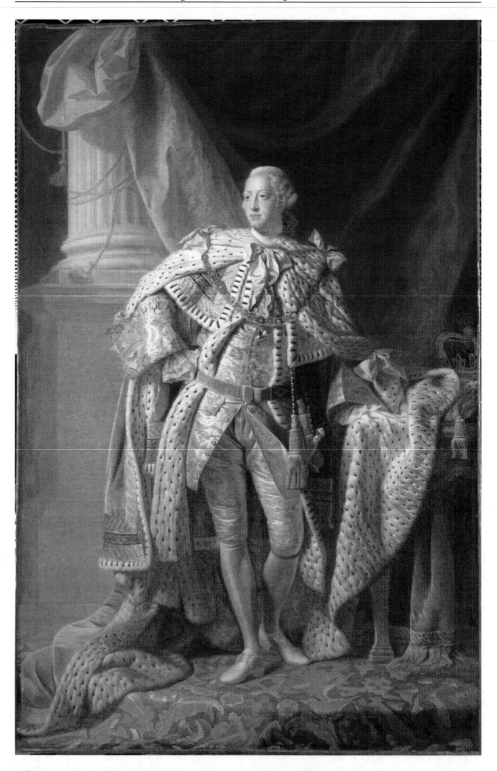

Figure 2. Allan Ramsay, *George III*, 1763. Oil on canvas, 249.7 × 163 cm, National Galleries of Scotland, Edinburgh. Purchased 1888. © National Galleries of Scotland, Dist. RMN-Grand Palais / Art Resource, NY.

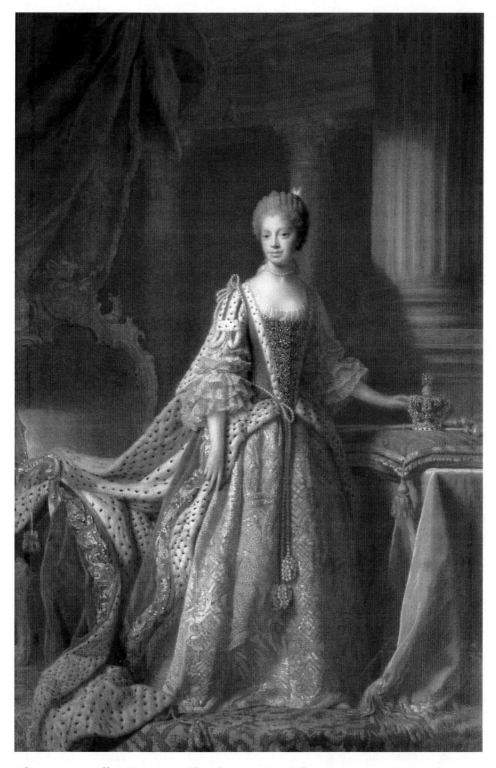

Figure 3. Allan Ramsay, *Charlotte*, 1762. Oil on canvas, 248.9 × 161.3 cm. Royal Collection, Buckingham Palace, London. ART Collection / Alamy Stock Photo.

movements while the queen is indebted to French models, the gesture and back-
ground repeating Pierre Gobert's and Jean-Baptiste Van Loo's compositions for
Queen Marie Leszczynska of the mid-1720s.[6] Since the majority of British state por-
traits were sent abroad as pairs in the late eighteenth century, it is remarkable that
the poses and gestures of the royal couple do not complement or respond to each
other, reflecting an ambiguity on the part of the painter about how to render the
consort's station and attitude. One has the sense that the king's gentlemanly attitude
is being studied while the queen's youthful body is being displayed. The Ramsay
pair were not the only portraits in circulation as President of the Royal Academy
Joshua Reynolds managed to overcome George III and Charlotte's antipathy toward
him to extract sittings in 1779–80, the king nonchalantly sprawled on a pinnacled
throne set in a medieval hall and the queen quietly self-contained before a delicately
pilastered wall (figures 4 and 5), and these served as models for about half a dozen
replicas.[7] Whatever the disparities of pose and setting, matching frames designed by
René Stone or Isaac Gosset would have contributed to an illusion of uniformity; ac-
cording to Jacob Simon, these were practical rectangular affairs subtly carved with
parallel rows of acanthus, shells, ribbon, bead, or egg-and-dart topped with a few
rose and thistle branches supporting a small coronet.[8] The cost was about £84 for
each painting and £33 for each frame, presuming nothing special was added.[9]

As head of the Royal Household, the Lord Chamberlain was responsible for
overseeing reproduction and distribution of the portraits, ordering copies and
frames for ambassadors and colonial governors in coordination with the Secretary
of State for the Colonies at the Colonial Office or Home Secretary at the Foreign
Office, and paying for them out of funds set aside for court ceremonies, entertain-
ments, and gifts.[10] In his catalogue of Ramsay's oeuvre, Alastair Smart is fairly
precise about distribution: pictures were reserved for royal residences and close
relations; gifts were made to dukes, earls, and marquesses, city corporations, and
trading companies, but the bulk of the output went to ambassadors and colonial
governors, a subject on which I will have more to say later; gifts of paired portraits
of the king and queen vastly outnumbered single portraits of the king as if to sug-
gest a symbolic union to the beholder, where every man and woman was simulta-
neously bound to each other and the state, and where the family line was mirrored
in the royal succession.[11]

[6] T. Lawrence Larkin, "Marie-Antoinette and Her Portraits: The Politics of Queenly Self-Imaging
in Late Eighteenth-Century France" (Ph.D. diss., University of California, Santa Barbara, 2000),
1: 25–26, 2: 439 (fig. 14), 442 (fig. 17).

[7] Nicholas Penny, ed., *Reynolds* (London: Royal Academy of Arts and Weidenfeld and Nicolson,
1986), 286 (nos. 114, 115); Malcolm Cormack, "The Ledgers of Sir Joshua Reynolds," *The Volume
of the Walpole Society* 42 (1968–1970): 167–168, mentions that on 28 November 1789 eight
portrait pairs had been completed.

[8] Simon, "Frame Studies II," 452.

[9] Simon, "Frame Studies II," 454.

[10] Smart, *Allan Ramsay*, 112 (no. 192); Simon, "Frame Studies II," 452. Although there were
rules in place that forbade lower-level emissaries like envoys from requesting state-subsidized
portraits of the king and queen, they did not forbid minor members of the foreign service from
purchasing pairs directly from an artist's atelier; envoys were sometimes granted portraits if their
mission or achievement was deemed significant; see Smart, *Allan Ramsay*, 113 (192d).

[11] Smart, *Allan Ramsay*, 111–121 (no. 192).

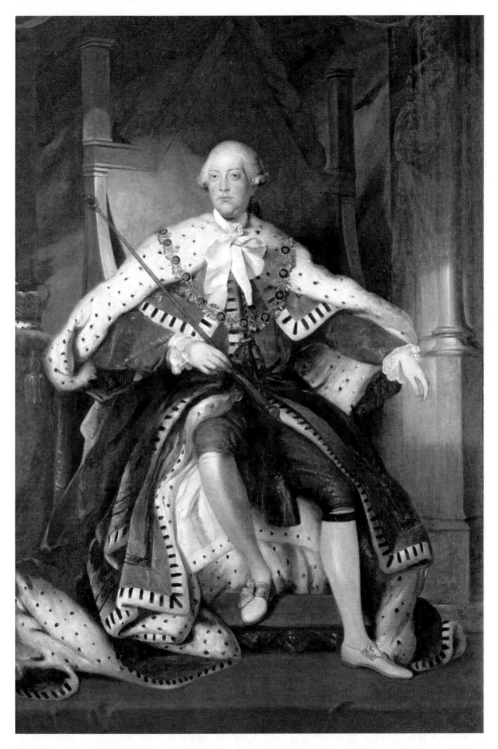

Figure 4. Joshua Reynolds, *George III*, 1780–85. Oil on canvas, 238.8 × 147.3 cm. Attingham Park, Shropshire, UK. National Trust Photographic Library / John Hammond / Bridgeman Images.

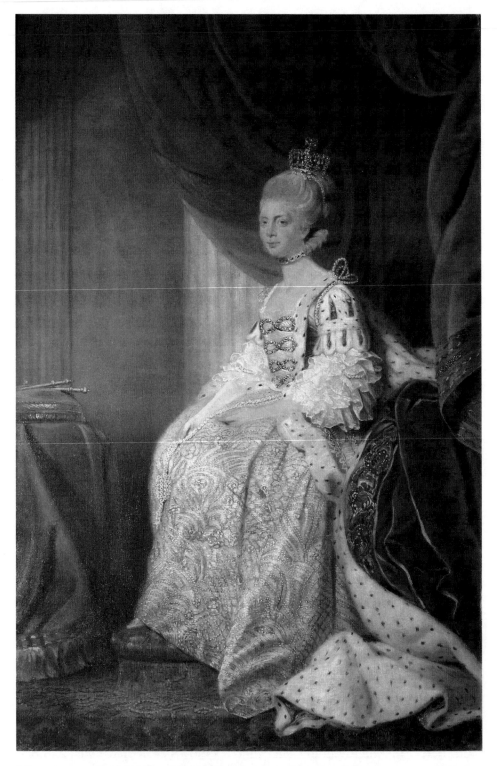

Figure 5. Joshua Reynolds, *Charlotte*, 1780–85. Oil on canvas, 238.8 × 147.3 cm. Attingham Park, Shropshire, UK. National Trust Photographic Library / Bridgeman Images.

Louis XV and Louis XVI, respectively, entrusted to French academic painters Louis-Michel Van Loo and Joseph-Siffred Duplessis the task of completing portraits of the king in an animated counterpoise, although the Foreign Ministry intervened in 1779 to commission Antoine-François Callet to realize a more traditional static frontal model to serve as a basis for diplomatic gifts.[12] Van Loo's model of the early 1760s, *Louis XV in Robes of State* (1759; figure 6), paraphrases Hyacinthe Rigaud's formula for Louis XIV (1701; figure 7) by representing the middle-aged monarch piled with velvet and ermine robes standing before a marble plinth supporting colossal columns and an immense gilded and brocaded throne, his right hand resting the scepter of France on a footstool spread with regalia and his left grasping an abundantly plumed hat which grazes the sword of Charlemagne fastened at the waist.[13] Instead of echoing his great grandfather's direct gaze, Louis XV turns his head to the right as if to anticipate the approach of a minister, general, or emissary. Joining Louis XIV's direct gaze to Louis XV's splayed figure, Antoine-François Callet imagined Louis XVI contemplating the viewer from atop voluminous velvet robes parting to reveal a cascading lace sleeve, billowing silken doublet, and a single shimmering calf; the throne supports a personification of justice at right and the marble wall a ship patrolling a fortified coast at left (figure 8).[14] The iconic stare demands that the beholder recognize a political relationship to the sovereign as head of the French state both within the European court and the foreign embassy.

As I have observed elsewhere, such stately compositions were at the nexus of history and portrait painting, parading an idealized body and allusions to a symbolic role meant to promote the king's presence and, therefore, authority wherever they were displayed. Rooted in medieval juridical-political theory, the notion of the king's "two bodies" held that the sovereign possessed a physical or mortal body subject to growth, maturity, decay, and death, and an abstract or immortal body transcending physical and temporal limitations and manifested in dynastic continuity, the notion of the Crown or state, and continuous dignity; the effigy or portrait attributed to the current occupant of the throne the awesome power of the state and thereby encouraged blind faith in and general submission to its promulgations; the artist strove to achieve a good likeness and authoritative pose within the boundaries of long-established pictorial conventions.[15] Élisabeth Vigée Le Brun provided

[12] T. Lawrence Larkin, "Observations on the Cabinet des Tableaux du Roi at Versailles, ca. 1774-1792," *Notes on Early Modern Art* 4, no. 2 (2017): 55–62; and Christian Baulez, "Souvenirs of an Embassy: The comte d'Adhémar in London, 1783–87," *The Burlington Magazine* 151, no. 1275 (June 2009): 376, notes that the original work cost 12,000 livres for the canvas and 1,800 livres for the frame and was displayed in the foreign minister's apartment at Versailles.

[13] Fernand Engerand, ed., *Inventaire des tableaux commandés et achetés par la direction des Bâtiments du roi (1709–1792)* (Paris: Ernest Leroux, 1901), 490.

[14] Larkin, "A 'Gift' Strategically Solicited," 45–52.

[15] T. Lawrence Larkin, "The U.S. Congress's State Portraits of Louis XVI and Marie-Antoinette: The Politics of Display and Displacement at the Capitol, 1800–1814," in *Politics & Portraits in the United States & France during the Age of Revolution*, ed. Larkin (Washington, D.C.: Smithsonian Institution Scholarly Press, 2019), 21–22; also see Ernst H. Kantorowicz, *The King's Two Bodies: A Study in Medieval Political Theology* (Princeton: Princeton University Press, 1957), 259–272, 314–317, 328–336, 413–437, and Louis Marin, *Portrait of the King*, trans. Martha M. Houle (Minneapolis: University of Minnesota Press, 1988), 3–15, 206–219.

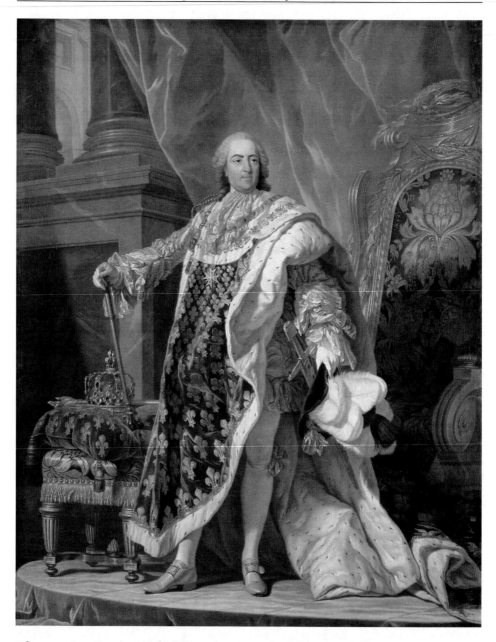

Figure 6. Louis-Michel Van Loo, *Louis XV*, 1759. Oil on canvas, 227 × 184 cm. Musée national du Château de Versailles. Album / Alamy Stock Photo.

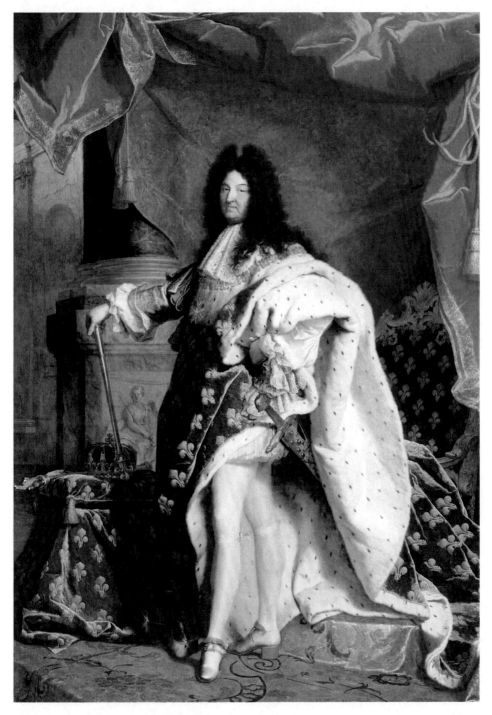

Figure 7. Hyacinthe Rigaud, *Louis XIV*, 1701. Oil on canvas, 227 × 194 cm. Musée national du Louvre, Paris. World History Archive / Alamy Stock Photo.

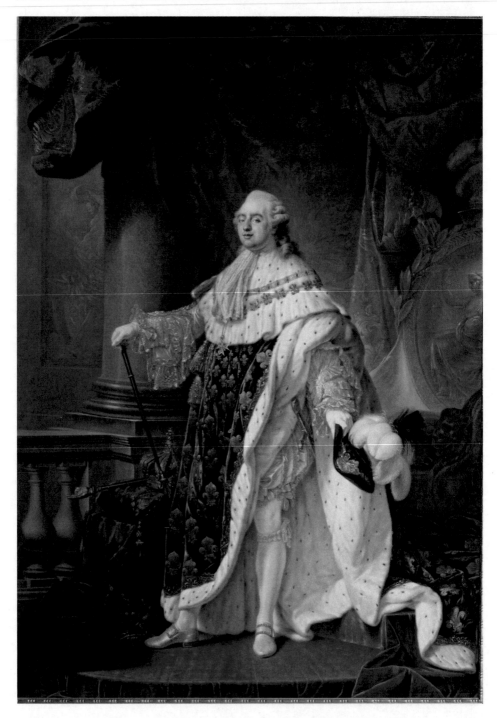

Figure 8. Antoine-François Callet, *Louis XVI*, 1780. Oil on canvas, 275.5 × 193.5 cm. Schloß Ambras, Innsbruck. Photo: Erich Lessing / Art Resource, NY.

a rare companion portrait of Marie-Antoinette, wherein the queen, modeled after Joseph Krantzinger's facial type and Joseph-Siffred Duplessis's counterpoise, is weighed down by an enormous, tank-like satin dress overlaid with swags and bows yet turns her head to the left in an expression of alertness to matters beyond the scope of ceremonial display (figure 9). Frames carved under François-Charles Butteux's direction and consisting of parallel rows of shells, acanthus, and beads at the perimeter and cartouches inscribed with royal signets at the corners, the crown and arms of France and Navarre at the cresting, would have affected a degree of equilibrium between the two unlike compositions. Sarah Medlam suggests on the basis of watercolor sketches at the Musée des arts décoratifs that Butteux tailored the carved elements at the top of the frame to the recipient; whereas a border destined for a French or Spanish ambassador instrumental in the War of Independence (e.g., comte d'Ahémar, comte d'Aranda) incorporated lowered military standards and trophies to signify a new era of peace (figure 10), one directed to the Congress of the United States may have included a Phrygian bonnet and Indian feathered headdress, scepter and hand of justice, club, rattlesnake, and quiver with arrows (as in figure 11).[16] Diplomatic gifts on a grand scale usually cost 3,000 livres for each portrait copy and 1,800 for each custom frame, making them about 40 percent more expensive than the British product.[17]

It was not the ministre du Maison du roi (minister of the king's household) but his subordinate, the surintendant des Bâtiments du roi (superintendent of the king's cultural projects), who was responsible for overseeing portrait production and distribution, working with the Premier Peintre du Roi and Directeur of the Académie royale de peinture et de sculpture (first painter to the king and director of the Royal Academy) in the selection of an artist to achieve an official image and the Garde des tableaux de la couronne (keeper of crown pictures) in the supervision of the Cabinet de tableaux (king's picture atelier) to furnish a steady supply of copies and frames.[18] Although to date there is no catalogue raisonné for Van Loo and a tentative one for Callet, the Correspondance des Bâtiments du roi at the Bibliothèque nationale and the Régistre des présents at the Ministère des Affaires étrangères provide insight on the matter of distribution: the king's portrait was reserved for royal residences and presented to the king's family and ministers,

[16] Sarah Medlam, "Callet's Portrait of Louis XVI: A Picture Frame as Diplomatic Tool," *Furniture History* 43 (2007): 143–150. The inscription on the reverse of the watercolor sketch of the frame dated 11 August 1780 directs the joiner/carver as follows: "L'Allegorie des trieze Provinces-unies de l'Amérique Septentrionale, est exprimée d'un coté par le Bonnet Simbole de la liberté, et par la Massue, et le Serpent à Sonnettes: Le Sceptre du Roi les accompagne. De l'autre coté par un Bonnet de plumes, et un Canquois écaillé, avec la main de Justice qui favorise la cause de l'Amérique." Medlam, "Callet's Portrait of Louis XVI," 2007, 146–147, concludes that "this note makes clear that the frame, as originally designed in 1780, constituted the boldest possible propaganda in favour of the new United States of America, designed to declare France's championship of the American cause." A reduced version of this conceit, made for Charles-Clément Bervic's engraving of Louis XVI (ca. 1790) and currently at Mount Vernon, suggests that carvers were able to execute this allegory in wood; see "Louis Seize, Roi des français, Restaurateur de la Liberté," Mount Vernon Collections, Mount Vernon Website, accessed 15 June 2019, https://www.mountvernon .org/preservation/collections-holdings/browse-the-museum-collections/object/w-767a-b/. Wendy Wick Reaves, "The Prints," *Magazine Antiques* 135, no. 2 (February 1989): 502–503.

[17] Larkin, "A 'Gift' Strategically Solicited," 68.

[18] Larkin, "Observations on the Cabinet des Tableaux," 50.

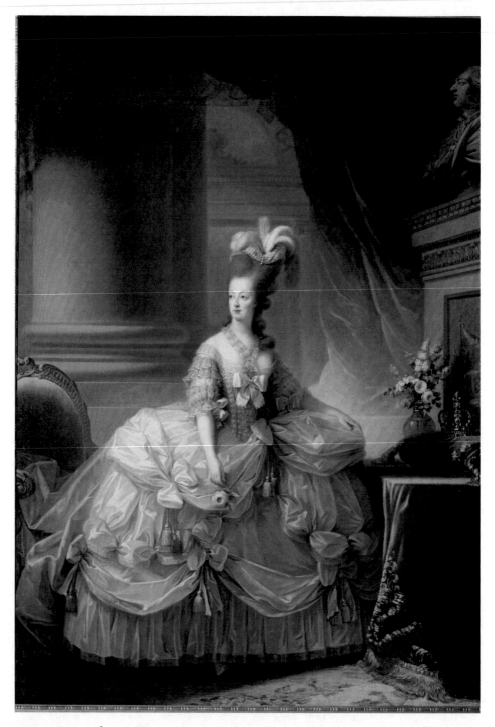

Figure 9. Élisabeth Vigée Le Brun, *Marie-Antoinette*, 1777–78. Oil on canvas, 273 × 193.67 cm. Schloß Ambras, Innsbruck. Photo: Erich Lessing / Art Resource, NY.

preeminent dukes, peers and marshals, regional parlements and sovereign courts, eminent clerics and venerable confraternities, ambassadors, and foreign heads of state in equal measure; the gift of paired portraits of the king and queen was seldom made, usually when it was desirable to promote the illusion of dynastic ties with other monarchies or strategic alliance with other governments.[19]

British and French sovereigns approved the dispatch of state portraits abroad, though for different reasons rooted in their objectives as dominant and curtailed colonial powers. Notwithstanding the different natures of "constitutional" monarchy in Britain and "absolute" monarchy become "representative" republic and "republican" dictatorship in France, the two heads of state (George III and his regent Prince George, Louis XVI and his successor Napoleon Bonaparte), took very different approaches to the administration of empire: one sought "possession" via rapid colonization of territories and exploitation of resources for the benefit of home manufacturers; the other sought possession with somewhat less commitment to development and later discarded this for a policy of "assimilation" through gradual extension of the rights of French citizenship. The British colonial administration, confident that its grasp on overseas territories was largely secure, were especially active in distributing portraits throughout their colonies—in what could be called a policy of "general saturation" intended to reach the greatest body of politically invested people attendant at governors' mansions, councils, and assemblies—while the French, mindful that their hold on colonies was tentative, sent a few portraits abroad to important heads of state and deliberative bodies—a policy of "strategic precision" intended to reach a select group at the point of greatest political impact at a chief's compound, president's mansion, or representatives' chamber. There is a sense that whereas the British employed the state portrait to stamp territories under their jurisdiction and to encourage loyalty to the Crown, the French employed the state portrait as a sign of approval, grace, or friendship extended to a sympathetic ally. In this way, the British sought to bind the loyal subject firmly to the "mother country," though shared customs and interests and the French sought to cultivate the ruling class on the basis of shared philosophies and values.

The nature and extent of the British and French colonial empires in North America and the Caribbean had a direct bearing on why and where government administrators in London and Versailles/Paris distributed portraits and more indirectly how the portraits appeared and what they signified. Ian Steele observes that George III was determined to rule the British Empire as "king-in-Parliament"— that is, to manage personally the affairs of the colonies through appointment of senior departmental bureaucrats and consultation with the current party majority in the legislature, which resulted in tighter central control.[20] Responsibility for colonial affairs was initially entrusted to the Secretary of State for the Colonies who presided over the Colonial Office (ca. 1768–82), but then passed to the Home Secretary at the Foreign Office (1782–1801), and finally to the Secretary of State for War and the Colonies at the Foreign Office (1801–54). For any one colony, the king or delegated crown official appointed a personal representative, a governor

[19] Larkin, "Observations on the Cabinet des Tableaux," 52.

[20] Ian K. Steele, "The Anointed, the Appointed, and the Elected: Governance of the British Empire, 1689–1784," in *The Oxford History of the British Empire, Vol. 2: The Eighteenth Century*, eds. P. J. Marshall and Alaine Low (Oxford: Oxford University Press, 1998), 121.

(usually a gentleman or nobleman), in whom was vested exclusive and ultimate executive authority; the governor in turn formed a council, which advised on general policy and drafted, commented on, or recommended specific bills and legislation; finally, the governor permitted the formation of an assembly along representative lines (especially in the case where a majority of colonists were English), which over time evolved from questioning to absorbing aspects of governance.[21]

When these assemblies began to abrogate power, challenging or eclipsing that of the governor, the colony headed toward semi-independent or independent status, as in the case of the Thirteen Colonies, whose assemblies, protesting additional taxes imposed to pay for the cost of the Seven Years' War, moved the region toward autonomy and, once achieved, would play havoc with the U.S. Congress's attempts to establish a federal government and strong executive branch for the purpose of waging war, settling collective debt, and conducting foreign policy. The American Revolution taught the British king-in-Parliament an important lesson in the management of colonies: never expect a possession to pay for itself in the form of raw materials and taxes to the imperial administration. What was left to London was, as Peter Marshall puts it, "the possibility of aligning the social structure and values of the remaining colonies with the established practices of the mother country."[22] To this should be added the responsibility of shepherding the assemblies to maturation as representative and self-governing blocs.

In the West Indies, the British had from the early seventeenth to early eighteenth centuries maintained the strategic and profitable colonies of Barbados, Jamaica, the Leeward Islands, and the Bahamas. War with the French in the mid-1750s permitted them to acquire Dominica, St. Vincent, Grenada, and Tobago to maintain a presence in parts of the Virgin Islands and Honduras. The Napoleonic Wars provided a pretext to take St. Lucia, Trinidad, and part of Guiana. These colonies tended to be comprised of plantation societies, where small planters worked large numbers of slaves in the production of sugar and resisted any attempts on the part of imperial or religious authorities to change or lessen the brutal work regimen.[23] Older, more developed colonies tended to have a governor on hand to represent the crown, councils to advise on legislation, and elected assemblies possessed of legislative, taxation, and nominating capacities; newer, less developed territories were administered directly from London as "Crown Colonies" which did not permit local participation in political and economic affairs.[24]

[21] H. E. Egerton, "The System of British Colonial Administration of the Crown Colonies in the Seventeenth and Eighteenth Centuries Compared with the System Prevailing in the Nineteenth Century," *Transactions of the Royal Historical Society* Vol. 1 (1918): 202.

[22] Peter Marshall, "British North America, 1760–1815," in *The Oxford History of the British Empire, Vol. 2: The Eighteenth Century*, eds. P. J. Marshall and Alaine Low (Oxford: Oxford University Press, 1998), 384.

[23] Christopher L. Brown, "The Politics of Slavery," in *The British Atlantic World, 1500–1800*, eds. David Armitage and Michael J. Braddick (Houndmills, England: Palgrave Macmillan, 2002), 219. Brown, "The Politics of Slavery," 220, observes, "the planter class [in the British Atlantic colonies] was the first to suggest that, with respect to slaves, these powers should be absolute and unqualified."

[24] Gad Heuman, "The British West Indies," in *The Oxford History of the British Empire, Volume 3: The Nineteenth Century*, eds. Andrew Porter and Alaine Low (Oxford: Oxford University Press, 1999), 470.

In North America, the British had by the terms of the Treaty of Paris (1763) ensured that Quebec and East and West Florida were added to the empire, though administration of both regions was complicated by a lack of English colonists.[25] The Floridas were more speedily invested with a governor, council, and assembly as the last of the Spanish Catholic population emigrated to other Spanish possessions. Despite George III's Proclamation (7 October 1763) to the Quebecois that the governors were directed to work with the council to summon general assemblies, the business of instituting assemblies was put off indefinitely because the French catholic inhabitants were determined to remain in the territory. In the meantime, as Steele observes, "an appointed Governor, Council, and judiciary cautiously applied British criminal law and French civil law."[26] French inhabitants felt pressures to anglicize the province not only in politics but also in trade and culture. The crisis was finally broken in 1783 when Britain's formal recognition of the United States caused remaining Loyalists there to cross the northern border and settle in Nova Scotia and Quebec.[27] Precisely because of this influx of "English" settlers, the British colonial administration was able to create a new Canada divided into two separate provinces: by the Constitutional Act of 1791 the newly settled, English-speaking area of Southwestern Quebec was designated Upper Canada, and the long settled, French-speaking area of Northeastern Quebec, Lower Canada. Government was stacked to ensure loyalty to Britain: while the English dominated the governorship, executive, and legislative councils, the French constituted the majority in the assembly.[28]

Several British colonial governors manning posts from Nova Scotia to Tobago requested and received a pair of state portraits of George III and Charlotte by Ramsay, making them the most well-known images of sovereigns in North America and the West Indies from their accession in the early 1760s up to their deaths in 1818 and 1820, respectively (Ramsay made 86 pairs of the coronation type before he died in 1784). State portraits of the Ramsay type could be found in Nova Scotia, New Brunswick, Canada, Bermuda, the Bahamas, Jamaica, Dominica, Barbados, St. Vincent, and Grenada under various colonial administrations between 1764 and 1820; state portraits of the Reynolds type could be found in Quebec, Jamaica, and St. Vincent.[29] As a general trend, a colonial governor would request the portraits from the king (via the Secretary of State for the Colonies or Home Secretary and the Lord Chamberlain as head of the Royal Household) to serve as a sign of

[25] Jean Bérenger and Jean Meyer, *La France dans le monde au XVIIIe siècle* (Paris: Sedes, 1993), 236–237.

[26] Steele, "The Anointed, the Appointed, and the Elected," 123.

[27] Marshall, "British North America," 385.

[28] Steele, "The Anointed, the Appointed, and the Elected," 123, observes, "After the American Revolution the new Governor and Lieutenant-Governor in the Canadas had broader patronage and fiscal powers, support from an established church aided by 'clergy reserves' of Crown land, and had not only the traditional appointed executive Councils but new appointed legislative Councils that became oligarchic upper houses."

[29] Penny, *Reynolds*, 286 (nos. 114, 115); Cormack, "The Ledgers of Sir Joshua Reynolds," 167–168, shows that portrait pairs were completed for [Guy Carleton,] Lord Dorchester, whose brother Colonel Thomas Carleton (also mentioned) was governor of Quebec, for Governor [James] Seaton, who was governor of St. Vincent, and for [Thomas Howard,] Lord Effingham (still unpaid), who was governor of Jamaica.

his credentials and the king's extended sovereignty and display them in his mansion for the duration of his tenure and then carry them home to the British Isles as a reward for loyal service; however, there were exceptions, as American revolutionaries could store or vandalize paintings (possibly those at Richmond and Williamsburg) and British representatives could leave portraits behind as a gift to the province or town corporation (e.g., Nova Scotia and Hamilton, Bermuda).[30] They affirmed the chain of command within the colonial administration and order of social precedence within the colonial court; they also vouched for the integrity of the assembly's legislation and court's application of law within a hall. A visual culture of royal sovereignty was in force throughout the region during the War of 1812 and would have had an ideological influence on the British as fleet and regiments advanced from Bermuda to raid Chesapeake farms, stores, and public buildings or escorted captured American ships, seamen, and cargo northward to Nova Scotia for adjudication.

Sobered by his grandfather's loss of most French dominions, Louis XVI took an interest in the remaining plantation colonies and provincial outposts partly from a sense of duty to the state and partly from a passion for geography and exploration. His cabinet du conseil (cabinet of state) contained, in addition to a policy-forming Secretaire d'État des Affaires Étrangères (foreign minister), a service-oriented Secretaire d'État de la Marine (Secretary of State of the Navy) who oversaw the development of the French navy and ports and administration of the colonies.[31] The sovereign in consultation with his cabinet appointed a gouverneur-général (usually a nobleman), who served as his personal representative in the colony, aided by a conseil or conseil superieur. There were two gouverneurs-général in the Americas during the eighteenth century: one presided over the colony of Saint-Domingue (Santo Domingo) in the Greater Antilles and the other presided over the Iles du Vent (Winward Islands) in the Lesser Antilles, although the National Convention suppressed both positions in 1794 as British occupation of the islands made French governorships untenable.[32] The king and his navy minister could also appoint a gouverneur particulier (lieutenant or local governor), who wielded military power for the defense of the colony and quelling of uprisings, and an intendant (intendent), who decided civil matters relating to police, justice, and finance.[33]

[30] See Smart, *Allan Ramsay*, 113 (no. 192r), 116 (nos. 192az, 192bg, 192bh, 192bk, 192bx), 117 (nos. 192cc, 192cf, 192cg), 118 (nos. 192cr, 192da), 119 (nos. 192dz, 192ea), 120 (no. 192ez). The only portraits on view in the Thirteen Colonies prior to 1776 that survived are a portrait of Charlotte which belonged to the 1st Baron Amherst, Governor of Virginia (1757–68) and portraits of George III and Charlotte, which belonged to the 4th Earl of Dunmore, Governor of New York (1769–70) and of Virginia (1770–76). Also see Ellen G. Miles, "The Portrait in America, 1750–1776," in *American Colonial Portraits 1770–1776*, eds. Richard H. Saunders and Miles (Washington, D.C.: Smithsonian Institution Press, 1987), 53–55.

[31] John Hardman, *French Politics 1774–1789: From the accession of Louis XVI to the fall of the Bastille* (London: Longman, 1995), 22.

[32] See Médéric Louis Elie Moreau de Saint-Méry, *Loix et constitutions des colonies françoises de l'Amérique sous le vent*, 6 vols. (Paris: Chez l'Auteaur, Moutard, and Mequignon jeune, 1784), 1:xxix, xxxv, accessed 17 June 2019, https://books.google.com/books?id=IMRFAAAAcAAJ &pg=PR29#v=onepage&q&f=false.

[33] See Moreau de Saint-Méry, *Loix et constitutions des colonies françoises*, 1:xxiii, xxxviii.

Although the title of Secretaire d'État de la Marine would change to Ministre de la Marine et des Colonies (Minister of the Navy and the Colonies) during the French Revolution, the appointee's duties, including the delegation of authority to governors general, lieutenant governors, and intendents, would remain largely the same. However, the appointee's approach to governing changed drastically under a new ethos of "liberté, égalité, et fraternité," necessitating attempts to facilitate "assimilation" of the colonized through gradual extension of the rights and responsibilities of citizenship. The benefits of assimilation of the colonial population into the national body of citizens went unquestioned. As Carl Cavanagh Hodge observes, "[The Paris government's] belief in assimilation . . . not only led to efforts to 'civilize' native peoples through exposure to French language, culture, industry, and education, it also had a profound impact on colonial administration. . . . Metropolitan laws, tariffs, and forms of government were simply extended to newly acquired possessions" regardless of the needs or desires of the inhabitants because the benefits of the republican experiment were thought to transcend differences of culture, class, and condition.[34]

Having ceded Quebec, Eastern Louisiana, and the Floridas to the British, Western Louisiana to the Spanish (in recompense for the loss of the Floridas) in 1763, the French managed to maintain control of part of Guiana in South America, Saint-Domingue and the Iles du Vent (Marie-Galante, Guadeloupe, Dominica, Martinique) in the West Indies, and the islands of St. Pierre and Miquelon off the coast of Newfoundland.[35] Saint-Domingue was highly valued because of its large sugar, coffee, and tobacco plantations, for which planters required plenty of slave labor and merchant credit, a triangulation of trade among France, Africa, and the Antilles.[36] Olivier Grenouilleau points out that this "relational" commerce driven by families and networks in regional ports had no notable impact on the French economy or industry, which was compromised by a series of regional markets until the seeds were planted in the north and east

[34] Carl Cavanagh Hodge, ed., *Encyclopedia of the Age of Imperialism, 1800–1914*, 2 vols. (Westport, CT: Greenwood Press, 2008), 1: 245.

[35] Bérenger and Meyer, *La France dans le monde*, 236–237.

[36] Paul Cheney, *Cul de Sac: Patrimony, Capitalism, and Slavery in French Saint-Domingue* (Chicago: University of Chicago Press, 2017), 109–115, 118–119, 120–122, 124, 126, 161–162, 165, 199–200, 208–209, argues that the planters in France's most profitable colony, Saint-Domingue, endured considerable fluctuations of profit and loss in slave-based sugar production during the late eighteenth and early nineteenth centuries; planters in the Cul de Sac (or sugar-producing plains) region were challenged to make a profit during Revolutionary and Napoleonic Wars as markets were tenuous and ships carrying food and supplies were seized, merchants representing French ports were predatory about extending loans or selling futures, and slaves revolted to claim Revolutionary freedoms; the abolition of slavery in 1794 and its reinstatement in 1802, coupled with high export taxes, ended the plantation economy. See Olivier Grenouilleau, *Fortunes de mer, sirens colonials: Économie maritime, colonies et développement: la France, vers 1660–1914* (Paris: CNRS Éditions, 2019), 88–99. Grenouilleau, *Fortunes de mer*, 95, observes that between 1713 and 1791, 1 million slaves arrived in the Antilles, most of whom came from West Central Africa and of which more than 775,000 were sent to Saint-Domingue; Cheney, *Cul de Sac*, 127, notes that following the War of American Independence slaving voyages increased by 100 percent, with an average of 26,000 African captives arriving at Saint-Domingue each year between 1783 and 1791, with planters demanding slaves for the expanding coffee economy purchasing most from French merchants.

of the nation itself.[37] Hodge asserts more generally that France never had colonies of a number or cluster sufficient to warrant formulation of a coordinated development program; coffee, sugar, spices, rice, bananas, coconut, citrus, and hardwoods were forthcoming, but a lack of adequate roads and port facilities kept interior minerals from being effectively exploited.[38] French merchants in Europe even blocked efforts to develop local manufacturing in the colonies lest it interfere with their own exports, which in turn inhibited colonials from generating income sufficient to purchase French goods.[39] For this reason, the British navy's repeated attempts to isolate or occupy them during the radical phase of the French Revolution and the Napoleonic Wars affected the Paris government and economy very little.[40] Bonaparte briefly entertained expanding the French empire into the Caribbean and North America—he secretly pressured Spain to return Western Louisiana to France (Third Treaty of San Ildefonso of 1 October 1800)—but he gave up the idea in order to consolidate territories on the European continent and sold the port of New Orléans and the lands west of the Mississippi-Missouri Rivers to the United States by the Louisiana Purchase Treaty of 30 April 1803.

A few French governors and their councils in the Caribbean and ambassadors in North America promoted Bourbon sovereignty or the advantages of an alliance through the gift of Van Loo's *Louis XV* and Callet's *Louis XVI*, making them rare survivors of colonial wars up to the fall of the monarchy in 1792 and invasion of the capital in 1814. Correspondence, memoranda, and registries at the French national and diplomatic archives reveal that state portraits were dispatched to Canada, Martinique, and the United States. In March 1759, Jeanne Antoinette Poisson, marquise de Pompadour, placed an order for a framed bust portrait of

[37] Grenouilleau, *Fortunes de mer*, 106–111; also see Jeff Horn, *Economic Development in Early Modern France: The Privilege of Liberty, 1650–1820* (Cambridge: Cambridge University Press, 2015), 128–129.

[38] Cavanagh Hodge, ed., *Encyclopedia of the Age of Imperialism*, 1: 247. Horn, *Economic Development in Early Modern France*, 123, observes that Antilles coffee in particular had ready markets in Spain, Italy, and Egypt: Marseille surpassed Nantes and Le Havre to become France's second leading port for American colonial goods by 1789, and the port's imports from the Antilles amounted to 42 percent coffee and 46 percent sugar; the total value of coffee imports from the Antilles reached 104 million livres, the value of sugar imports 108 million. Although coffee production was largely associated with Martinique, it was deemed to be sufficiently profitable that planters in Saint-Domingue increased production from 7 million pounds in 1755 to 77 million in 1789.

[39] Horn, *Economic Development in Early Modern France*, 100–102, states that according to Ambroise-Marie Arnould's calculations, French exports increased fourfold in value between 1716 and 1787, and the positive balance of trade grew from 36 to 57 million livres; French manufactures went mostly to other European countries, and of the small share that went outside Europe, 72 percent went to the Levant and 23 percent went to the West Indies; on the basis of foreign trade, France was considered a major commercial power.

[40] Brown, "The Politics of Slavery," 217, notes that "to win wars in Europe and North America the British sometimes sacked French and Spanish plantations to deprive those empires of colonial wealth. . . . Acquiring and sustaining international power during the eighteenth and early nineteenth centuries meant, in many instances, commanding the territories where the slaves were . . ."

Louis XV (after Van Loo?) to be sent to "the Savages of Canada who have very humbly requested it," and it was duly dispatched from a Northeastern French port.[41] Nine years later, Louis XV's retired foreign minister, César Gabriel de Choiseul-Chevigny, duc de Praslin, requested a full-length portrait "to be placed in the Chamber where the Conseil supérieur [of Martinique] holds its audiences," doubtless to reassert the king's authority over one of his remaining Caribbean colonies (the British had already installed a governor and supplied portraits to the ceded colonies of Guadeloupe and the French West Indies).[42] In May 1783, Louis XVI's foreign minister, Charles Gravier, comte de Vergennes, dispatched a pair of full-length portraits of the king and queen by Callet and Vigée Le Brun to the American Congress.[43] The royal portraits subsequently followed the Republican delegates to meeting chambers at New York's City Hall in 1785, Philadelphia's Congress Hall in 1790, and Washington's Capitol in 1800, making them practically the only painted images of the French sovereigns in the Mid-Atlantic states.[44] They also reminded delegates of the shrewd foreign policy and diplomatic maneuvers that were necessary to guarantee the survival of the republic, the enormous balance of payments owed to France, and the uncertain benefits to be derived from a long-term military and commercial alliance. In mid-August 1791, the newly appointed French minister plenipotentiary, Jean-Baptiste Ternant, arrived in Philadelphia with eighteen of Charles-Clément Bervic's grand format engravings of Louis XVI after the Callet model and proceeded to gift a framed impression (figure 11) to Washington, probably one to Jefferson, and possibly

[41] "Portrait, Affaires Generales, 17 March 1759," Bons du roi: portraits, O 1 1074, "Memoire des portraits du Roy qui sont ordonnés au Sr. Jeaurat garde des tableaux de sa Majesté à la surintendance de ses Bâtimens à Versailles," 2 October 1773, O 1 1912, Archives nationales de France, Paris; "Extraits" from the Bâtiments bons du roy de 1746 à 1766, O 1 1062, Archives nationales de France, mention that in 1759 Louis XV consigned to the comte d'Arcourt (Anne Pierre, duc d'Harcourt, lieutenant général des armées du roi and governeur de Normandie, or Henri Claude, comte d'Harcourt, lieutenant général des armées du roi?) responsibility for the transfer of this portrait to the Indians of Canada.

[42] "Extrait des bons du roy du 22 mars 1768," Cahiers d'extraits de bons du roi, 1764–1774, p. 175, O 1 1063, Bons du roi: portraits, O 1 1074, Archives nationales de France, Paris. Smart, *Allan Ramsay*, 118–115 (no. 192au), shows that a pair of Ramsay portraits of George III and Charlotte were supplied to Robert Melville as Governor of Guadeloupe (from 1760) and West Indian Islands ceded by the French (from 1763).

[43] Registre du dépôt des bijoux et autres effets destines pour les présens du roi dans le Département des affaires étrangères, Année 1783, 30 (nos. 59, 60), Archives du Ministère des affaires étrangères, La Courneuve, Mémoirs et Documents France, Neuilly-sur-Marne, Société d'Ingenierie et de Microfilmage, 1991, vol. 2088 (1783); see Larkin, "A 'Gift' Strategically Solicited," 30, 68–70.

[44] The full-length portraits of Louis XVI and Marie-Antoinette in Congress's chamber at New York's City Hall in 1785–1790 were complemented by the addition of a solitary portrait of Louis XVI by Hubert (presumably after Callet) to the legation of the French minister plenipotentiary, Elénor-François-Elie, comte de Moustier, in New York City on 8 September 1787; the Régistre du dépôt des bijoux et autres effets destines pour les présens du roi dans le Département des affaires étrangères, Année 1787, 37–38, 43 (no. 64), Archives du Ministère des affaires étrangères, La Courneuve, Mémoirs et Documents France, Neuilly-sur-Marne, Société d'Ingenierie et de Microfilmage, 1991, vol. 2092 (1787), 37–38, shows that the copy cost the foreign ministry 1,000 livres for the portrait and 600 for the bordure.

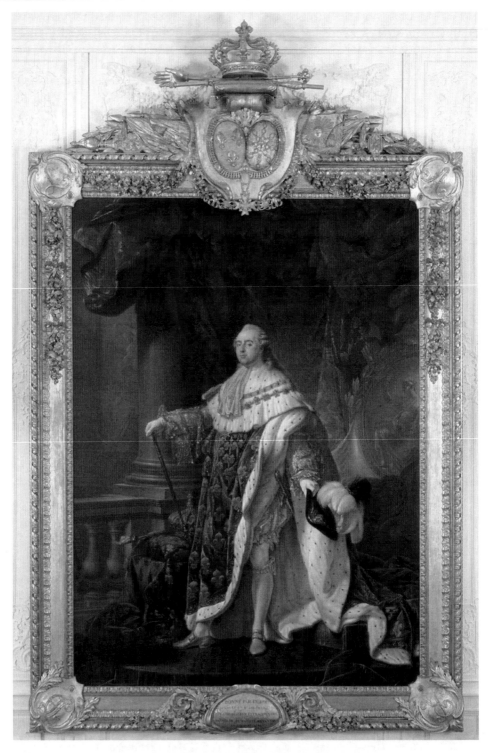

Figure 10. Antoine-François Callet, *Louis XVI*, 1781–82. Oil on canvas, 280 × 180 cm., with emblematic frame carved in the workshop of François-Charles Butteux. Waddesdon Manor, Buckinghamshire (Rothschild Foundation), on loan since 2006, accession no. 57.2006. Photo: Waddesdon Image Library / Mike Fear.

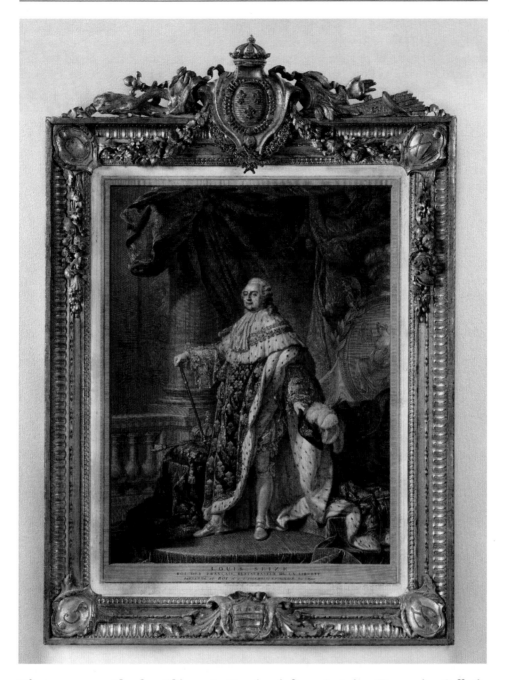

Figure 11. Charles-Clément Bervic (after Antoine-François Callet), *Louis Seize, Roi des français, Restaurateur de la liberté*, 1790. Engraving in frame with emblematic frame carved in the workshop of Butteux, 71.76 × 54.61 cm. Photo: Courtesy of Mount Vernon Ladies' Association.

another to Hamilton, as a testament of the king's regard.[45] During the radical phase of the French Revolution, these tributes to the French–American alliance seemed like vestiges of a bygone era, and under the Consulate, they could not be replaced by one of Bonaparte's "republican" avatars—Antoine-Jean Gros's and Jacques-Louis David's heroic general or Gros' and Jean-Auguste-Dominique Ingres' determined legislator—because Bonaparte instructed his foreign minister to sow distrust in Britain and confidence in France covertly so that restrictions on the carrying trade of the neutral Americans would not have to be rescinded.[46] Under the Bourbon Restoration, Louis XVIII seemed far more intent on recovering family portraits dispersed during the Revolution than bestowing new ones.[47] Thus, a visual culture of royal friendship was accessible to American political

[45] On the portrait engravings, see Memorandum of Armand Marc de Montmorin, 22 January 1791, Folder "1789–1793: Revolution," Carton "Présents et pierreries 1783–1830," 750SUP220.70, Archives du ministère des affaires étrangères, La Courneuve, which reads in part "Je propose de remettre à M. de Ternan[t], pour les joinder à ses bagages une douzaine d'epreuves du portrait du Roi, gravé, sans bordures; Et six avec cadres et bordures, dont trois d'environ 150 [livres], chaque cadre, et trois autres de moindre valeur, pour le tout être distribué à la discretion de M. de Ternan[t], après son arrivée à Philadelphia." For evidence of the engravings gifted to Washington, Jefferson, and Hamilton, see Testament of Jean Ternant, 10 October 1833, Minutier Central des Notaires, LXXXVII, 1468, Archives nationales de France, George Washington to Jean-Baptiste Ternant, 22 December 1791, in George Washington, *Writings of George Washington*, ed. John C. Fitzpatrick, 41 vols. (Washington D.C.: U.S. Government Printing Office, 1931–1944), 31: 448; Seymour Howard, "Thomas Jefferson's Art Gallery for Monticello," *The Art Bulletin* 59, no. 4 (1977): 599 (no. 42), located Jefferson's manuscript inventory of art objects displayed in the principal rooms at Monticello (ca. 1809), in which "42. Louis XVI. a print. a present from the king to Th. J." appears to hang in the parlor, at middle tier, presumably with "43. Bonaparte. a print." as a companion piece to demonstrate long-term fidelity to the notion of an American alliance with France; this print (i.e., grand format portrait engraving) of Louis XVI is sometimes confused with the painted miniature (i.e., boëte à portrait, or portrait medallion made of pigments on ivory or porcelain surrounded by diamonds) of the king which Jefferson received from Louis XVI in 1791 to honor the completion of his term as ambassador in Paris (1785–89); Elizabeth Schuyler Hamilton, "Will of Elizabeth Schuyler Hamilton, 2 July 1845," in Katherine B. Menz, *Historic Furnishings Report, Hamilton Grange National Monument, New York, New York* (Harpers Ferry Center, WV: National Park Service, U.S. Department of the Interior, 1986), 19, states "Sixth [Provision:] I do hereby give and bequeath to my beloved son, John C. Hamilton, my picture of Louis the Sixteenth, King of France, which was presented to my dear husband [Alexander] by Mr. Ternant, the last Minister of his King." Frank Whitney, *Jean Ternant and the Age of Revolutions: A Soldier and Diplomat (1751–1833) in the American, French, Dutch and Belgian Uprisings* (Jefferson, NC: McFarland and Company, Inc., 2015), 165–166, observes that the National Assembly desired Louis XVI to negotiate a new commercial treaty with the United States and Ternant was directed to meet with Washington, Jefferson, and Hamilton to discuss the details, including the Americans' desire for increased access to the West Indian market. Correspondance politique: États-Unis, 1791–1792, 39CP35 and 39CP36 (microfilms P5982 and P12121), Archives du ministère des affaires étrangères, La Courneuve, shows that Ternant also corresponded with Washington, Jefferson, and Hamilton about the crisis in France's prime colony, Saint-Domingue, as a result of slave insurrections and mass emigration to the United States.

[46] See Larkin, "The U.S. Congress's State Portraits," 29–30. Philippe Bordes, *Jacques-Louis David: Empire to Exile* (New Haven: Yale University Press, 2005), 83 (no. 4), shows that it was not until after the Empire government fell that Joseph Bonaparte brought one of two versions of David's *Bonaparte Crossing the Saint-Bernard* (1800) with him to the United States, where he sought sanctuary in 1815.

[47] See Whitney, *Jean Ternant*, 197–198; Joseph Baillio, "Marie-Antoinette et ses enfants par Mme Vigée Le Brun (Deuxième Partie)," *L'Oeil* 310 (May 1981): 59–60.

elites and their petitioners in the president's mansion, the delegates' chamber, and the offices of select members of the government in the Washington, D.C., area up to the outbreak of the War of 1812 and would have been prized as visual artifacts of the republic's inception.

Is it possible that those who imbibed royalist ideology from portraits at a European court, military academy, or aristocratic seat in Europe were acutely sensitive about how they should be displayed in a governor's mansion or assembly room of a current or former colony? A word should be written about the location and accessibility of British and French state portraits within governors' mansions and embassies in North America and the Caribbean. The extension of a portrait type originally seen at the courts of St. James and Versailles/Tuileries to the governor's mansion, council room, or assembly hall of the colonial seat or the ambassador's office or audience chamber in Nova Scotia and Bermuda would validate an elevated class of persons and their retainers in the pursuit of a common trans-Atlantic pictorial lexicon and political value system. Colonial governors, regimental commanders, and foreign dignitaries were often drawn from European nobility or gentry (indeed, several were junior members of prominent families) and would have seen state portraits at home and abroad as a reassuring touch stone of shared values; peace between two European kingdoms would have presented the opportunity to view a royal alliance as a guarantor of international diplomacy and war would have presented the prospect of competition for and seizure of lands, ports, and sea lanes; portraits would have been caught up in the pursuit of harmonious relations and bitter rivalries.[48] In the governor's mansion, the images were displayed in the audience chamber, ballroom, or other suitable public space, hung side by side or opposite one another to suggest the king's conferral of authority on his representative to administer the colony. In the foreign embassy, state portraits were displayed in an audience chamber, hung beneath the canopy of state behind the ambassador's chair so as to make potent official sanction of diplomatic activities carried out in the king's name.[49]

Crucial to the narrative that follows, European generals, admirals, and their immediate subordinates visiting a colonial capital in the Americas would also have been able to view state portraits in the course of participating in state ceremonial or evening entertainments and to recognize the display as an indispensable sign of the monarch's extended political dominion and the governor's extension of the social order. The colonial governor was enmeshed in an elaborate structure that involved mansion entertainments, cabinet and court appearances, and occasional ceremonies (e.g., the king's accession day, the king's and queen's birthdays, the birth of an heir, the coronation or death of a monarch) for which militia provided

[48] Smart, *Allan Ramsay,* 113 (no. 192n), 115 (no. 192an, 192ao), 117 (no. 192cn), 118 (no. 192da, 192di), 119 (nos. 192do, 192dp), shows that the British monarch gifted state portraits occasionally to British generals and major-generals who functioned as governors of Canada, New Brunswick, East and West Florida, and Grenada; Larkin, "Observations on the Cabinet des Tableaux," 52, 66, shows that the French monarch frequently gifted ceremonial portraits to governors of the École Royale Militaire and the Hôtel Royale des Invalides for assembly rooms, generals, admirals, lieutenants distinguished in war, or captains of royal guard units for regimental headquarters or apartments.

[49] Simon, "Frame Studies II," 452.

escorts, fired salvos, and stood guard at the gate of an important building or even at the main thoroughfare leading to the capital.[50] It is likely that the rank and file soldier was acquainted less with state portraits per se than with royal escutcheons in officer's quarters, royal insignia on uniforms, and royal standards borne in battle. However, Brendan McConville raises the possibility that the British monarch's image in visual and material culture was so widespread in colonial government buildings or domestic households from the 1730s that they would have been difficult to escape.[51] Of the domestic context he states, "People in every colony had royal portraits and imperial prints by 1765. From the numbers mentioned in newspaper ads, it seems probable that at least thousands [and possibly tens of thousands] of households had prints or portraits of the royal family. . . . These representations, along with tiles, delftware, slipware, and glassware, allowed for an imperialized household."[52] It is therefore likely that a soldier could easily purchase a royal miniature to be suspended from a chain or a diminutive print to be sewn into the coat lining to be borne as an oath or talisman into battle.

It would seem that the European monarchy with the most efficient system of portrait production, the most effective iconography, the most extensive network of distribution, and the most prominent venues for displaying them would have the best chance of securing the loyalty of North American and West Indian settlers. However, the situation was not so straightforward with the growth of the American republic between Canada and the Caribbean. Logistically, British desire to shut the French out of their Western empire and French desire to explore mutual interests with amenable tribes, assemblies, and politicians was bound to create friction, but ideologically, American perception that sovereignty was no longer vested in an individual or a king-in-Parliament but in a common set of egalitarian ideals sent the British into a panic. With the overthrow of the absolute monarch in France, the defense of the "constitutional" monarchy in Britain became the de facto conservative position, and the advance of moderate republicanism in the United States and radical republicanism in France, the liberal position. What room was there for royal portraits and imperial prints of either absolute or moderate monarchs within this new political order? The Americans had wrecked or put away their portraits of George III at the outbreak of the revolution in 1776; the French had sought to eradicate all images of Louis XVI with the overthrow of the monarchy in 1792, as signs of tyranny.[53] The twenty years of warfare that followed made politicians

[50] Graham Hood, *The Governor's Palace in Williamsburg: A Cultural Study* (Williamsburg, VA: The Colonial Williamsburg Foundation, 1991), 74–76, 89–90.

[51] Brendan McConville, *The King's Three Faces: The Rise and Fall of Royal America, 1688–1776* (Chapel Hill: University of North Carolina Press, 2007), 124–137. McConville, *The King's Three Faces,* 124–125, 127, speculates that while sellers of goods stamped with royal images or ciphers sought to profit from popular affection being generated for the monarchy, consumers of these items hoped to increase their social status, validate political ties to the empire, and demonstrate emotional regard for the royal family.

[52] McConville, *The King's Three Faces,* 134.

[53] McConville, *The King's Three Faces,* 306–311; Arthur S. Marks, "The Statue of King George III in New York and the Iconology of Regicide," *American Art Journal* 13, no. 3 (Summer 1981): 65, 68, 76; Stanley J. Idzerda, "Iconoclasm during the French Revolution," *American Historical Review* 60 (October 1954): 13–26.

more circumspect about royal portraits: the Republicans who dominated Congress proposed to retire the *Louis XVI* and *Marie-Antoinette* to a museum as outdated diplomatic gifts; the Tories who ran Parliament supported the Bourbons' return to power as a guarantor of world peace and with it their reclamation of family objects as a sign of dynastic continuity.[54] However, British forces might feel differently about them in the heat of battle and latent cries for vengeance, American citizens in the aftermath of defeat and the absence of lawful authority.

[54] Larkin, "The U.S. Congress's State Portraits," 32–34.

Origins of the War of 1812

When members of the U.S. Senate assembled at the Capitol in Washington, D.C., on 12 February 1810, the business on the agenda was how to protect the neutral American merchant marine from being molested or impounded by warring British and French vessels.[55] Since the Seven Years' War, the European powers' mercantile ambitions had led to repeated clashes over North American colonies, but the French Revolution provided them a political pretext to embark on twenty years of continuous warfare. A public face was put to their quarrel in verse and caricature: the mental decline of the heavy-handed George III saw the emergence of his self-indulgent heir, George, as Prince Regent; the ascendancy of Napoleon Bonaparte as general in the Italian States saw his political ambitions realized as First Consul of the Republic and Emperor of the French. The American traders preferred to be left to the carrying trade, the profitable business of transporting home agricultural products to Western Europe and imported manufactured goods to the Caribbean, so great was their belief in the power of commercial relations to foster peace and harmony among nations. But British and French authorities viewed the practice of neutral shipping during wartime as a threat to their goal of ruining the other's commerce. Americans employed a series of stratagems to circumvent the latest British directives, including transport of French colonial goods from the West Indies to an American port, reworking or relabeling them as national goods, and then sending them on to France. The British responded by ordering their vessels to detain or impound American ships filled with prohibited cargo and to impress into service seamen suspected of having been born in Britain or having deserted from the British navy; the French retaliated in like manner, encouraging their vessels to impound American ships found to be carrying British cargo. And so it went. In the mid-1800s, the Empire and Regency governments issued a series of proclamations with the intention of wrecking the other's trade—the French "Berlin and Milan Decrees" were designed to deprive England and its carriers of markets on the European continent, and the British "Orders in Council" forbade the French from trading with England, its allies, and neutrals via blockade of ports.[56] These proclamations showed that the great powers were prepared to use weaker nations to inflict damage on each other.

Democratic-Republican administrations in the United States were convinced that commerce needed to be protected from European harassment for the duration

[55] Senate Proceedings, 6 February 1810, *Journal of the Senate of the United States of America*, 70 vols. (Washington, DC: Gales and Seaton, Ritchie and Heiss, Government Printing Office, 1820–1874), 4: 435; "A Century of Lawmaking for a New Nation: U.S. Congressional Documents and Debates, 1774–1875," Library of Congress, accessed 11 November 2015, http://memory.loc.gov/cgi-bin/query/r?ammem/hlaw:@field(DOCID+@lit(sj004446)).

[56] Richard Buel, *America on the Brink: How the Political Struggle Over the War of 1812 Almost Destroyed the Young Republic* (New York: Palgrave MacMillan, 2005), 30–31; Michel Chevalier, *Notice biographique sur feu M. le comte de Serurier, pair de France et minister plénipotentiaire* (Paris: Librairie de Firmin Didot Frères, 1862), 15.

of the Revolutionary and Napoleonic Wars. Thomas Jefferson, sympathetic to France as a former republic, attempted to retaliate against Britain with the threat of a Non-importation Act (April 1806), prohibiting a range of goods from abroad if agreement could not be reached on impressment and commerce, but it had no effect. Frustration with British and French restrictions then led Congress to impose a general embargo on all European trade (December 1807 to March 1809), but this further damaged American commerce: a $108 million business in sea enterprise lost four-fifth of its value and a $138 million export of raw materials declined 60 percent.[57] In response to complaints from Boston and Providence merchants, Federalists agitated Republicans until the latter voted to replace the embargo with the Nonintercourse Act (March 1809), which limited the trade prohibition to Britain and France and promised to resume trade relations with the first power that canceled its prohibition against American commerce and to restrict trade relations with the other. Despite reservations about James Madison's failed trade policies as Secretary of State to Jefferson, he was elected to the presidency in late 1808 and attempted to maintain fiscal responsibility. In his Annual Message to Congress of 29 November 1809, Madison expressed frustration that the latest round of negotiations with the British minister had broken down over American traders' refusal to prohibit carrying French manufactures and docking in French ports.[58] Equally vexing was the French emperor who, despite declaiming support for neutral traders, quietly encouraged his privateers to seize American ships and cargo. The best the delegates could do in this situation was to adopt defensive measures on an ad hoc basis, whether issuing permits, furnishing arms, or providing escorts to ships likely to run into foreign patrols.[59]

Because neither the foreign ministry of Britain nor that of France jumped at the opportunity to enter into an exclusive trade agreement with the United States, Republican senator John Taylor sponsored a bill that in its final form—Macon's Bill No. 2—acknowledged the Madison administration's failed efforts at economic retaliation, lifted restrictions on trade with both Britain and France, but pledged that if one power should revoke its restrictions or modify its edicts the other power should be banned from commercial dealings with the United States.[60]

[57] Bernard Bailyn, Robert Dallek, David Brion Davis, David Herbert Donald, John L. Thomas, and Gordon S. Wood, *The Great Republic: A History of the American People*, 4th ed. (Lexington, MA: D. C. Heath and Company, 1992), 362–363.

[58] James Madison, Annual Message to Congress, 29 November 1809, transcript, Miller Center, University of Virginia, Charlottesville, http://millercenter.org/president/madison/speeches/speech-3608 (accessed 21 August 2015); Rufus King to Charles Ingersoll, 8 October 1809, in William M. Meigs, *The Life of Charles Jared Ingersoll* (Philadelphia: J. B. Lippincott Company, 1897), 57; Gerard H. Clarfield, *Timothy Pickering and the American Republic* (Pittsburgh: University of Pittsburgh Press, 1980), 243.

[59] Senate Proceedings, 9–11 January, 12 February 1810, in *Journal of the Senate 1820–1874*, no 4: 423–424, 437.

[60] House of Representatives Proceedings, 7, 11, 18, and 19 April 1810, *Journal of the House of Representatives of the United States*, 75 vols. (Washington, D.C.: Gales and Seaton, Thomas Allen, Blair and Rives, Ritchie and Heiss, A. Boyd Hamilton, Cornelius Wendell, James B. Steedman, Government Printing Office, 1825–1875), 7: 352, 357, 372–378, 380–382, in "A Century of Lawmaking for a New Nation: U.S. Congressional Documents and Debates, 1775–1875," Library of Congress, accessed 11 November 2015, http://memory.loc.gov/ammem/amlaw/lwhjlink.html#anchor13; Henry Adams, *The Life of Albert Gallatin* (Philadelphia: J. B. Lippincott and Company, 1879), 416.

The bill passed and was signed into law on 1 May 1810. Madison wrote that he hoped that "one or other of those powers" would view it "not as a coercion or threat" but as a rare opportunity to "attack . . . the other."[61] The stratagem seemed to work, for three months later the French ministre des relations extérieurs (minister of overseas relations), the duc de Cadore, issued a document that gave the impression that Napoléon would revoke the detested decrees and challenged his British counterpart, George Canning, to repeal George III's equally despised orders within the stipulated three-month window or face sanctions.[62] Consequently, the British government offered a series of vague concessions—granting the United States an equal share of their license trade with the European continent, staying clear of the American coast, and treating American ships and seamen with tact.[63] However, the Madison administration, egged on by Henry Clay's "War Hawks" of Ohio and Missouri, rejected them as the sort of empty promises a royal superpower made to a colonial suppliant, and applied Macon's Bill to Britain. In his Annual Message to Congress of 5 November 1811, Madison rationalized that all peaceful efforts to persuade the British and French to suspend prohibitions against American commerce had failed; the British continued to harass American ships as they left home port and to impress American seamen into the royal navy; the French behaved with equal animosity, impounding British goods carried in neutral vessels, but the British had to be designated the enemy because their monopoly on trans-Atlantic navigation and commerce presented the greatest threat to the American economy.[64] Around the same time, Madison sent the delegates a secret missive requesting that they prepare for war by increasing the number of regular troops, auxiliary forces, and volunteer corps and providing for the manufacture of cannon and muskets.[65]

Congress declared war on Britain on 18 June 1812. The timing was unfortunate because two days earlier the British foreign secretary, Lord Castlereagh, had proposed to Parliament that the Orders-in-Council be suspended on condition the United States reverse its prohibition on British imports and a week later offered to drop the system of blockades and licenses altogether, news of which did not reach the opposite side of the Atlantic until mid-August.

The war declaration was not inevitable or unanimous, but it did help the two political parties clarify their relations to foreign governments and the citizens

[61] Senate Proceedings, 1 May 1810 (evening session), *Journal of the Senate 1820–1874*, no. 4: 513; James Madison to William Pinkney, 23 May 1810, cited in Abraham D. Sofaer, *War, Foreign Affairs and Constitutional Power: The Origins* (Cambridge, MA: Ballinger Publishing Company, 1976), 282–283.

[62] Adams, *The Life of Albert Gallatin*, 420–421.

[63] Donald R. Hickey, *The War of 1812: A Forgotten Conflict* (Urbana, IL: University of Illinois Press, 2012), 39.

[64] James Madison, Annual Message to Congress, 5 November 1811, transcript, Miller Center, University of Virginia, Charlottesville, accessed 14 September 2015, http://millercenter.org /president/madison/speeches/speech-3613.

[65] Hickey, *The War of 1812: A Forgotten Conflict*, 40–41, states that Madison's secret message was dated 1 June 1812. Charles M. Wiltse, *John C. Calhoun: Nationalist, 1782–1828* (New York: Russell and Russell, 1968 re-issue of 1944 ed.), 61–64; Dice Robins Anderson, *William Branch Giles: A Study in the Politics of Virginia and the Nation from 1790 to 1830* (Gloucester, MA: Peter Smith, 1965), 174–179.

become cognizant their collective responsibility to defend the nation.[66] Federalists and Republicans had very different visions of the nature of the United States and its standing vis-à-vis the European empires: the former, the minority party once led by Alexander Hamilton, consisted of landed gentry, city merchants, and financiers who sought reconciliation with the monarchy as the surest way to maintain traditional social distinctions and guarantee its preeminence as a ruling class; the latter, the majority party led by Jefferson, consisted of artisans, small shopkeepers, and yeoman farmers who were hopeful that an alliance with a former sister republic would encourage the citizenry to embrace revolutionary republican values. Several prominent women and women's societies, who had helped shape the nation's sociopolitical culture in Philadelphia salons of the 1790s, expanded their public role at inaugurations, addresses, and balls and thereby helped clarify the ideological differences between Federalists and Republicans and the social implications of warfare to the nation.[67] Presented with William Pinkney's bill defining the parameters of the war as a conflict over land and sea rights, the Republicans agreed that Britain had been historically opposed to their right of self-governance and was currently a threat to their integrity and livelihood; after briefly entertaining an alternative bill that would restrict battles to the high seas, they passed the original bill with 61 percent of the vote—that is, about 81 percent of Republicans in the South and West for, and 100 percent of the Federalists in the South and East against.[68] It was thus to be the Republicans' war, and their viability as a party was thought to depend on its success or failure.

The Republicans articulated a pair of strategies and outcomes: they would use the non-importation law and armed troops to force the British to discontinue navy impressments and trade ordinances; they would employ regiments to weaken the British presence in the Northwest and secure for the United States the respect due a sovereign country. They were slow to establish means for waging war because they feared that expansion of the War Department and general mobilization of troops would strengthen the executive branch, normalize a standing army, increase taxes, and balloon the national debt.[69] Moreover, they were hopeless at convincing Federalists to provide crucial administrative, tactical, and financial support. Efforts to mobilize were inevitably compromised: on one hand, Republican delegates from the Southern and Western states, including Clay, John C. Calhoun, and George M. Bibb, submitted bills for the reorganization of the army, rallied the base with assurances of victory, and attempted to ingratiate Easterners by proposing a repeal of the non-importation law.[70] On the other, Federalists from New England, such as Rufus King, Christopher Gore, and Timothy Pickering, openly opposed

[66] Henry Adams, *History of the United States of America during the Administrations of James Madison* (New York: Literary Classics of the United States, 1986), 447–454.

[67] Susan Branson, *These Fiery Frenchified Dames: Women and Political Culture in Early National Philadelphia* (Philadelphia: University of Pennsylvania Press, 2001): 144–145, 148–149.

[68] Hickey, *The War of 1812: A Forgotten Conflict*, 43.

[69] Bailyn, Dallek, Davis, Donald, Thomas, and Wood, *The Great Republic*, 365.

[70] Merrill D. Peterson, *The Great Triumvirate: Webster, Clay, and Calhoun* (New York: Oxford University Press, 1987), 4–5, 18, 39–43; Wiltse, *John C. Calhoun*, 70–71, 73–74, 90–91; John Niven, *John C. Calhoun and the Price of Union: A Biography* (Baton Rouge, LA: Louisiana State University Press, 1988), 44–46.

the war, communicated with British friends and officials, coordinated their op-position to taxes, and withheld state militias from federal leaders.[71] Both factions would experience glaring setbacks. In the beginning Republicans pinned their hopes on overwhelming the limited British forces and persuading the wily French emperor to repeal the trade restrictions, oblivious that the enemy could inflict con-siderable damage on the Canadian front and that their ally was too absorbed with the Russian front to lend much assistance.[72] Over time, Federalists would find it a matter of supreme irony that much of the cost of the war had been shifted from the hawkish South and West to the pacifist East through the imposition of higher taxes on imported goods.[73] Division within Congress and among states severely compromised their ability to marshal a defense and wage war.

[71] J. C. A. Stagg, *Mr. Madison's War: Politics, Diplomacy, and Warfare in the Early American Republic, 1783–1830* (Princeton: Princeton University Press, 1983), 112–115, 258–261; William Howard Davis, *Gouverneur Morris: An Independent Life* (New Haven: Yale University Press, 2003), 290–292; Robert Ernst, *Rufus King: American Federalist* (Chapel Hill: University of North Carolina Press, 1968), 314–317, 328; Clarfield, *Timothy Pickering*, 250–251; Hervey Putnam Prentiss, *Timothy Pickering as the Leader of New England Federalism, 1800–1815* (New York: Da Capo Press, 1972; originally published 1933–34), 78–80, 90, 93, 95–96, 117; Anderson, *William Branch Giles*, 196, 290–292.

[72] Ernst, *Rufus King*, 310; Chevalier, *Notice biographique sur feu M. le comte de Serurier*, 17; Adams, *History of the United States of America*, 472–475; Adams, *The Life of Albert Gallatin*, 421–426.

[73] Hickey, *The War of 1812: A Forgotten Conflict*, 46–47.

Theft and Conflagration in the North American Theater of Military Operations

Some remarks about British and French regiments' respective roles in looting towns in Western Europe as a tactic of warfare during the Revolutionary and Napoleonic Wars are necessary to establish the extreme consequences of occupation as British and American troops engaged in raids across the Great Lakes and Chesapeake Bay regions during the War of 1812. There is evidence that after a regiment's initial storming of a fortified town, subduing of forces, and appropriation of supplies, generals discouraged their troops from pillaging or molesting the local citizenry and clergy in conformity with eighteenth-century guides of moral conduct but that abuses proliferated nonetheless.[74] Recent histories of modern warfare on the Iberian Peninsula and in the Lowlands point to a trend wherein the British general attempted to suppress his junior officers and enlisted men from pocketing anything but modest souvenirs of their travels while the French general forwarded bureaucrats' schemes to extract indemnities, loans, or taxes that might augment the Paris treasury and to appropriate coins, sculptures, and paintings to fill the Louvre museum.

Lieutenant general of British armed forces Arthur Wellesley lead an expedition of 9,000 troops against the French occupying the Iberian Peninsula in mid-July 1808, and his subsequent maneuvers were so promising than allied forces turned over their regiments to him in late summer 1812. From the start of the campaign, Wellesley was determined that his troops should respect the local inhabitants and their property; he issued a general order that any soldiers found plundering or harming civilians would be punished. His reasoning was perhaps motivated less by moral than strategic aims; as Gavin Daly observes, "Wellesley was acutely aware that plunder and violence [on the peninsula] at the expense of the inhabitants would not only weaken the army's discipline and honour, but also risked alienating the local population and thereby undermining the war

[74] David Gilks, "Attitudes to the Displacement of Cultural Property in the Wars of the French Revolution and Napoleon," *The Historical Journal* 56, no. 1 (2013): 115–117, observes that during the seventeenth century, sovereigns and generals expropriated cultural property from their enemies with near impunity, limited their conduct only from fear of retribution or desire to maintain good relations, and felt no need to justify their actions. Those who plundered were careful to appropriate cultural property during war, before law was restored and treaties were signed, when properties were vulnerable. During the eighteenth century, monarchs such as Frederick II of Prussia began to pay their soldiers as a way of discouraging pillage and added art collections and libraries to the list of institutions outside the rules of warfare. Even so, unscrupulous generals and troops ensured that the tradition of military plunder never ceased entirely and with it the displacement of entire art collections and the growth of the international art market.

effort itself."[75] British Articles of War provided for the convocation of regimental and general courts martial to hear cases, and those found guilty of willful murder, rape, robbery, or plunder could be lashed, transported, or executed. British military codes distinguished "lawful" plunder of government buildings, military forts, and supply magazines from "unlawful" looting of civilian homes, businesses, farms, plus community churches and hospitals.[76] These distinctions inevitably broke down when regiments were tempted to scout the field for souvenirs, to strip a comfortable home, or to occupy of an ill-defended palace, treasury, or museum. Indeed, British regimental discipline broke down almost entirely during the peninsular campaigns of 1812 as attempts to dislodge the French from strategic positions led to widespread drunkenness; plunder of homes, shops, and churches; and rape and murder of inhabitants.[77]

British soldier diaries and courts martial records show that junior officers and enlisted men plundered objects for different reasons. Daly observes that officers employed "making" as a euphemism for stealing items from public and private buildings to serve as mementos of having been there, an assemblage of which would evoke a "progress" through various sites.[78] Thomas Browne of the 23rd Royal Welsh Fusiliers, who was attached to the General Staff between 1812 and 1814, suggested that officers' plundering practices were aligned with souvenir collecting during the Grand Tour. Nonetheless, officers had to be careful not to get caught looting lest they sacrifice their reputation as gentlemen in a court martial, and so they often told adjutants or servants what to steal on their behalf. Daly also remarks that trials of common soldiers reveal mostly theft of food (especially pigs and chickens), wine, and valuables as well as a few instances of highway robbery, breaking and entering, beating, and murder.[79] In the most egregious incident, six or seven soldiers entered a farmhouse outside Guarda (Portugal), murdered a man and his eight-year-old daughter, seriously injured his wife, and made off with money, gold, and jewelry.[80] Over time, soldiers learned how to extract loot more efficiently: "they searched for buried food and valuables with bayonets and ramrods, and watered floors to reveal hidden treasure spots," and once the treasure was extracted, "they evenly divided up the spoils, helping to foster group solidarity and collective responsibility . . ."[81] They were not above plundering churches of religious objects, especially if there was evidence of a prior sweep; rosaries, crucifixes, and chalices were bagged for their precious metals or stones.

[75] Gavin Daly, *The British Soldier in the Peninsular War: Encounters with Spain and Portugal, 1808–1814* (New York: Palgrave Macmillan, 2013), 112.

[76] See Gilks, "Attitudes to the Displacement of Cultural Property," 115–117, who shows that eighteenth-century conventions of warfare had come to include humanitarian clauses meant to protect farms, hospitals, and churches.

[77] Daly, *The British Soldier in the Peninsular War,* 114, cites British taking of French-held cities Ciudad Rodrigo, Badajoz, and San Sebastian as particularly egregious instances of plunder and violence.

[78] Daly, *The British Soldier in the Peninsular War,* 117.

[79] Daly, *The British Soldier in the Peninsular War,* 116.

[80] Daly, *The British Soldier in the Peninsular War,* 115.

[81] Daly, *The British Soldier in the Peninsular War,* 116.

By comparison, the French military command was far more focused and systematic in looting, although this did not keep unscrupulous bureaucrats and soldiers from pocketing choice items when an opportune moment arose. In the spring of 1794, the National Convention delegates, confident of their success in repelling foreign armies seeking to crush the Revolution, turned their attention to the "liberation" of surrounding provinces, including the Austrian Netherlands and the Rhineland, and the "confiscation" of their cultural treasures. On 27 June, the Convention's Comité d'Instruction Publique proposed to the Comité de Salut Public that artists and men of letters accompany the army to the Lowlands in order to seek out important works of art and science and claim them for the Louvre, Bibliothèque Nationale, and Jardin des Plantes.[82] Eleven days later, the Commission Temporaire des Arts was formed, consisting of Jean-Baptiste-Pierre Le Brun, Casimir Varon, André-Charles Besson, and Abbé Henri Grégoire, and charged with drawing up guidelines for generals and their troops to care for valuable objects they encountered in the field.[83] On 18 July, the National Convention issued an order to the Revolutionary Army: "The People's Commissioners with the Armies of the North and Sambre-et-Meuse . . . have learned that in the territories invaded by the victorious armies of the French Republic in order to expel the hirelings of the tyrants there are works of painting and sculpture and other products of genius. They are of the opinion that the proper place for them, in the interests and for the honour of art, is in the home of free men."[84] It seemed appropriate that European despots should cede the best products of beauty and knowledge to French artists who would make better use of them. Although the commissioners were no connoisseurs and thus could only set about their job in a haphazard fashion, they enacted a policy of systematic confiscation and redirection: the selection of paintings and sculptures was made by consultants in Paris, and the operations of location and removal were advanced by sub-experts abroad.

Connoisseurs' object lists and official news reports drawn up at the time of the initial French invasion of the Lowlands and the Rhineland suggest that Convention officials were well informed about the best works to be appropriated. Cecil Gould has observed that Parisian art dealer Lebrun, a specialist in Dutch and Flemish pictures and author of a three-volume *Galerie des peintres flamands, hollandaise et allemands* (1792–96), drew up lists of important paintings in the Lowlands and submitted them to inspectors as a prescription for plunder.[85] Andrew McClellan is more specific: the Commission Temporaire des Arts in Paris was to a large degree responsible for the selection of works of art, and they benefited from Lebrun's experience and possibly his publication (the first three paintings sent triumphantly from Belgium in September 1794—Rubens's *Elevation of the Cross, Crucifixion,* and *Descent from the Cross*—were not only well known but also had been singled

[82] Wilhelm Treue, *Art Plunder: The Fate of Works of Art in War and Unrest*, trans. Basil Creighton (New York: The John Day Company, 1961), 143; Cecil Gould, *Trophy of Conquest: The Musée Napoléon and the Creation of the Louvre* (London: Faber and Faber, 1965), 30; Andrew McClellan, *Inventing the Louvre: Art, Politics, and the Origins of the Modern Museum in Eighteenth-Century Paris* (Berkeley: University of California Press, 1999), 114.

[83] Gould, *Trophy of Conquest*, 31; McClellan, *Inventing the Louvre*, 114.

[84] National Convention quoted in Treue, *Art Plunder*, 144; Arthur Tompkins, *Plundering Beauty: A History of Art Crime during War* (London: Lund Humphries, 2018), 64.

[85] Gould, *Trophy of Conquest*, 41.

out for praise in his book) sufficient to fill the Louvre with the best pieces.[86] But not all French citizens were excited to see these pictures in the museum, as one critic wrote, "[With regard to] *The Descent from the Cross* and the two other large paintings done on wood, which came to us from Belgium at enormous expense, have they not lost more in their displacement [from their original location] than we have gained [by seeing them here]?" and "Should the tortures which catholic mythology so frequently displays be offered to a people delivered from the superstitions of Catholicism?"[87] In other words, the religious paintings had been crudely wrenched from their catholic context only to be of questionable benefit to a rationalist citizenry. William Treue states that the commissioners learned to broaden the scope of plunder after the revolutionary army took Cologne the following October, as the commissioners reported, "The guns, the antique remains, the coins, the sketches and drawings, the manuscripts in various languages, the printed books of the fifteenth century, the valuable works on the natural sciences, the arts, and history found in this city were collected and will now be added to the libraries and galleries of the Revolution."[88] French politicians like Luc Barbier represented to the Convention a patriotic rationale for continuing to deprive conquered states: thanks to a disciplined military, the works of Rubens, Van Dyck, and other Flemish masters had been deposited at the Louvre where they would serve to instruct artists and to affirm the republic's commitment to cultivate the arts and foster genius.[89] But this presumed that the military could continue to conquer more cities and maintain itself adequately, which it was challenged to do on inadequate pay and food from the republican regime throughout 1795, resulting in a breakdown of discipline as officers took matters into their own hands by drawing up agreements with local officials and soldiers compensated themselves by pillage and rape.[90] To the ideals of patriotism and education were soon added the motives of profit and glory. In March 1796, General Napoleon Bonaparte took the policy of confiscation south to the Italian states and in 1806 north to the German states, where the French army relied for its sustenance almost entirely on the resources of the occupied territory, entertained plunder of ordinary civilians as a substitute for poor or late pay, and tied the confiscation of a specific object, entire collection, or representative number of objects to armistice terms or peace treaties.[91]

To recapitulate, British and French armies relied on different resources and ideologies that contributed to different patterns of inappropriate behavior: Wellesley was confident that his army was supported by a large navy, several

[86] McClellan, *Inventing the Louvre*, 115; also see Treue, *Art Plunder*, 145.

[87] George Forster, "Extrait de *Voyage philosophique et pittoresque sur les rêves du Rhin, à Liége, dans la Flandre, le Brabant, la Hollande, etc.*," in *La Décade Philosophique, littéraire et politique*, t. 3 (1 October 1794), 286–287, accessed 13 October 2020, https://gallica.bnf.fr /ark:/12148/bpt6k423971p/f318.item.

[88] Unidentified commissioners quoted in Treue, *Art Plunder*, 145.

[89] Luc Barbier, address to the National Convention, September 1795, quoted in McClellan, *Inventing the Louvre*, 116.

[90] Jordan R. Hayworth, *Revolutionary France's War of Conquest in the Rhineland: Conquering the Natural Frontier, 1792–1797* (Cambridge: Cambridge University Press, 2019), 145–193.

[91] McClellan, *Inventing the Louvre*, 116–117; Gould, *Trophy of Conquest*, 43–57; Treue, *Art Plunder*, 147–148.

strategic ports, and relatively efficient supply chains that enabled his men to engage with the enemy with discipline and precision; Bonaparte was confident that his conscription army was vast and his generals tactically daring to roll over the continent as far as the Russian plains. Wellesley marshaled troops under the banner of traditional liberties against the radicalism of French republicans and the tyrannies of the dictator; Bonaparte rallied troops to his own person as the embodiment of revolutionary principles for the glory of the nation. The British military brass, mindful that their troops were passing through or temporarily occupying a foreign country to engage with and defeat enemy forces, insisted on a policy of respectful detachment from citizens and prosecuted instances of assault and looting, while the French command, ambitious to weaken, burden, or annex a state, sent in agents to terrorize officials and rob city treasuries, obligate merchants to take out loans of reparation, and slated important state objects and collections for removal. It might be said that the former tolerated "fortuitous theft" as a regrettable but unavoidable product of occupation and the latter enacted a policy of "selective confiscation" as heirs to the ancient right of spoils to the victor. Cutting across these distinctions in types of plunder were "a range of shifting causal factors . . . varying across time, place and circumstance," including poverty, opportunity, prejudice, and cruelty; for example, Daly points out that British troops were just as likely to view the Portuguese and Spanish inhabitants they encountered as "uncivilized" as French troops were to stereotype Italians and Spanish as "barbaric and inferior," and that this may have lessened inhibitions to assault and steal.[92] Indeed, British troops' self-image as a strong, industrious, rationalist, and Protestant people could be conjured to justify plundering Spanish citizenry, whom they dismissed as weak, lazy, superstitious, and Catholic.[93] Such bigotry could just as easily be turned against other states in possession of strategic positions or important resources but espousing different political doctrines, as when a British subject confronted an American citizen along the Canadian border.[94]

How, then, was the British command's allowance for the requisition of food supplies and theft of minor articles tested in strategic raids on American cities and towns during the War of 1812? Conflict between the British and American troops over two years and eight months intensified encounters to a point where bitterness and recrimination could be felt in strike and counterstrike. Items were targeted for theft based on their perceived market value and political prestige, and atrocities were inflicted with a view to their capacity to shock and demoralize. Alan Taylor proposes that the American republic and the British empire competed for the allegiance of natives, settlers, and immigrants in North America, and tensions were felt most acutely along the Canadian border, where kinship, settlements, patterns

[92] Daly, *The British Soldier in the Peninsular War,* 118–119.

[93] See Daly, *The British Soldier in the Peninsular War,* 175–178, who asserts that British plunder of Portuguese and Spanish holy sites of sacred objects in the wake of French invasion of them may have been motivated by greed for precious materials or contempt for Catholicism.

[94] Jack P. Greene, *Evaluating Empire and Confronting Colonialism in Eighteenth-Century Britain* (Cambridge: Cambridge University Press, 2013), 305–316, discusses several instances of critics disparaging British government and corporate policy in India in the second half of the eighteenth century as an example of the dire consequences illiberal conduct toward the American colonies in the late 1770s and early 1780s may have on the inhabitants' culture and economy.

of subsistence, and interests of commerce were close.[95] Brutal methods of warfare were employed on both sides to humiliate, terrify, displace, and ultimately defeat the other and thus determine whether the independent republic/free citizen or the royal colony/loyal subject would prevail as the dominant political order/identity in the Western Hemisphere. However, these extreme methods inevitably shocked, horrified, and hardened the inhabitants of both regions and thus preempted peaceable coexistence, cross-pollination, or assimilation for a few generations.[96] Christopher George argues that the British, contemptuous of American militias, attempted to terrorize and prey upon the inhabitants of the Chesapeake but in time found that the Americans were determined to defend their land.[97] The people of the bay region suffered repeatedly from invasion, rape, plunder, and conflagration as part of a new type of vicious warfare that eventually led the citizen soldiers of Maryland, Virginia, and Pennsylvania to join forces with the navy and marines to defeat the British invaders.[98] What emerges from both historians is a sense of the materially punitive and physically savage nature of early modern warfare, the fairly even pace of thrust and counter-thrust along the Great Lakes in contrast to the nearly one-sided destructive raids carried out in Virginia and Maryland, a show of overwhelming force that must be reviewed as a prefiguration of the outrageous exploits carried out during the sack of Washington, D.C.

American–British Warfare
Across the Great Lakes

Jefferson and Madison had speculated that a high concentration of old Loyalist and new Republican settlers north of the Great Lakes and the St. Lawrence River would make Upper and Lower Canada (figure 12) ripe for conquest by the United States. As soon as war was declared, backwoods settlers in Upper Canada attempted to flee across Lake Ontario, the Niagara River, or Lake Erie to the United States, but British regiments used superior lines of communication, patrol boats, and Indian scouts to prevent them from reaching their destination, determined that the resident population should remain to defend the colony. The British and American militias engaged in vicious assaults and counterassaults to obtain mastery of the area, the by-product of which was the plunder and burning of fortresses and homes and mutilation or slaughter of people and animals.

Madison appointed General William Hull Commander of the Army of the Northwest Sector far in advance of the mobilization effort and soon after the war declaration the general took charge of three ill-trained and equipped Ohio and Indiana regiments and made plans to march them to Fort Detroit at the southeastern edge of the Michigan peninsula. The mission was to patrol key forts and rivers and to make incursions into Upper Canada in such a way as to come between

[95] Alan Taylor, *The Civil War of 1812: American Citizens, British Subjects, Irish Rebels, & Indian Allies* (New York: Alfred A. Knopf, 2010), 3–12.

[96] Taylor, *The Civil War of 1812*, 259.

[97] Christopher T. George, *Terror on the Chesapeake: The War of 1812 on the Bay* (Shippensburg, PA: White Mane Books, 2000), vii.

[98] George, *Terror on the Chesapeake*, viii–ix.

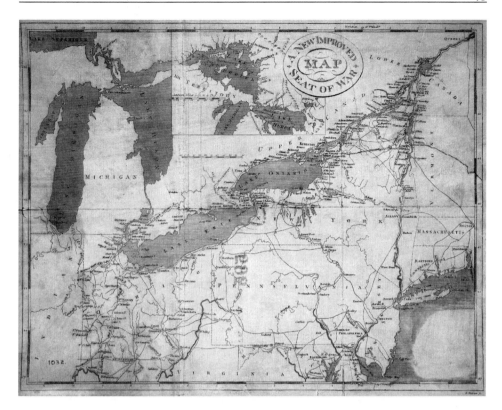

Figure 12. D. Haines, *A New Improved Map of the Seat of War*, 1817. Line engraving, 35.5 × 45 cm. Public Domain. Courtesy of the Baldwin Collection, Toronto Public Library.

Indian tribes on the west and the British military on the east. However, the British were quicker off the mark; on 2 July 1812 their forces at Fort Amherstburg on the southwestern tip of the Erie peninsula seized the American schooner *Cuyahoga Packet* carrying Hull's advance shipment of supplies and documents as it passed along the Detroit River. In revenge, Hull led his troops across the river, attacked the town of Sandwich, and "looted homes. . . . tore down fences and cut down fruit trees to obtain firewood and to build barricades. And mounted patrols returned with plundered sheep, blankets, boats, and flour."[99] This early instance of plunder and counter-plunder suggests that troops under British and American banners kept an eye out for provisions and staples that would provide sustenance and warmth during the deployment and that border communities were often placed in the difficult position of having to choose a side worthy of provisioning. A regiment could quickly turn against a town if troops were convinced that it had previously aided the enemy.[100]

In their raids on American communities, the British had an important ally in regional Native American tribes, especially Tecumseh and his warriors. A chief of

[99] Taylor, *The Civil War of 1812*, 161.

[100] Hickey, *The War of 1812: A Forgotten Conflict*, 187.

the Shawnee Tribe, Tecumseh had formed a confederation of tribes to resist white settlement beyond the Ohio River, the boundary agreed to by the United States in the treaty of 1783. On 8 August, Hull withdrew his 2,500 troops from Sandwich, leaving it to British Major General Isaac Brock, who was advancing from the south with a regiment of 1,925 regulars; after Brock took possession of the town, he directed his troops to fire a line of cannon across the river at Detroit and promoted the idea that he would unleash "savages" upon the town to hack and scalp at will. A week later, Hull, believing himself to be outnumbered by superior British and Indian forces, surrendered Fort Detroit despite protest from his subordinates. As a prize of war, the British seized public property—including the arsenal and provisions—valued at £35,000, while the Indians broke into private houses and plundered them, with an eye for horses and carriages.[101] Hull's surrender of Fort Detroit permitted the British and Native Americans to control the Michigan territory (indeed, they had already taken Mackinac and Dearborn) and to plunder houses and farms in search of food, clothing, or excitement.[102] While British troops employed looting of mostly public, sometimes private, establishments as a means of survival, Native Americans employed it indiscriminately as a vehicle to inflict humiliation and suffering so that settlers would flee the area.

The most notorious instance of looting and burning of public property occurred during the Americans' assault on York, the capital of Upper Canada, and Fort George, an important garrison overlooking the Niagara River in late April. Three months earlier, Madison had invested Brigadier General John Armstrong of the Port of New York with the position of Secretary of War. Armstrong immediately prepared his cabinet to challenge British control of Lake Ontario and to sever lines of communication between Upper and Lower Canada by means of an attack on the naval base at Kingston at the northeastern end of the lake, to be followed by attacks on York at the northwestern edge of the lake and Fort George a few miles south on the Niagara River.[103] The attack on Kingston had to be deferred given the strength of the British navy there, but movements against York and Fort George remained viable. The Commander of the Army of the Northeast Sector, Henry Dearborn, brought together 1,700 troops from New England, Pennsylvania, and Maryland at Fort Niagara (on the American side) for an assault on York.[104] On 25 April, Commodore Isaac Chauncey carried the regiment across the lake in his vessels, and two days later Dearborn's adjutant, Brigadier General Zebulon Pike, led the boats ashore for an assault on the colonial administrative center. Pike's men quickly overwhelmed and captured the batteries; the acting Lieutenant Governor of Upper Canada, Roger Hale Sheaffe, and his regulars, anticipating having to flee

[101] Taylor, *The Civil War of 1812*, 165.

[102] As Governor of the Michigan Territory, Hull had lobbied the U.S. government for funds to build a fleet that could properly defend the forts at Detroit, Mackinac, and Dearborn, but was ignored, so that when news that British-led forces took Mackinac from a small American garrison on 17 July 1812 reached him nine days later, he gave orders for the evacuation of the vulnerable Dearborn garrison, although its convoy of soldiers and settlers was killed by Potawatomi Indians a mile and a half into their trek to Fort Wayne (in Indiana Territory) on 15 August.

[103] J. C. A. Stagg, *The War of 1812: Conflict for a Continent* (Cambridge: Cambridge University Press, 2012), 85.

[104] Stagg, *The War of 1812*, 86.

to Burlington Heights a few miles southwest, torched the *Sir Isaac Brock* under construction in the harbor and a magazine containing 200 barrels of gunpowder and other munitions. The resulting explosion of wood, stone, and metal killed Pike and his 38 men, wounded 222 more, and created enough chaos to provide cover for Sheaffe and his men to escape.

Dearborn, who remained aboard one of Chauncey's vessels on account of infirmity and illness, did not wish to grant generous terms of surrender to the militia and magistrates who remained at York. Taylor observes that although "the town fathers promised to surrender all government and military property" in return for an assurance "to protect private property and to parole the local militiamen," the occupying regiment did not ratify the agreement for a day in order to permit the troops to plunder the town.[105] The Americans would have prioritized burning military fortifications, barracks, and storehouses so that the town could not be easily garrisoned or defended in the future, but some would also have been tempted to despoil public buildings like the Government House, Legislative Assembly, and the homes of military officers. Only the plan of the Government House (1799), the official residence of the lieutenant governor, survives: a single-story U-shaped building consisting of a central chamber with fireplaces at each end and a sequence of mid-sized rooms and cabinets letting on to porches (figure 13).[106] It may have served not only as the lieutenant governor's residence but also a meeting place for members of his Executive and Legislative Councils. Although state portraits of George III and Charlotte after Ramsay or Reynolds were gifted to Canadian governors from the 1760s through the 1790s, a pair does not seem to have been displayed in this new Government House after General Robert Prescott's recall in 1799, and Sheaffe's decision to abandon York to the invaders would not have endeared him to London.[107]

The Legislative Assembly was a modest single-story brick structure or perhaps two structures joined by a wooden covered corridor (figure 14). Of the destruction of these government facilities, Hickey observes that Sheaffe determined to blow them up as he was withdrawing his troops to Burlington Heights, whereas Taylor maintains that some vengeful sailors burned the structures upon discovering an American scalp in the lower house of the Assembly, "suspended near the Speaker's chair, in company with the Mace & other Emblems of Royalty," an unwelcome

[105] Taylor, *The Civil War of 1812*, 215; George Sheppard, *Plunder, Profit, and Paroles: A Social History of the War of 1812 in Upper Canada* (Montreal and Kingston: McGill-Queen's University Press, 1994), 101, states that "During the capture of York . . . any homes found abandoned were considered fair game by American looters."

[106] Carl Christie, "Pilkington, Robert," in Francess G. Halpenny and Jean Hamelin, eds., *Dictionary of Canadian Biography*, vol. 6 of 14 (Toronto: University of Toronto/ Université Laval, 1966-1982) n.p., University of Toronto / Université Laval Website, accessed 28 June 2019, http://www.biographi.ca/en/bio/pilkington_robert_6E.html, states that Pilkington, an army officer and military engineer, built an extension to the Legislative Assembly in 1797 and designed and constructed the Government House in 1799–1800; the plan of the Government House is reproduced in Eric Ross Arthur, *Toronto, No Mean City* (Toronto: University of Toronto Press, 1964), 19.

[107] Smart, *Allan Ramsay*, 118–119 (nos. 192dg, 192dp, and 192dz), suggests that there was a gap in the conferral of state portraits on the governor of Nova Scotia after John Parr's term ended in 1783 and on the governor of Canada after General Robert Prescott's term ended in 1807, with the giving of such gifts resuming a few years after the War of 1812.

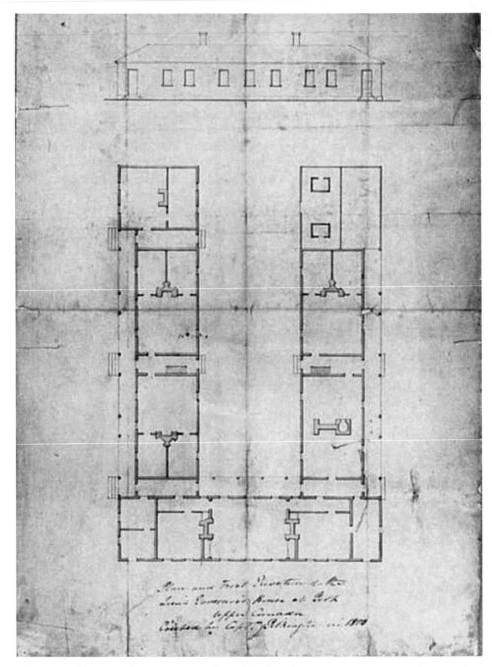

Figure 13. Captain Robert Pilkington, *Plan and elevation of the first residence for the Lieutenant Governor ('Government House') built* [at York] *in Upper Canada, 1799–1800*. The Picture Art Collection / Alamy Stock Photo.

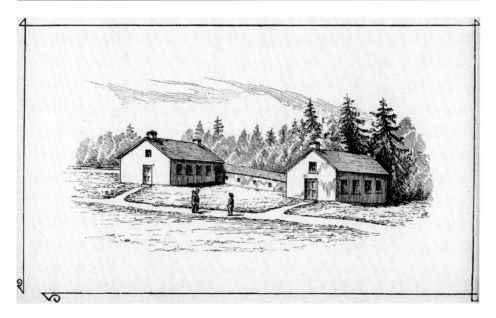

Figure 14. Unknown, *Ontario's First Parliament Buildings* [i.e., Legislative Assembly], *1796–1813*, 1910. Brick structures linked by a wooden corridor. Public Domain. James Salmon Collection, City of Toronto Archives, Fonds 1231, Item 2076.

reminder that the British were employing Indians to commit the most grisly atrocities in the name of George III.[108] There is consensus that whereas the Government House was probably impacted by the explosion of the powder magazine, the Legislative Assembly was probably looted and torched by renegade American troops. George Sheppard observes that the chief residents of York met on 30 April to compose a letter of complaint for the destruction of the government buildings, and John Strachan witnessed that Dearborn responded by expressing regret over the destruction of the provincial parliament and assuring that the acting commander was "greatly embarrassed" about the whole affair.[109] For many years, an oversized standard, a carved and painted mace with coronet (figure 15), and a lion *statant guardant* with orb thought to have been taken from the lower house were conserved at the U.S. Naval Academy Museum at Annapolis.[110] Their rudimentary

[108] Taylor, *The Civil War of 1812*, 217; Stagg, *The War of 1812*, 86.

[109] John Strachan to James Brown, 26 April 1813, in John Strachan Papers, Archives of Ontario, quoted in Sheppard, *Plunder, Profit, and Paroles*, 102.

[110] President Franklin Roosevelt obtained Congress's approval to return the mace of the Parliament of Upper Canada (and other war trophies), taken by American forces at the Battle of York on 27 April 1813 and preserved at the U.S. Naval Academy at Annapolis in time for the American Daughters of 1812 to unveil a memorial tablet to the memory of General Pike and his forces killed in action at Toronto on 4 July 1934. See "Joint Resolution," 16 June 1934, Statutes at Large, 73rd Congress, Session 2, Chapter 559, p. 978, Library of Congress, Washington, D.C., Library of Congress Website, accessed 10 June 2019, https://www.loc.gov/law/help/statutes-at-large/73rd-congress/session-2/c73s2ch559.pdf.

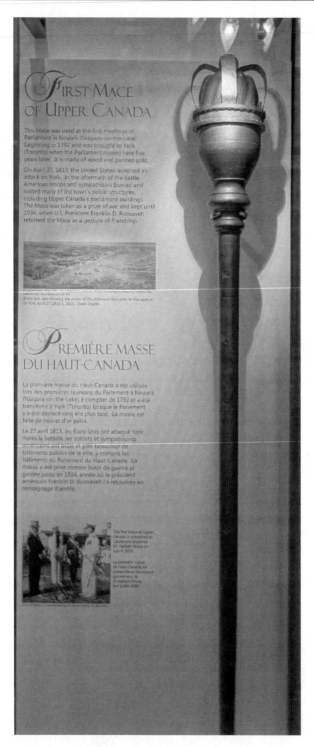

Figure 15. Unknown, First ceremonial mace from the Assembly of Upper Canada, 1792. Wood and metal painted gold. Ontario Legislative Building, Toronto. Public Domain (Wikimedia Commons).

materials and forms point to the modest resources of early government representatives; their value would have resided in their symbolic association with constitutional monarchy.[111] However, costly metal objects were purloined from the homes of British military officers, as an American naval officer reported, "Some of them [i.e., Major Benjamin Forsyth's riflemen] . . . have made several hundred dollars in one battle. They have mashed up, between two stones, some of the most elegant Silver embost [sic] urns, turines [sic] and plate of every description to get them in their knapsacks."[112] Dwelling in wretched encampments and dodging sniper fire from the brush had some compensation at York. Americans' pillaging in violation of military rules of engagement or moral codes not only alienated locals but also encouraged the British to plot revenge despoliations.

The British would cite the sack of York repeatedly as a pretext for planning an attack on Washington, D.C., although there was really no comparison between the fledgling advisory board of a colony and the mature legislative assembly of an independent nation. There was no point in attempting to justify acts of revenge on either side as British and American forces deployed along the Great Lakes were so caught up in a desperate and deadly game, impelled on some occasions by strategy and on others by indignation, that only a government bureaucrat in London or Washington would attempt to find logic in it. The important point is that as the war dragged on, British and American regiments participated in the destruction of military garrisons and appropriation of military stores on one hand and the looting and burning of civilian businesses and homes on the other in a flagrant disregard for eighteenth-century codes of conduct.

Indeed, between the spring of 1813 and the spring of 1814, a pattern emerges as the capture of forts and destruction of magazines is carried out in tandem with the storming of towns and robbing of homes. When in mid-May, American forces 4,700 strong reconnoitered at Fort Niagara at the north end of the Niagara River and planned a surprise attack on the 1,500 British stationed at Fort George a few miles downstream, the former welcomed the prospect of not only capturing troops and arms but also plundering the town of Newark. Denied the satisfaction of capturing Brigadier General John Vincent's men, guns, and magazine on the morning of 27 May, General Winfield Scott and his regiment turned on the local houses and shops, looting furnishings and apparel.[113] At that time, silver, porcelain, and glassware as well as fine linen, fitted clothing, and leather goods were prized, especially if they had been imported from Europe. It was not long before the British returned the jab. On 11 July, Lieutenant Colonel Cecil Bisshopp and 250 men gathered before dawn at Fort Erie at the south end of the Niagara and crossed over to attack Black Rock, New York. There Brigadier General Peter B. Porter and his men were caught off guard and compelled to flee to Buffalo, leaving the enemy to plunder Porter's mansion and public stores and to set fire to "the blockhouses, barracks,

[111] Taylor, *The Civil War of 1812*, 219, offers the possibility that "the plunder taken at York" (armaments and provisions?) was lost for good in late May when Commander-in-Chief of British Forces in North America George Prevost and his troops departed Kingston with Commodore James Yeo and sacked the American naval base (i.e., burned the warehouses) at Sackett's Harbor on 29 May 1813.

[112] Unidentified American naval officer quoted in Taylor, *The Civil War of 1812*, 216.

[113] Stagg, *The War of 1812*, 87; Taylor, *The Civil War of 1812*, 218.

navy yard, and a schooner," although Porter eventually returned with 250 soldiers and 37 Seneca warriors to reclaim the position, killing Bisshopp and a dozen of his men in the process.[114]

By late summer the theater of war shifted back to the Northwest, where Master Commandant Oliver Hazard Perry, employing a newly built American fleet, incapacitated the British line, seized control of Lake Erie, and ferried troops in campaigns to liberate Michigan and attack positions in Upper Canada.[115] Perry had been blockading the British strongholds of Amherstburg and Detroit for some months before he collected General William Henry Harrison's 5,000-man army from the Ohio territory and deposited them at the south end of the Detroit River on 27 September. During those months, British Major General Henry Proctor and his 850 regulars and Tecumseh's 3,000 Indians had deployed at various points between Fort Malden and Fort Detroit, burned the forts, barracks, and storehouses, and fled east through the Thames Valley toward Burlington Heights.[116] In retaliation, Harrison and his troops occupied the town of Amherstburg, looted and burned the houses of the officers, and then moved on to Detroit, where they were distressed to find that the Indians had already plundered the locals.[117] Harrison and 3,500 fearsome Kentucky volunteers and 200 Shawnee Indians gave chase of Proctor and Tecumseh and caught up with them and their spoils at Moraviantown on 5 October. While Proctor fled on horseback, Tecumseh fell in the storm of bullets. In addition to seizing six cannon, supply wagons, and personal effects, the Americans pillaged, vandalized, and burned the town before returning to Detroit and securing Northwest Upper Canada.[118] By this action, a wedge was finally driven between the Western Confederation of Indian Tribes and the British Empire.

In autumn the theater of war swung back to the Niagara River, where American and British regiments alternated laying siege to a fort and ransacking a local town. Brigadier General George McClure and about 80 American troops had occupied Fort George (figure 16) on the Canadian side of the river for some months when in early December they received word that Lieutenant Colonel John Murray, acting on the orders of Lieutenant General Gordon Drummond, was advancing with 500 British troops to recapture the fort and drive the Americans from the area. McClure ordered a general evacuation in the midst of a snowstorm, but not before setting fire to the fort; his colleague, Lieutenant Colonel Joseph Willcocks, ordered his volunteers to torch the adjoining town of Newark, which included a courthouse, library, two churches, and ninety-eight houses (including the mansion of businessman and lawyer William Dickson), leaving the citizenry destitute.[119] Seeking to attribute a cruel "burning system" to American forces, Governor General of the Canadas George Prévost issued a proclamation in which he expressed shock "that in the enlightened era of the 19th century, and in the inclemency of a Canadian

[114] Taylor, *The Civil War of 1812*, 229.

[115] Oliver Hazard Perry defeated commodore Robert H. Barclay's slightly smaller and woefully undermanned fleet at Put-in-Bay on 9–10 September 1813, badly damaging the HMS *Detroit* and *Queen Charlotte* and taking possession of several smaller craft.

[116] Stagg, *The War of 1812*, 89–92.

[117] Taylor, *The Civil War of 1812*, 244.

[118] Taylor, *The Civil War of 1812*, 245.

[119] Taylor, *The Civil War of 1812*, 250–251; Stagg, *The War of 1812*, 115.

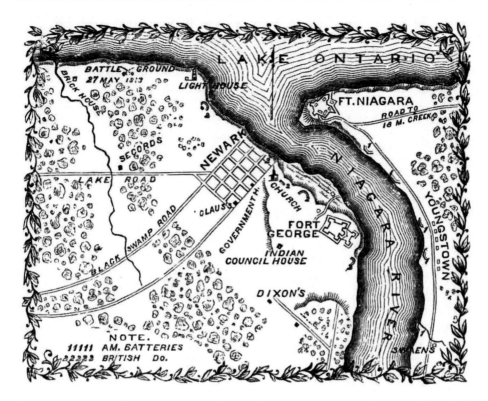

Figure 16. William Barritt, *Plan of Operations at the Mouth of the Niagara River*, from Benson J. Lossing, *The Pictorial Field-Book of the War of 1812* (New York: Harper and Brothers, 1868), 599. Public Domain.

Winter, the troops of a nation calling itself civilized and christian [sic] . . . forced 400 helpless women and children . . . to be the mournful spectators of the conflagration and the total destruction of all that belonged to them."[120] When questioned about the incident, Willcocks responded that he had received a report that the British had permitted the Indians to burn an American captive to death; there was no substance to the report, although it must have seemed credible in light of the scalpings, hackings, and dismemberments (especially the heart) that indigenous warriors had inflicted on incoming troops and the grisly souvenirs Americans had confiscated from prominent defeated warriors like Tecumseh.

On 12 December, Murray and his company entered the smoking ruins of Newark, gazed across the river at McClure's untouched Fort Niagara, and contemplated a revenge attack, followed by a short trek down the river to sack Lewiston. A week later, at Drummond's command, Murray and 550 regulars rose before dawn and quietly crossed the Niagara River; they were expecting to find the fortress heavily guarded, but McClure had left it in the hands of the indifferent Captain Nathaniel Leonard; the British easily subdued the gate guards, slaughtered officers

[120] Proclamation in *Kingston Gazette*, 1 February 1814, 2, quoted in Sheppard, *Plunder, Profit, and Paroles*, 103.

and sentries playing cards in a nearby house, and poured into the keep, killing 65 and arresting 300.[121] The arsenal was well stocked, with 27 cannon, 3,000 stands of arms, and massive quantities of ammunition to redirect against the Americans. Murray stayed behind to secure the fort as Drummond ordered General Phineas Riall along with 500 soldiers and 500 Native Americans to advance on Lewiston the day before Christmas. Most of the citizenry fled at the first terrifying sound of the Indian war cry, leaving the obstinate, slow, or infirm to be cut down and the stores and houses to be plundered, trashed, and burned. Such immediate success emboldened the British to take aim at American settlements farther south, at the convergence of the Niagara River and Lake Erie. Within a few days, Riall led 50 militiamen, 965 regulars, and 400 Indians on the area, hoping to take Black Rock and Buffalo from the Americans, whose generals had fallen out and whose troops were disorganized and confused. Once again, the British sent forward an advance group of shrieking warriors, which had the effect of terrifying the Americans. General Amos Hall's corps of 2,000 men fled Black Rock, and Lieutenant Colonel Cyrenius Chapin was among 130 men captured at Buffalo and taken to Quebec as a prisoner. As there were no forts in either town, the British put powder and torch to features of strategic benefit to the Americans: Porter's stone mansion and storehouse at Black Rock and four schooners in the Buffalo River. The Indians did the rest, pillaging and burning nearly every building—102 homes, 43 barns, and 18 stores. The business complete, the British returned to the Canadian side of the Niagara River on 1 January 1814, retaining only Fort Niagara with a strong garrison. The American frontier between Sackett's Harbor and Detroit lay unprotected, and New York Republicans inundated the War Department with demands for a counterattack, though Madison was reluctant to approve a deployment.[122]

The British used American looting and burning at Sandwich in 1812 and York, Moraviantown, and Newark in 1813 as justification for outrages they inflicted at Detroit, Lewiston, Black Rock, and Buffalo in 1813. Although George III's government was effective at promoting the notion that the Madison administration embraced theft and conflagration as a part of its war policy, both were to blame as neither would guarantee a steady supply of food and pay or institute correctives for reckless officers, undisciplined troops, and enflamed tribal allies who inflicted damage to public and private property.[123] For the residents of the frontier divided in their loyalties, it only mattered that both British and Americans were willing to run roughshod over the Great Lakes region, terrorizing, robbing, slaughtering, and burning as they went.[124] Sheppard has made a study of property losses reported by the inhabitants of nine provincial districts of Upper Canada and finds that the amount of each claim varied widely according to the intensity of wartime activities in each area (Niagara suffering the worst damage due to a nearly endless

[121] Taylor, *The Civil War of 1812*, 253.

[122] Stagg, *The War of 1812*, 116.

[123] On the challenges presented to the British military command of feeding and provisioning their troops and horses in Upper Canada, see Sheppard, *Plunder, Profit, and Paroles*, 107–118.

[124] [Canandaigua, Ontario County, New York] *Ontario Repository*, 4 Jan. 1814, in E. A. Cruikshank, ed., *Documentary History of the Campaigns upon the Niagara Frontier in 1812–1814*, 9 vols. (Welland, Ont.: Tribune Press, 1896–1908), 9: 80; Sheppard, *Plunder, Profit, and Paroles*, 9, 118–130.

succession of attacks and counter-attacks, or 678 claims amounting to £182,169) and the party inflicting the damage (American troops having burned more towns and villages than the British, or losses amounting £248,000 compared to £140,000, although the British were involved in almost as many incidents of damage as the Americans).[125] He proposes that incidents of British theft and destruction of property were more frequent along the border with the United States than they were in Portugal and Spain due to the steady decline in available resources as the supply chain broke and local crops and stores were depleted.[126] In other words, deprivation caused men to do desperate things in order to survive.

British Raids in the Chesapeake

Reports of the retributive raids in the Great Lakes region inevitably reached British Secretary of State for War and the Colonies Henry Bathurst in London. He believed that the only way to end the vicious stalemate was to draw the Americans away from the northern border through a series of attacks on government and commercial centers in the Chesapeake Bay (figure 17).[127] While the war with Napoleon raged, the British high command could afford few resources to enforce a complete blockade of the U.S. coastline, so they concentrated their efforts on Mid-Atlantic coastal fortifications and towns, employing looting and burning where they encountered resistance to demands for armaments and provisions. Supervised by the commander-in-chief of British naval operations in North America, Vice-Admiral John Borlase Warren, and his successor, Alexander Cochrane, a fearsome new brand of fighter, Rear Admiral George Cockburn, emerged from British blockade operations at Spain to ravage the Americans.

Dispatched to Bermuda, the center of British military operations in North America and the West Indies, Cockburn reported to Warren on 17 January 1813 and assumed command of the fleet off the Chesapeake a month later.[128] The admiral and his men entered the bay and explored various inlets and rivers to assess the strength of the enemy's resources, including frigates and schooners, foundries and stores, state militia and guerilla fighters.[129] Captain James Scott recollected that "captures, incursions, and assaults" occurred "almost every day in the week."[130] At Frenchtown, which marked the bay's northern terminus, Lieutenant George Augustus Westphal led 150 royal marines on a circuitous trek up the Elk River on the night of 28–29 April and as day broke seized an army warehouse loaded with uniforms, horse fittings, and flour and burnt it to the ground; they also disabled

[125] Sheppard, *Plunder, Profit, and Paroles*, 122–127.

[126] Sheppard, *Plunder, Profit, and Paroles*, 130.

[127] Henry Bathurst to Robert Ross, 20 May 1814, quoted in Kathleen Burk, *Old World, New World: Great Britain and America from the Beginning* (New York: Atlantic Monthly Press, 2007), 236, gave instructions "to effect a diversion on the coasts of the United States of America in favor of the army employed in the defense of Upper and Lower Canada."

[128] Roger Morriss, *Cockburn and the British Navy in Transition: Admiral Sir George Cockburn 1772–1853* (Columbia, SC: University of South Carolina Press, 1997), 87.

[129] Jon Latimer, *1812: War with America* (Cambridge, MA: Belknap Press, 2007), 156.

[130] James Scott, *Recollections of a Naval Life*, 3 vols. (London: Richard Bentley, 1834), 3: 207.

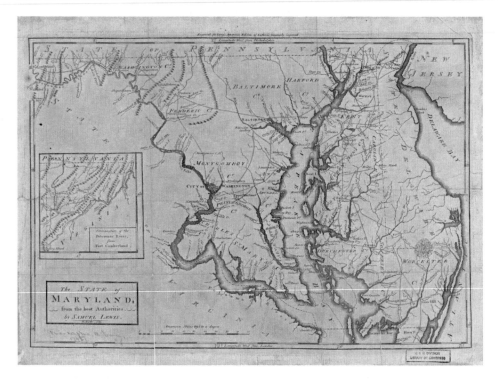

Figure 17. William Barker (after Samuel Lewis), *The State of Maryland from the best authorities* (Philadelphia: Mathew Carey, 1795). Map, 29 × 43 cm. Geography and Map Division, Library of Congress, Washington, D.C. Public Domain.

the guns of a battery and destroyed five merchant vessels anchored nearby.[131] The destruction of government property in isolation was consistent with the articles of war; however, the barrage of towns with improvised defenses or near fortified garrisons was highly problematic. Wherever Cockburn encountered resistance to his efforts to search and disarm an area, he laid waste to the town, as George states, "Cockburn's *modus operandi* [in an elaboration of the accepted law of the sea] was that if a town offered resistance, it would be considered a fortified post and the male inhabitants as soldiers."[132] Following this logic, every unfriendly town could be considered a military post. When the commander noticed guns firing from a new battery at Havre de Grace, guarding the entrance to the Susquehanna River, he ordered the boats readied on the morning of 3 May. Westphal landed 150 marines and artillerymen, who proceeded to storm the main bulwark at Concord Point under cover of fire from fifteen launches and rocket boats.[133] The 2,000-strong American militia fell back from the main battery to the Potato Battery, and then from the sixty or so town buildings to the woods. Because the local defense fled

[131] George, *Terror on the Chesapeake*, 27; Morriss, *Cockburn and the British Navy*, 91; Scott, *Recollections of a Naval Life*, 3: 97.

[132] George, *Terror on the Chesapeake*, 27.

[133] Latimer, *1812: War with America*, 160.

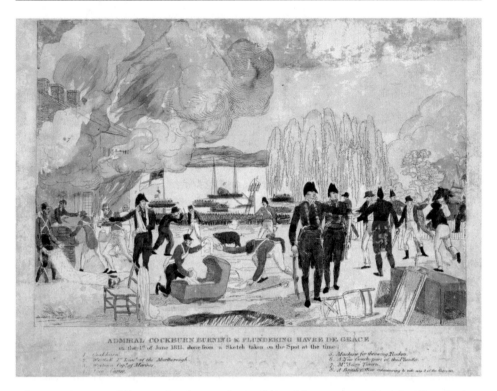

Figure 18. William Charles, *Admiral Cockburn Burning & Plundering Havre de Grace on the 1ˢᵗ of June 1813, done from a Sketch taken on the Spot at the time*, ca. 1813. Hand-colored etching on laid paper, 22.5 × 32.5 cm. Courtesy of the Maryland Center for History and Culture, Image H151.

through the town, the invaders justified looting and torching businesses, houses, and farms, as Jared Sparks, a tutor in history to one of the prominent families, noted, the British seamen were equipped with hatchets in anticipation that they would have to break open wardrobes and bureaus, and as Cockburn reported, the structures were set alight "to cause the Proprietors . . . to understand and feel what they were liable to bring upon themselves" by resisting his forces.[134] In other words, Cockburn and his men intentionally blurred the lines between appropriate conduct toward a military installation, a defensive battery, and a barred business or home in order to assert complete control over the area. An etching derived from a sketch purportedly made on the spot shows Cockburn and a few officers presiding over the captured town as marines and redcoats ransack houses and deposit their spoils—cabinet, chairs, mirror, portrait, tureen, candleholder, fine linens, and even baby clothes—in the common area, a glimpse of the barges landing more men beyond (figure 18). All items have utilitarian or monetary value except the portrait, which may well represent a particular founder or dignitary meaningful to

[134] Sparks paraphrased in George, *Terror on the Chesapeake*, 32; Cockburn quoted in George, *Terror on the Chesapeake*, 32. Latimer, *1812: War with America*, 161, describes Cockburn's "policy of retribution," which included the burning of dwellings used to store arms or houses abandoned by their owners.

the British rather than the standard family ancestor or admired prelate who might be attacked or disfigured.[135] British officers would recall the incident as a cruel and unjust episode in which an American town was sacked though the citizens had made no resistance.[136]

Having proved that he needed no pretext beyond armed or uncooperative citizenry to snatch, smash, or burn things, Cockburn and his squadron doubled back to the east and entered the Sassafras River with the intention of inspecting the nearly parallel villages of Georgetown and Fredericktown. He sent ahead a warning to the inhabitants that they must surrender peacefully or face devastation. Lieutenant Colonel Thomas W. Veazey's 400-man Maryland regiment nevertheless pounced on the squadron with heavy musket fire, and Cockburn ordered the bombardment of the American positions until they were dislodged and "fled through the town [i.e., Fredricktown] into the woods."[137] Cockburn retaliated for injuries to five men by plundering and destroying several houses, and helping himself to stores of sugar, lumber, and other merchandise, along with four vessels anchored in the river. The neighboring residents of Georgetown were so terrified they offered up supplies in exchange for an assurance to be spared.[138] While the American press railed at Cockburn for laying a path of destruction, the British Admiralty scolded him for failing to enforce the blockade, to destroy the frigate *Constellation*, and to achieve major strategic gains that would pressure a final settlement.[139]

In early May, Cockburn and his fleet made the return voyage south, noting along the way those ports that had not yet been searched, and rendezvoused at Lynnhaven Bay (Virginia), at the entrance to the Chesapeake, to divide the captured vessels with Warren before going their separate ways to Bermuda and Halifax. By this time, they had received word that the coalition powers had occupied Paris and forced the abdication of Napoleon, potentially freeing up fleets and battalions for North American operations. On 26 May, Warren formally proclaimed a blockade from New York to Mississippi and secretly planned to target the dockyards, foundries, ships, and stores of Norfolk, Baltimore, and Washington, D.C., consistent with the articles of war.

[135] Laurel Thatcher Ulrich, *The Age of Homespun: Objects and Stories in the Creation of an American Myth* (New York: Alfred A. Knopf, 2002), 12–17, 20–21, 37–38, 102–105, 177–207, 279–304, 309–339, explores Horace Bushnell's nostalgic recollections of the piety and labor of women in the production of valued "homespun" (or domestically spun thread and woven cloth) and the realities of a transition to a manufacturing economy in rural New England during the colonial and early republican periods. On the relatively low value accorded to the family portrait during the colonial period, see Margaretta Lovell, *Art in a Season of Revolution: Painters, Artisans, and Patrons in Early America* (Philadelphia: University of Pennsylvania Press, 2005), 8–9, 21–22. See Lauren Lessing, Nina Roth-Wells, and Terri Sabatos, "Body Politics: Copley's Portraits as Political Effigies during the American Revolution," in *Beyond the Face: New Perspectives on Portraiture*, ed. Wendy Wick Reaves (Washington, DC: National Portrait Gallery, London: D. Giles Limited, 2018), 32, 34, who discuss violence directed against John Singleton Copley portraits during British occupation of Boston in March 1775.

[136] *Nile's Register*, 8 May 1813, in Scott, *Recollections of a Naval Life*, 3: 103–108 note.

[137] George, *Terror on the Chesapeake*, 36; Scott, *Recollections of a Naval Life*, 3: 110.

[138] Latimer, *1812: War with America*, 161–162.

[139] See *Nile's Register*, 15 May 1813, in Scott, *Recollections of a Naval Life*, 3: 112–114 note; Scott, *Recollections of a Naval Life*, 3: 114; George, *Terror on the Chesapeake*, 37–39.

Warren and Cockburn reconnoitered at the entrance to the Chesapeake in mid-June, this time accompanied by Colonel Thomas Sidney Beckwith and Captain S. J. Pechell's force of 2,400 men (Royal Marines, infantry, and Independent Companies of Foreigners). They determined to turn southwest and attack Norfolk, together with the Gosport Navy Yard and the *Constellation*, on 22 June. It was a dreadful mistake. Believing that rag-tag American troops would take flight whenever confronted by organized British regiments, Cockburn managed to persuade his colleagues to besiege the well-fortified Craney Island at the mouth of the Elizabeth River rather than to land troops eight miles west and march on Portsmouth and the Navy Yard (figure 19).[140] But American Brigadier General Robert B. Taylor had already ordered his 737 Virginia militia to build defenses around Norfolk and Portsmouth, to commandeer several ships and crews to blockade the Elizabeth River (then providing safe haven to the frigate *Constellation*), and to secure additional soldiers and sailors to help defend the island. Beckwith and Pechell attempted a two-pronged assault under the British standard, the one leading a brigade across a submerged shoal and the other driving fifty rowboats into mud flats under withering fire from Taylor's militia and Major James Faulkner's seven cannons.[141] Forced to return to their ships, the British recorded 3 marines killed, 8 marines and soldiers wounded, and 52 missing (it was rumored that many who tried to swim ashore were drowned or killed on the spot).[142]

Unwilling to accept that a well-trained American navy and militia could pose an obstacle, Cockburn turned his attention to the more vulnerable neighboring town of Hampton to wreak revenge. Just before dawn on 25 June, he led a corps of 2,400 soldiers and marines in thirty or so boats across Lynhaven Bay, landed them on the north shore of Hampton Roads, and ordered them to fire on two batteries defended by Captain B. W. Pryor, and to engage with Captain R. Servant's rifle company in a thick wood. Overcome by the superior firepower of the British, the head of American operations, Major Stapleton Crutchfield, ordered a general retreat of what remained of his 436 men and escaped through the woods. Although both sides recorded a comparable number of killed and missing, the British took in nearly three times more wounded than the Americans.[143] Cockburn then unleashed the French Independents, prisoners freed from British hulks on condition they fight Americans, on the town, and they pillaged and burned the communal centers and private habitations, raped and murdered the citizenry.[144]

[140] George, *Terror on the Chesapeake*, 42.

[141] Scott, *Recollections of a Naval Life*, 3: 142.

[142] George, *Terror on the Chesapeake*, 47; Latimer, *1812: War with America*, 171, contends that of the British forces, 16 were killed and 62 were missing.

[143] George, *Terror on the Chesapeake*, 50.

[144] Stagg, *The War of 1812*, 96; Donald G. Shomette, *Flotilla: Battle for the Patuxent* (Solomons, MD: Calvert Marine Museum Press, 1981), 10–11. According to historian Donald E. Graves, who examined the charges in the Journal of the War of 1812, the evidence of pillaging is persuasive, with two British officers seen looting a Hampton store and the communion plate being stolen at St. John's Church, among other crimes; see Mark St. John Erickson, "War of 1812: British Raiders Pillage Hampton," 22 June 2018, Daily Press Website, accessed 20 September 2018, http://www .dailypress.com/features/history/war-of-1812/dp-nws-war-of-1812-hampton-20130622-story .html. Morriss, *Cockburn and the British Navy*, 96, states that there were several reports that British seamen, marines, and soldiers who landed indiscriminately looted and destroyed things.

Figure 19. William Barritt, *Battle of Craney Island* from Benson J. Lossing, *The Pictorial Field-Book of the War of 1812* (New York: Harper and Brothers, 1868), 679. Public Domain.

British Lieutenant Colonel Charles Napier, while admitting that the outrages had occurred, attempted to distance himself from them: "Whatever horrible acts were done at Hampton, they were not done by the 102nd [Regiment], for they [i.e., the men] were never let [allowed] to quit the ranks, and they almost mutinied at my preventing them joining the sack of that unfortunate town"; rather, the French company was responsible for "rape, murder and pillage."[145] The British withdrew the independent company from service on the front lines pending an investigation and assured the American command that the behavior at Hampton would not be repeated. Nevertheless, the damage to the citizens of Hampton and to the reputation of the invading forces was done. Word spread quickly via broadsides that the British were prepared to employ proxies to commit the grisliest acts on their behalf. The British had long allied with Western tribes to discourage American settlement in Michigan territory; they were now providing French prisoners a chance to redeem criminal records by participating in the Chesapeake campaigns; and they would shortly offer plantation slaves the opportunity to form regiments in exchange for their freedom.

Warren was relieved of duty at Halifax in March 1814 and replaced by Vice-Admiral Alexander Cochrane, who had harbored a hatred for the U.S. government since the War of Independence and was determined to continue the current hostilities until the nation was soundly beaten and the leaders punished, a position which most of the British public shared. Cochrane began his appointment by requesting "thirty frigates, forty sloops, and twenty armed vessels together with an additional 1,000 men" from the Admiralty and issuing a proclamation promising slaves the "choice of either entering into His Majesty's Sea or Land Forces, or of being sent as FREE Settlers, to the British Possessions in North America or the West Indies" (2 April 1814).[146] With a chronic shortage of forces (due to fighting on several fronts as well as constant casualties and defections), British officers could forge black refugees into a disciplined fighting force. There is no doubt that thousands of slaves flocked to the British ships, as Scott observed, "The desertion of the slaves from the shore became more numerous and frequent; many of these were relanded [sic], and, communicating with their comrades, increased the list of deserters. . . . Canoes full of the runaways now constantly sought the protection of some of the squadron, and it is to be feared that many perished during the dark nights by drifting out to sea."[147] However, the majority of refugees were not interested in fighting their former overseers: as Cockburn opined from Bermuda, most freed men and women would naturally prefer the hopeful life of a settler to the dangerous life of a soldier. Around 3,600 slaves found asylum with the British during the war, and of these 550 enlisted in a special Corps of Colonial Marines

[145] Charles Napier quoted in Latimer, *1812: War with America*, 171; also see George, *Terror on the Chesapeake*, 51. It had been proposed that the dreadful behavior of the French company was motivated by (rumor of?) American slaughter of French troops as their boat *Centipede* ran aground, sank, or they attempted to swim ashore at Norfolk. See Scott, *Recollections of a Naval Life*, 3: 142–143, 148, 151.

[146] Latimer, *1812: War with America*, 245, 247, 248; 2 April 1814 proclamation quoted in Hickey, *The War of 1812: A Forgotten Conflict*, 213.

[147] Scott, *Recollections of a Naval Life*, 3: 118–119.

while the rest were transported to Nova Scotia, Bermuda, and the West Indies.[148] Cochrane established a base at the south end of Tangier Island near the mouth of Chesapeake Bay to uniform, train, and provision black soldiers and Cockburn lauded "the astonishing rapidity with which he [Sergeant William Hammond] has since brought these Negroes forward [as a corps] to which in very great measure must be attributed their extraordinary standing and good conduct in action with the Enemy."[149] Cockburn betrays the prejudices of his race and class in lauding the performance of the black corps; other officers would have appreciated that their knowledge of the local terrain made them effective guides and informers.[150]

At least in theory, it seemed to American and British commanders that the side which employed the most aggressive tactics along the Great Lakes and the Chesapeake had the best chance of demoralizing the opponent, turning public opinion, and winning the war. In reality, looting and burning only incentivized officers and troops to imagine even more horrific marks of brutality, subjects and citizens to trade habitual generosity for cruel indifference, and politicians to harness reports of enemy outrages to rally support for continuing the war indefinitely. Wherever there was a fort, bunker, or bulwark, a barracks, warehouse, or stores to be neutralized, there was a city, town, or village, a church, hall, or mansion ripe for the picking. Violence directed at elusive authorities in the public realm degenerated into immediate ramifications for civilians in the private realm. Residents of the Western and Mid-Atlantic states possessed a pragmatic capacity to extend the spectacle of columns and draperies, stretchers and canvases, masts and sails, and poles and tents into so many points along the material spectrum from luxury to necessity, decoration to utility, which explained how the noble sentiments of the British colonial and American republican administrations could give way to the horrible deeds of enlisted and mercenary fighters. Looting and burning required both a prized object and a daring act. But it was one thing to run away with somebody else's possession, leaving only the charred receptacle, which suggested a desire to efface the scene of the crime, and quite another to do violence to both object and building, which suggested that nothing of value had ever resided there.

[148] Hickey, *The War of 1812: A Forgotten Conflict*, 213; George, *Terror on the Chesapeake*, 37.

[149] Scott, *Recollections of a Naval Life*, 3: 187, 188; George, *Terror on the Chesapeake*, 68; Stagg, *The War of 1812*, 128; George Cockburn to Alexander Cochrane, 23 June 1814, Papers of George Cockburn, ms. 17,576, reel no. 6, item no. 13, Manuscript Division, Library of Congress, Washington, D.C.

[150] Scott, *Recollections of a Naval Life*, 3: 120, noted, "The opportunities afforded us of safely traversing the enemy's country at night by means of these black guides, placed a powerful weapon in the Rear-admiral's [i.e., Cockburn's] hands. . . . By their assistance we were enabled to pass the enemy's patroles [sic], make the circuit of their encampments, and cut off the post beyond it." Benjamin G. Benyon, Journal kept during the years 1813–14 by Lieut. Benyon, Royal Marines, serving on board H.M.S. Menelaus on the American Station during the War of 1812, n.d., 172, Western Reserve Historical Society, Cleveland, noted that on 1 September 2014 "The Black fellow we took for a guide was taken and sentenced to suffer Death, which was to be put in [to] execution the next morning, however the poor fellow escaped and came on Board here the next morning in a Canoe." *National Intelligencer*, May 1813, quoted in George, *Terror on the Chesapeake*, 37, reported that several blacks deserted to the British and "became pilots for them in plundering."

To Attack, to Defend
Washington, D.C.

Although the British military command nursed an ambition to capture and level the U.S. capital, the American defensive forces were incredulous that such a scheme could ever be successful. Cochrane, stiffened in patriotic resolve by his recent tenure as Governor of Guadeloupe, was outraged by reports of the American sack of York and other British settlements in Canada, and declared that the "sea port towns" of the United States would be reduced to "ashes" and "the country invaded" as far as Washington, D.C.[151] Directed to resume hostilities with the inhabitants of the Chesapeake in early summer, Cockburn and his men foraged in the vicinity of Saint Clement's Bay at the mouth of the Potomac, received the first reinforcements from abroad, and carried out a series of raids in Virginia and Maryland. Cockburn burned enemy ships, destroyed military stores, secured meat and provisions in exchange for promissory notes, and seized tobacco and flour.[152] On 18 July, Cochrane issued a general order to "lay waste" to towns along the East Coast until Americans agreed to give compensation for the destruction of settlements in Upper Canada, though in a private dispatch he tempered this with an order to spare citizens who were unarmed or furnished supplies and to respect private property that was secured with a tribute.[153] Cockburn chose to regard the directive as a license to resume looting and burning, as Frederick Chamier, a midshipman of the *Menelaus*, observed: "If by any stretch of argument we could establish the owner of a house, cottage, hut &c. to be a militia-man, that house

[151] Alexander Cochrane to George Cockburn, 24 April 1814, quoted in James Pack, *The Man Who Burned the White House* (Annapolis: Naval Institute Press, 1987), 166–167.

[152] George Cockburn to Alexander Cochrane, 21 July 1814, p. 3, The Papers of George Cockburn, ms. 17,576, reel 6, Manuscript Division, Library of Congress, Washington, D.C., describes gunfire from Americans along a steep bank on the Nominy River, Virginia, and the necessity of landing a division to suppress it: "This morning (neither seeing nor hearing anything of the Enemy), after embarking all the Tobacco and other stores discovered in the place, and a quantity of cattle, and destroying all the Storehouses and Buildings, I again embarked the Marines and dropped down to another Point of this Nominy River . . ."; Benyon, Journal kept during the years 1813–14, n.d., 159, 162, 165–166, 168, 169, Western Reserve Historical Society, Cleveland, described several occasions in August 1814 where British troops were sent ashore at various points in the Chesapeake Bay to purchase food and stores from the local farmers and, where inhabitants were uncooperative, threatened to take their stores and burn their houses, and, where the property of a military officer was detected, to set land and house ablaze; Latimer, *1812: War with America*, 159, observes that during the Elk River campaign of 28 April 1813, Cockburn declared he would pay for cattle with "bills on the Victualling Office for the fair value of whatsoever is taken but should resistance be made, I shall consider them as prize of war," but livestock was routinely assessed at one sixth to one fourth of the value, and the bills were redeemable only after the war.

[153] Latimer, *1812: War with America*, 304.

we burn[ed], because we found arms therein; that is to say, we found a duck gun, or a rifle. It so happens, that in America every man must belong to the militia; and, consequently, every man's house was food for a bonfire. . . ."[154] In other words, Cockburn was looking for pretexts to raze structures so that the British military might be distinguished for their own incediary tactics.

The day before Cochrane issued the general order, Cockburn consulted detailed maps of Maryland prepared by his adjutant, Captain Joseph Nourse, and formulated a plan to attack Washington, D.C. He was obsessed with the idea of capturing the capital—as Scott put it, "The Rear-admiral had, from the commencement of his operations, always fixed an eye of peculiar interest upon Washington. It had been the concentrated object of his thoughts and actions. . . . the determination to accomplish the capture of the republican metropolis was a settled purpose in his . . . mind."[155] In the main thrust, regiments would follow the Patuxent northward, debark at Benedict, and march on the capital. Cockburn rationalized that the river was deep enough for frigates, the country rich in food and horses (for the transport of cannon), and the Americans too unorganized to mount much of a resistance. He concluded that victory was in reach: "The facility and rapidity [he estimated 48 hours] . . . with which an army by landing at Benedict might possess itself of the capital—always so great a blow to the government of a country, as well on account of the resources as of the documents and records the invading army is almost sure to obtain thereby—must strongly . . . urge the propriety of the plan . . ."[156] Furthermore, the unexpected news that the British had captured the American capital would shock neighboring towns into capitulation and convince the politicians to abandon the war.[157] If the plan was to succeed, however, Cockburn would have to step up barge raids along the Potomac to distract from his main thrust up the Patuxent; he would also have to coordinate with forces on land. Thus, as he orchestrated raids at Leonardtown and Chaptico (Maryland) on 19 and 30 July and at Mundy Point and Kinsale (Virginia) on 3 August, Wellesley dispatched Major-General Robert Ross to preside over the ground campaign.[158]

Madison had privately dismissed the pillaging and firing of York as the work of a few renegade militia but appreciated the usefulness of American agitations on the Canadian border as a counterweight to British vessels harassing the Atlantic coast.[159] British extension of the blockade to New England curtailed American trade and reduced government revenue even further: as farmers could not ship their produce to market and merchants and fishermen could not put to

[154] Frederick Chamier quoted in George, *Terror on the Chesapeake*, 29.

[155] Scott, *Recollections of a Naval Life*, 3: 239.

[156] George Cockburn to Alexander Cochrane, 17 July 1814, quoted in Morriss, *Cockburn and the British Navy*, 101.

[157] Stagg, *The War of 1812*, 128–129, observes that Cockburn was quick to sense the diplomatic and psychological advantages that Great Britain might derive from exposing the vulnerability of the American capital.

[158] See George, *Terror on the Chesapeake*, 79.

[159] James Monroe, "Copy of a Letter from Mr. Monroe to Sir Alex Cochrane, Vice Admiral, &c, &c," 6 September 1814, *National Intelligencer*, 9 September 1814, 1, elaborated this position.

sea, exports of $61 million in 1811 fell to one eighth of that in 1814, while imports of $53 million were reduced to one fourth of that.[160] If troops were to be paid and federal borrowing to cease, it was imperative that the western War Hawks' ambitions to annex Canada be abandoned, northeastern trade resumed on the Atlantic, and revenue restored through customs on imported goods.[161] Congress' repeal of the Embargo and Non-Importation Act against enemy ships and goods was a step toward that end, although Madison's offer of an armistice to the British military command was rebuffed in the interest of prolonging the suffering. As Cochrane wrote, "I have it much at heart to give [the Americans] a complete drubbing before Peace is made."[162] As the London ministry felt the balance of power shift to them with the fall of the bellicose Bonaparte dictatorship and restoration of a more pacific Bourbon monarchy to France, they had no reason to abandon impressment of seamen or to restore free trade but every incentive to send reinforcements to North America and pressure the United States to relinquish fishing rights off Newfoundland and navigation of the Great Lakes.[163] Presented with these obstacles in June, Madison and his cabinet reluctantly agreed to resume raids and skirmishes in Canada.

The American military command at Washington, D.C., was ill prepared to repel British squadrons advancing up the Patuxent and Potomac. The president and his war secretary were never on good terms due to the desire of Madison to be consulted on major personnel and policy changes made by Armstrong.[164] Intensification of their quarrel at a time when the British were multiplying attacks along the coast was particularly unfortunate. Over Armstrong's objections, Madison entrusted to Brigadier-General William H. Winder the tenth military district covering parts of Maryland and Virginia. The president likely made the appointment in order to curry the favor of the Federalist governor of Maryland, Levin Winder, who seemed to be in the best position to raise men and money for the defense of the district.[165] Armstrong made his disapproval of the appointment all too plain. He declared that the British would never attempt to take Washington, D.C., in light of the challenges posed by rivers and terrain; he protested that fortifications were not needed as long as state militias were provided with enough bayonets; he pretended that Winder could never be competent and withheld adjutants, forces, and supplies.[166] Winder was indeed inexperienced, unfocused, and unprepared: he had seen battle only once, on the Canadian front, and had been captured; he was a ruminative administrator rather than a pragmatic commander; he neglected to train his 500 regulars in the construction of bulwarks or the practice of hand-to-hand combat. He was in desperate need of strategic advice, for he maintained

[160] Hickey, *The War of 1812: A Forgotten Conflict*, 200.

[161] Stagg, *The War of 1812*, 114.

[162] Hickey, *The War of 1812: A Forgotten Conflict*, 184; Stagg, *The War of 1812*, 115.

[163] Hickey, *The War of 1812: A Forgotten Conflict*, 183.

[164] Stagg, *The War of 1812*, 126.

[165] Stagg, *The War of 1812*, 127; Latimer, *1812: War with America*, 303–304.

[166] See Stagg, *The War of 1812*, 127; Louis Barbe Charles Sérurier to Charles Maurice de Talleyrand, 22–26 August 1814, 39CP: Correspondance Politique États-Unis, vol. 71, page 158, Archives du Ministère des affaires étrangères, La Courneuve.

against all logic that the British intended to march toward Annapolis and then seize Baltimore.[167] Promotion of this fantasy frightened the populations of those towns and provided an opening for Cockburn's plan.

The consequences of these ambitions and denials were finally realized in late summer. Cochrane and Ross joined Cockburn on the *Tonnant* at St. George's Island at the entrance to the Potomac on 14 August to determine how to employ 3,700 men from 4th, 44th, 85th, and 21st Regiments newly arrived from Bordeaux and the Mediterranean.[168] Ross was not convinced that the capital should be the immediate objective of the campaign because British troop numbers were relatively small compared to those of American forces and soldiers would have to march far inland, distancing them from the fleet. Cockburn conditioned Ross by degrees: he took him ashore to show how easy it was to move about unopposed, led him up the St. Mary's River and assaulted a factory, and worked closely with him to seek out the enemy flotilla commanded by Captain Joshua Barney.[169] On 17 August, two small British squadrons, acting as diversions, respectively moved along the Potomac toward Alexandria south of the capital and ascended the Chesapeake Bay toward Annapolis and Baltimore to the east. The following day, Ross's main force of 4,500 men quietly moved up the Patuxent, gradually debarked at Benedict, and marched northward to Upper Marlboro to set up camp in range of the fleet (figure 20).[170] Meanwhile, Cockburn and his boats closed in on Barney's flotilla in the upper reaches of the river on 22 August; he turned the bend at Pig Point the following evening in time to witness the flagship *Scorpion* and seventeen ships explode in succession as Barney and his seamen were making their way to reinforce Winder's army.[171] His mission accomplished, Cockburn proceeded to join Ross at Upper Marlboro and to make an impassioned argument for marching troops along the back route to the capital. The discussion was complicated because both men had received a dispatch from Cochrane ordering them to disengage from the area and return to the ships.[172] Smith was not impressed by

[167] George, *Terror on the Chesapeake*, 78, 87; Latimer, *1812: War with America*, 309; Stagg, *The War of 1812*, 129.

[168] Harry Smith, *The Autobiography of Lieutenant-General Sir Harry Smith Baronet of Aliwal on the Sutlej*, ed. G. C. Moore Smith, 2 vols. (London: John Murray, 1901), 1: 193, 194; Arthur Brooke, 25 August 1814, in Christopher T. George, "The Family Papers of Maj. Gen. Robert Ross, the Diary of Col. Arthur Brooke, and the British Attacks on Washington and Baltimore of 1814," *Maryland Historical Magazine* 88, no. 3 (Fall 1993): 305; Scott, *Recollections of a Naval Life*, 3: 272; Morriss, *Cockburn and the British Navy*, 100, 103; Latimer, *1812: War with America*, 307, puts the total number of British troops at 4,500 men by including the 3rd Battalion, Royal Marines, and bluejackets.

[169] See Morriss, *Cockburn and the British Navy*, 103–104, George, *Terror on the Chesapeake*, 81.

[170] Arthur Brooke, 19 August 1814, in George, "The Family Papers of Maj. Gen. Robert Ross," 302; Scott, *Recollections of a Naval Life*, 3: 272, 274; Latimer, *1812: War with America*, 308.

[171] Scott, *Recollections of a Naval Life*, 3: 277–278; Arthur Brooke in George, "The Family Papers of Maj. Gen. Robert Ross," 302; James Scott in Latimer, *1812: War with America*, 310; George, *Terror on the Chesapeake*, 89; Morriss, *Cockburn and the British Navy*, 105.

[172] See Scott, *Recollections of a Naval Life*, 3: 281–282; George, *Terror on the Chesapeake*, 93; Morriss, *Cockburn and the British Navy*, 106; Latimer, *1812: War with America*, 311.

Figure 20. William Barritt, *March of the British Army from Benedict to Bladensburg*, from Benson J. Lossing, *The Pictorial Field Book of the War of 1812* (New York: Harper and Brothers, 1868), 929. Public Domain.

Ross's prudence: "he [Ross] was very cautious in responsibility—awfully so, and lacked that dashing enterprise so essential to carry a place by a *coup de main*."[173] Cockburn wore Ross down with the ideas that the larger American militia were no match for disciplined British troops and that they had come so close to inflicting a devastating victory.[174] Ross relented and ordered the march.

Reports of British activity in the area soon made their way to the American high command, who realized too late they should have reinforced the capital. Winder could hardly predict where Ross would attempt to cross the Anacostia River moating Washington, D.C.—at the lower bridge near the Navy Yard or at the upper bridge near the port of Bladensburg?[175] On 24 August, intelligence that Ross and Cockburn were marching toward Bladensburg triggered Brigadier General Tobias Stansbury to order his Baltimore regiment, Winder to direct his district militia, and belatedly Barney to send marines to Bladensburg and defend the bridge.[176] Madison and Armstrong would inspect the defenses and watch the proceedings. British and American regiments were ill-prepared to fight a battle in 90- to 104-degree heat; however, Ross was decisive, and his troops were disciplined to make it across the narrow bridge under heavy fire from the hill opposite and route local forces, capture cannons, and pursue snipers hiding in the lush terrain.[177] Winder ordered a general retreat and advised Madison to flee the area or face capture; this left only Barney and his flotilla men (Captain Samuel Miller and his marines) behind a single battery to inflict damage on redcoats approaching from the bridge. Ross eventually extinguished this last threat by ordering the 85th Regiment to take the gun mound from the right; Barney fell with his horse, took a bullet in the thigh, and was captured.[178] When the firing finally ceased around 4 p.m., the British counted 250, the Americans 70, killed and wounded.[179] Having won the battle, Ross was resolved to allow his troops two hours' rest before pressing on to the capital six miles southwest.

[173] Smith, *The Autobiography of Lieutenant-General Sir Harry Smith*, 1: 197.

[174] Scott, *Recollections of a Naval Life*, 3: 283–284.

[175] George, *Terror on the Chesapeake*, 92.

[176] Arthur Brooke in George, "The Family Papers of Maj. Gen. Robert Ross," 302; Smith, *The Autobiography of Lieutenant-General Sir Harry Smith*, 1: 198; Hickey, *The War of 1812: A Forgotten Conflict*, 205; Joshua Barney to William Jones, 29 August 1814, in William S. Dudley and Michael J. Crawford, eds., *The Naval War of 1812: A Documentary History*, 3 vols. (Washington, D.C.: Naval Historical Center, Department of the Navy, 1985–2002), 3: 207.

[177] Scott, *Recollections of a Naval Life*, 3: 285–291, 295–296; Arthur Brooke in George, "The Family Papers of Maj. Gen. Robert Ross," 302–303; Smith, *The Autobiography of Lieutenant-General Sir Harry Smith*, 1: 199–200; George, *Terror on the Chesapeake*, 94, 96, 98. Benyon, Journal kept during the years 1813–14, n.d., 162, Western Reserve Historical Society, Cleveland, served on board H.M.S. *Menelaus* as it went up to Annapolis and noted that on 18 August 1814 "the thermometer stood in the sun at 104. and 90 in the shade," and despite this he was obliged to forage for food along the shore.

[178] Joshua Barney to William Jones, 29 August 1814, in Dudley and Crawford, eds., *The Naval War of 1812*, 207–208; Scott, *Recollections of a Naval Life*, 3: 290–292, 295.

[179] Hickey, *The War of 1812: A Forgotten Conflict*, 206; George, *Terror on the Chesapeake*, 102; Morriss, *Cockburn and the British Navy*, 108; Latimer, *1812: War with America*, 315, estimated that 249 British were killed or wounded and 77 Americans were killed or wounded.

Had Winder been willing to coordinate his troops with Lieutenant Colonel Jacint Lavall's light cavalry and Brigadier General Walter Smith's local militia, he might have repelled or at least stalled the British as they approached Washington, D.C. But he inexplicably ordered his men to withdraw to the Georgetown heights, at which point they broke ranks, hid, or fled, causing the citizenry to bolt their doors or gather their belongings for departure.[180] Mordecai Booth, a clerk in the Navy Department, drew up a detailed report to Commodore Thomas Tingey, in which he related his consternation at the lack of collective resolve to defend the capital: "I blush Sir! to tell you—I saw the Commons Covered with the fugitive Soldiery of our Army—running [sic], hobling [sic], Creaping [sic], & appearently [sic] pannick [sic] struck—One solitary company Only . . . that was formed—I was told the Army had rallied at the Capitol. . . . With this impression—I received your order to go to the Capitol, for intelligence.—I went but found only men who had been dispersed, resting—Principally I conceived, Barney's Flotilla Men—The Citizen-Militia had Chiefly taken refuge at their houses—as I saw Officers, as well as men at their doors—"[181] Nor was there any point to rallying around the Executive Mansion, for Madison and his assistants returned only to grab a few items and to seek refuge in Virginia. This withdrawal of military and political authority would occasion much finger pointing on the part of the nation's representatives and recrimination on the part of the local citizenry.

[180] Louis Barbe Charles Sérurier to Charles Maurice de Talleyrand, 22–26 August 1814, 39CP: Correspondance Politique États-Unis, vol. 71, page 161, Archives du Ministère des affaires étrangères, La Courneuve; A Traveller [pseud. Ann Royal], *Sketches of History, Life, and Manners in the United States* (New Haven, 1826), 172, in "Works of Art Destroyed by Fire: Portraits of Louis XVI and Marie-Antoinette" file, Curatorial Department, Office of the Architect of the Capitol, Washington, D.C.

[181] Mordecai Booth to Thomas Tingey, 24 August 1814, in Dudley and Crawford, eds., *The Naval War of 1812*, 209–210.

Evacuation and
Invasion of the Capitol

Congress would have been singularly unprepared for an assault on the Capitol, which at that time consisted of two free-standing pavilions joined by a raised wooden thoroughfare running north to south on Capitol Hill. Surveyor of Public Buildings Benjamin Latrobe prepared a watercolor image for Jefferson to give a sense of how the structure might look if the temporary wooden passage were pulled down and the planned rotunda built in its place (figure 21). As it was, Congress had to make do with two imposing wings five bays wide and seven deep, articulated with Corinthian pilasters and crowned with a heavy balustrade. The delegates had been in recess for most of August, leaving only a few staff to impress men and vehicles into service for the conveyance of important letters, documents, records, and books out of the area.[182] Patrick Magruder, clerk of the House of Representatives, later reported that he had been absent from his post owing to a prior indisposition but had left "the [assistant] clerks in charge of the office, with instructions as to their official duties."[183] Two of these clerks, S. Burch and J. T. Frost, explained in turn that "every clerk of the office" had been "taken into the field . . . and marched to meet the enemy."[184] Frost alone remained behind, and Burch had to obtain a

[182] Charles J. Ingersoll, *Historical Sketch of the Second War between the United States of America and Great Britain Declared by Act of Congress, the 18th of June 1812 and Concluded by Peace, the 15th of February 1815*, 2 vols. (Philadelphia: Lea and Blanchard, 1845–49), 2: 185, recalled "The clerks, door-keepers and officers [of the Capitol] were most of them absent under arms, or had fled. Two days before the capture, one of them, more provident than the rest, removed a cart-load of papers and documents out of town to a place of concealment in safety. But for the most part the halls of legislation, with their appurtenances, were derelict, without superintendent, occupant or care. . . . The particulars of the destruction of the Capitol it is almost impossible to obtain. After diligent inquiry, I can find no one within sight, such was the terror of all."

[183] Patrick Magruder, Report to the Speaker of the House of Representatives dated 20 September 1814, Thirteenth Congress, Third Session, House of Representatives, 22 September 1814, in *The Debates and Proceedings in the Congress of the United States, 1789–1824* (Washington, D.C.: Gales and Seaton, 1854), 305–306, in "Annals of Congress: Debates and Proceedings, 1789–1824," Library of Congress, accessed 11 November 2015, https://memory.loc.gov /ammem/amlaw/lwac.html; also see House of Representatives Proceedings, 22 September 1814, *Journal of the House of Representatives of the United States*, 9: 454, in "A Century of Law-making for a New Nation: U.S. Congressional Documents and Debates, 1775–1875," Library of Congress, accessed 11 November 2015, http://memory.loc.gov/ammem/amlaw/lwhjlink .html#anchor13.

[184] S. Burch and J. T. Frost, Report to Patrick Magruder, 15 September 1814, in *The Debates and Proceedings in the Congress of the United States, 1789–1824* (Washington, D.C.: Gales and Seaton, 1854), 306, in "Annals of Congress: Debates and Proceedings, 1789–1824," Library of Congress, accessed 11 November 2015, https://memory.loc.gov/ammem/amlaw/lwac.html.

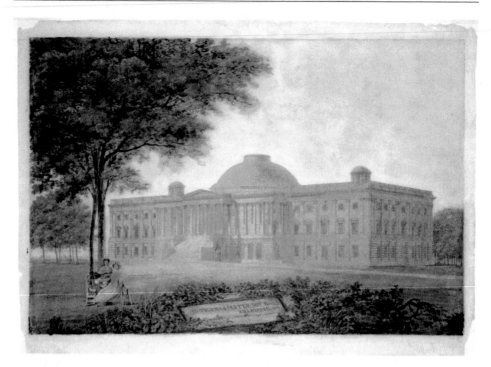

Figure 21. Benjamin Henry Latrobe, *United States Capitol Viewed from the Northeast* [with conjectural completion of Rotunda], 1806. Watercolor, ink, and wash on paper. 49 × 59 cm. Prints and Photographs Division, Library of Congress, Washington, D.C. Public Domain.

special furlough "for the purpose of returning to the city, to take care of, and save such part of the books and papers of the Clerk's office, as he might be able to effect, in case the enemy should get possession of the place."[185] Even with these men on the scene, the military high command would not allow them to start packing up things until noon on 22 August, by which time they found it nearly impossible to locate a wagon, cart, or carriage that had not been commandeered by the army or piled with the possessions of civilians intent on fleeing the city.[186] Eventually the clerks were able to secure a cart and four oxen from John Wilson, who lived some six miles outside the city, and over twenty-four hours they filled and refilled it with "the most valuable records and papers" destined for "a safe and secret

[185] S. Burch and J. T. Frost, Report to Patrick Magruder, 15 September 1814, in *The Debates and Proceedings in the Congress of the United States, 1789–1824* (Washington, D.C.: Gales and Seaton, 1854), 306, in "Annals of Congress: Debates and Proceedings, 1789–1824," Library of Congress, accessed 11 November 2015, https://memory.loc.gov/ammem/amlaw/lwac.html.

[186] Mordecai Booth to Thomas Tingey, 10 September 1814, in Ray W. Irwin, "The Capture of Washington in 1814 As Described by Mordecai Booth, with Introduction and Notes," *Americana* (January 1934): 9–12, describes the difficulty obtaining wagons for the removal of powder and public stores from the Navy Yard in his capacity as a clerk of the Navy Department.

place in the country."[187] However, they were frustrated that a lack of vehicles kept them from saving "Everything belonging to the office, together with the library of Congress [in the north pavilion] . . ."[188] Among the documents left behind were the secret journal of Congress, petitions of citizens, and accounts, receipts, and vouchers of the House clerk.[189]

The clerks of the Senate must have undertaken similar measures for the preservation of the legislators' effects, although I have been unable to locate any official or comprehensive account. Lewis Machen, an engrossing clerk, recalled that "With the aid of the messenger of the office . . . and the Waggoner [sic], I engaged in removing from the Office all the Books and papers of the office which I considered of more value: and when the sun was nearly setting, our vehicle being able to contain no more, I departed with it for my residences in the country."[190] He identified as the messenger African American Tobias Simpson, who was later compensated $200.00 "for his exertions to save the public property in the Capitol both before and after the destruction thereof by the enemy."[191] Senate records indicate that citizens were willing to lend a hand in preserving the property of the Capitol: Henry Hines was compensated $5.50 for the "hire of self, horse, cart, [for] 2 ¾ days collecting public property removed from [the] Capitol . . ."; Abraham Bessford $20.00 and Mark Remick $36.00 for "saving from the Capitol. . .a large trunk filled with silk curtains . . . being 24 pieces estimated at $600 . . ."[192] The high value attributed to window dressings of the period is affirmed by Dolley Madison's decision to flee the executive mansion with a box of red velvet hangings acquired for the drawing room as the Battle of Bladensburg was raging; these, along with silver, two eagle ornaments, books, documents, and Gilbert Stuart's full-sized

[187] S. Burch and J. T. Frost, Report to Patrick Magruder, 15 September 1814, in *The Debates and Proceedings in the Congress of the United States, 1789–1824* (Washington, D.C.: Gales and Seaton, 1854), 307, in "Annals of Congress: Debates and Proceedings, 1789–1824," Library of Congress, accessed 11 November 2015, https://memory.loc.gov/ammem/amlaw/lwac.html.

[188] S. Burch and J. T. Frost, Report to Patrick Magruder, 15 September 1814, in *The Debates and Proceedings in the Congress of the United States, 1789–1824* (Washington, D.C.: Gales and Seaton, 1854), 307, in "Annals of Congress: Debates and Proceedings, 1789–1824," Library of Congress, accessed 11 November 2015, https://memory.loc.gov/ammem/amlaw/lwac.html.

[189] See George C. Hazelton, *The National Capitol: Its Architecture, Art and History* (New York: J. F. Taylor and Company, 1897), 36, who stated "The Congressional Library, and the secret journal of Congress . . . were consumed in the building itself, together with many private papers, petitions, valuable effects and the private accounts and vouchers of Patrick Magruder, Clerk of the House of Rep[resentative]s . . ."

[190] Lewis Machen quoted in "August 1814: Saving Senate Records," U.S. Senate Website, accessed 15 September 2015, https://www.senate.gov/artandhistory/history/common/generic /Origins_SavingSenateRecords1814.htm#:~:text=When%20British%20forces%20attacked%20 the,Senate%20messenger%20named%20Tobias%20Simpson.

[191] Record of compensation for Tobias Simpson, in SEN 13A-D2 Memoranda of Bills and Resolutions Examined, Presented and Approved, Records of the U.S. Senate 13th Congress, RG 46, box 10, National Archives, Washington, D.C.

[192] Superintendent of the City of Washington to Henry Hines, 8 October 1814, in Accounts of 1 July 1813 to 1 July 1815, Thomas Munroe to Abraham Bassford, 21 September 1814, Abraham Bassford to Mark D. Remick, 24 September 1814, in Miscellaneous Treasury Records, National Archives, in "Burning of the Capitol" file, Office of the Architect of the Capitol, Washington, D.C.

canvas *George Washington* (1796) she entrusted to banker Jacob Barker and his friend Robert de Peyster for safekeeping, and they managed to move them safely to a farm north of Georgetown.[193]

As the leader of the White House salon of socially and politically prominent women, the First Lady probably led a discussion of methods to safeguard government and household property in the event of a foreign invasion, which saw her actions repeated throughout the district.[194]

It can be surmised that while the governing class attributed value to textiles and metalwork as luxury items, to books and documents as important tools of statecraft, and to state portraits as somewhere between the two, the Capitol volunteers were so focused on gathering up tomes, papers, and silk window dressings in the Senate Chamber that they had to leave the cumbersome *Louis XVI* and *Marie-Antoinette* with surrounds in an adjoining committee room (figure 22).[195] A year earlier, Senator King had successfully rallied Federalists and counter-administration Republicans to support a motion to direct sergeant-at-arms Mountjoy Bayly to install the Callet and Vigée Le Brun copies "in one of the committee rooms of the Senate, causing the portraits to be first cleaned and repaired by a person skillful in such business."[196] As I have argued elsewhere, the portraits would have served the mature Federalists as a sign of former legislative and diplomatic achievements and current threats of republican extremism, which defined them as a pro-British party.[197] Margaretta Lovell suggests in a more general sense that portraits of public figures reminded early American viewers of civic order, heroic sacrifice, and public virtue.[198] Common sense would have prescribed that full-length portraits of Louis XVI and Marie-Antoinette with elaborate frames some thirteen feet in height be placed in the largest of four committee rooms—the

[193] William Seale, *The President's House: A History*, 2 vols (Washington, DC: White House Historical Association, 1986), 1: 123, 126, 133–134; Walter Lord, *The Dawn's Early Light* (New York: W. W. Norton and Company, 1972), 171. On the high cost of fabrics, especially an abundant drape or special weave for the bedroom, see Marla Miller, *Betsy Ross and the Making of America* (New York: Henry Holt and Company, 2010), 63, 73–74, 139, 141, 158. François Furstenberg, *When the United States Spoke French: Five Refugees Who Shaped a Nation* (New York: The Penguin Press, 2014), 101–102, 130–131, 133, 136, observes that American elites of Washington, D.C., like their Philadelphia counterparts, were becoming familiar with a range of French social customs and material culture through the influx of continental nobility and artisans into their cities between the French Revolution and the Bourbon Restoration; association with French elites, adoption of manners and customs, and consumption of luxurious fashions, furnishings, and foods became signs of social distinction. Seale, *The President's House*, 1: 123, points out that although "Mrs. Madison would probably have demanded French furniture, . . . Latrobe convinced the President's wife otherwise," that "court finery" was inappropriate for signifying the American republic, and had furniture made to his designs in the English "Grecian" style.

[194] Branson, *These Fiery Frenchified Dames*, 149.

[195] Hickey, *The War of 1812: A Forgotten Conflict*, 206; Ingersoll, *Historical Sketch of the Second War*, 2: 185.

[196] Senate Proceedings, 1 August 1813, *Journal of the Senate*, 1820–1874, 5: 365.

[197] See Larkin, "The U.S. Congress's State Portraits of Louis XVI and Marie-Antoinette," 29, 34, 35.

[198] Lovell, *Art in a Season of Revolution*, 11.

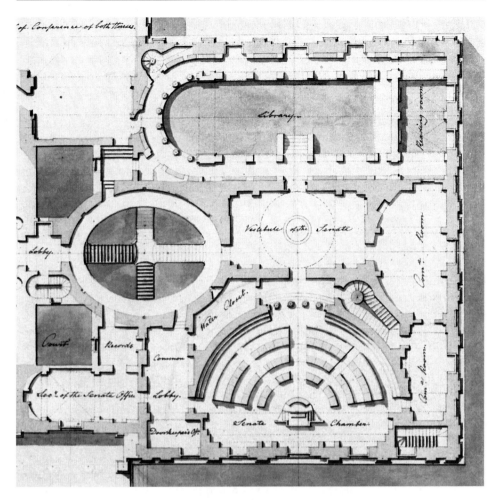

Figure 22. Benjamin Henry Latrobe, *Plan of the Principal Story of the Capitol U.S.* (detail), ca. 1806. Graphite, ink and watercolor on paper, 49.5 × 75.5 cm. Prints and Photographs Division, Library of Congress, Washington, D.C. Public Domain.

elliptical space between the Senate Chamber and the Library at the north end of the main floor. This would have made them less immediately visible and accessible but not impervious to vandalism or theft.

British forces reached the outskirts of Washington at 8 p.m. on 24 August. Ross led a brigade of about 1,500 men, comprised of the 21st Regiment, the Royal Marines, and Colonial Marines (former slaves), supported by Cockburn and his seamen.[199] Cockburn approached the government buildings and citizen

[199] Morriss, *Cockburn and the British Navy*, 108; Pack, *The Man Who Burned the White House*, 13–14; George, *Terror on the Chesapeake*, 105.

residences in the same manner he approached fortified camps and unprotected towns throughout the Chesapeake region—as pretentious products of republican governance and potential nests for insurgents. But Ross had to give the word for them to be destroyed and for this reason remained alert to every unwarranted encroachment. As Smith recalled, "we entered Washington for the barbarous purpose of destroying the city. Admiral Cockburn would have burnt the whole, but Ross would only consent to the burning of the public buildings. I had no objection to burn[ing] arsenals, dockyards, frigates building [i.e., under construction], stores, barracks, etc., but well do I recollect that, fresh from the Duke's humane warfare in the South of France, we were horrified at the order to burn the elegant Houses of Parliament [sic] and the President's house."[200] Cockburn added a dose of tactical and ideological meanness in encouraging petty theft and big burns to suppress any element of resistance to occupation and to punish the Madison administration for embarking on such a reckless course of foreign policy. As Ross, Cockburn, their staff, and guard advanced, they found the city eerily empty as if it had been abandoned. It was only when the British commanders ascended Capitol Hill behind a flag of truce and they encountered sniper fire, killing Ross's horse and perhaps one of the guard, that the commanders ordered a raid of nearby houses, including the Sewall house, which, though found to be devoid of snipers, was set ablaze.[201] The great conflagration had begun. Ross ordered his troops to form a line facing the Capitol and to fire at the windows; when the shots were not returned, he judged it safe to investigate.[202] In short order, Lieutenant George de Lacy Evans put a party to work breaking down the doors of the Capitol, roaming through halls and chambers, picking up souvenirs, and setting the structure ablaze. Because he had already been rebuked once by the Admiralty for heavy-handed tactics, Cockburn made a point of justifying an attack on the Capitol, as he reported the events to Cochrane three days later: "It was . . . dark before we reached that City, and on the General, myself and some officers advancing a short way past the first Houses of the Town without being accompanied by the Troops, the Enemy opened upon us a heavy fire of Musquetry [sic] from the Capitol and two other houses, these were therefore almost immediately Stormed by our People, taken possession of, and set on fire, after which the Town submitted without

[200] Smith, *The Autobiography of Lieutenant-General Sir Harry Smith*, 1: 200.

[201] Morriss, *Cockburn and the British Navy*, 108, states that one of the first houses sheltered snipers, but there was little further resistance; Arthur Brooke, 24 August 1814, in George, "The Family Papers of Maj. Gen. Robert Ross," 303, mentions that only Ross's horse was killed; Pack, *The Man Who Burned the White House*, 16, estimates the loss as minimal: Ross's horse and one of the guard; Latimer, *1812: War with America*, 316, follows the recollections of Corporal David Brown of the 21st Fusiliers that Ross's horse and two corporals were killed; George, *Terror on the Chesapeake*, 105–107, mentions that in addition to the death of Ross's horse and one man, wounds were sustained by four soldiers.

[202] George, *Terror on the Chesapeake*, 105–107; Lord, *The Dawn's Early Light*, 162–163, states that "the practical purpose [of deploying the 3rd Brigade into a line and firing a volley into the windows of the eastern façade of the Capitol] was, of course, to discourage any further sharpshooting [from the hill?], but it all seemed symbolic as well. It served as a formal announcement that this citadel of republicanism was being officially possessed in the name of His Majesty the King"; Latimer, *1812: War with America*, 317, agrees: "they fired a volley to deter any remaining sharpshooters, then advanced to complete its [the Capitol's] destruction."

further resistance."[203] The convoluted nature of the account—the exaggeration of sniper fire and the central position accorded the Capitol building within it—suggests that the admiral was frustrated at not having been able to apprehend the hill defender(s) and wished to link the sniper fire to a public monument.

As the years passed, the burning of the public buildings of Washington, D.C., became the subject of much recrimination as veterans wrestled over an exact sequence of events in their memoirs of the 1820s and 1830s. Royal Navy Captain Edward Pelham Brenton declared as a simple matter of fact that "A little musketry from one of the houses in the town, which killed the General's horse, was all the resistance they met with. This was quickly silenced; the house burnt; and the people within it put to death."[204] Nobody had actually been found within the house when it was torched. Indignant at this narrative, Captain James Scott exaggerated the level of resistance: "We [Ross, Cockburn and their adjutants] were just on the point of entering the open space where the Capitol stood, and abreast of a large house on our left, (I believe an hotel,) and Mr. Gallatin's, on our right, when we were assailed by a volley from three hundred men who had sheltered themselves in the Capitol, and a cross fire from the houses on either side of us. The General's horse was killed on the spot, and several of the guard that accompanied us. After this wanton display of irritating hostility, the Americans cheered, and retreated down the Capitol hill . . ."[205] Hundreds of men shooting from the Capitol would surely have hit more than a horse and a guard; they would have done a great deal of damage to surrounding homes. There is no bilateral agreement that any gunshot came from the Capitol. I am inclined to accept reports of the time that no shots came from there. Booth noted that after Winder's defeat at Bladensburg in late afternoon, he found about 250 to 300 men resting near the structure, but that at nightfall, he and a Mr. Cox passed

[203] George Cockburn to Alexander Cochrane, 27 August 1814, in "Letters sent by Gen. Cockburn Esq. R.N. from the 28th of April 1794 to the 25th of February 1807," Papers of George Cockburn, Manuscript 17,576, Reel no. 6, Document no. 40, microfilm Manuscript Division, Library of Congress, Washington, D.C.; Robert Ross to Henry Bathurst, 30 August 1814 in Dudley and Crawford, eds., *The Naval War of 1812*, 3: 224, reported the destruction of public buildings impassively: "Judging it of consequence to complete the Destruction of the Public Buildings with the least possible delay, so that the Army might retire [from Washington, D.C.] without Loss of time, the following Building[s] were set Fire to and consumed: the Capital [sic], including the Senate House and House of Representation [sic], the Arsenal[,] the Dock-Yard, Treasury, War Office, President's Palace, Rope Walk, and the Great Bridge across the Potowmack[sic]. . . . The Object of the Expedition being accomplished, I determined, before any greater Force of the Enemy could be assembled, to withdraw the Troops, and accordingly commenced retiring on the Night of the 25th . . ."

[204] Edward Pelham Brenton, *The Naval History of Great Britain from the Year MDCCLXXXIII to MDCCCXXII*, 5 vols. (London: C. Rice, 1823–25), 5: 166. George Robert Gleig, *A Narrative of the Campaigns of the British Army at Washington and New Orleans Under Generals Ross, Pakenham, and Lambert in the Years 1814 and 1815 with Some Account of the Countries Visited*, 2nd ed. (London: John Murray, 1821), 125–126, squares with Brenton's account: "scarcely had the party bearing the flag [of truce] entered the street, than they were fired upon from the windows of one of the houses, and the horse of the General himself, who accompanied them, killed. . . . All thoughts of accommodation were instantly laid aside; the troops advanced forthwith into the town, and having first put to the sword all who were found in the house from which the shots were fired, and reduced it to ashes, they proceeded, without a moment's delay, to burn and destroy every thing in the most distant degree connected with government. In this general devastation were included the Senate-house, the President's palace, an extensive dock-yard and arsenal . . ."

[205] Scott, *Recollections of a Naval Life*, 3: 298.

"the north end of the Capitol that we might see if anyone was there. We saw *not one soul*."[206] The French ambassador, Louis Barbe Charles Sérurier, who remained behind in the Octagon House (at New York Avenue and 18th Street) in Washington, wrote to Louis XVIII's foreign minister, the prince de Talleyrand, in Paris, that the British attacked the Capitol at 9 p.m. without opposition.[207] This position was maintained by Madison and Monroe in their proclamation—which sought to turn public indignation at having been abandoned by the government into anger at the liberties taken by the enemy—reproduced in the *National Intelligencer* a few days later: "they [the enemy] wantonly destroyed the public edifices having no relation in their structure to operations of war, *nor used at the time for military annoyance*; some of these edifices being also costly monuments of taste and of the arts, and others depositories of the public archives, not only precious to the nation as the memorials of its origin and its early transactions, but interesting to all nations, as contributions to the general stock of historical instruction and political science . . ."[208] Most Americans would have found belligerent repurposing of the twin deliberative houses inconsistent with their dignified appearance and dialogic function.

Upon entering the Capitol, the British troops were surprised to find assembly rooms more commodious and better appointed than those of their own parliamentarians, which seemed to elevate the impertinent republic to a level above that of a formidable empire. Scott was censorious of the spectacle: "the interior accommodations were upon a scale of grandeur and magnificence little suited to pure republican simplicity. We might rather have been led to suspect that the nation, whose councils were held beneath its roof, was somewhat infected with an unseemly bias for monarchical splendor . . ."[209] It was a judgment at odds with Latrobe's late neoclassical architecture whose lines—a continuous colonnade raised on a podium for the representatives and a concave wall surmounted by a half dome for the senators—kept pace with developments in France. Gleig was full of admiration: he recorded in his diary that the north wing contained a "handsome spiral hanging staircase," a "magnificent apartment" for the Senate and a large "public library" as well as "several smaller rooms, fitted up as offices . . . branching off from them."[210] If Gleig had determined to inspect the committee rooms, he would surely have come upon the state portraits of Louis XVI and Marie-Antoinette, but he does not mention them or any other work of art or furnishing. Believing that only European powers deserved such grand settings, Scott found it entirely appropriate that Americans should be divested of these signs of legitimacy, which would be "a severe blow to their pride."[211] In other words, the British officers were embarrassed that their own administrative buildings and the political culture within had appeared

[206] Mordecai Booth to Thomas Tingey, 10 September 1814, in Irwin, "The Capture of Washington in 1814," 14, 18.

[207] Louis Barbe Charles Sérurier to Charles Maurice de Talleyrand, 22–26 August 1814, 39CP, Correspondance Politique États-Unis, Vol. 71, page 162, Archives du Ministère des affaires étrangères, La Courneuve.

[208] James Madison and James Monroe, "A Proclamation," in *National Intelligencer*, 3 September 1814, 2, emphasis added.

[209] Scott, *Recollections of a Naval Life*, 3: 300.

[210] Gleig, *A Narrative of the Campaigns of the British Army*, 134.

[211] Scott, *Recollections of a Naval Life*, 3: 322.

not to have evolved as far as the Americans'. Madison's insistence that any peace settlement had to acknowledge the United States' right to be treated with the dignity due an independent nation and that the public buildings of its capital were monuments of taste and the arts touched a nerve rooted in a fear that the empire would fall apart if the trend toward republican self-governance continued.

As he dallied for an hour at the Capitol, Cockburn seems to have followed the First Lady and the Legislative clerks in identifying the most valuable material objects, though this time with the intention of consigning them to the pyre. Consistent with British military practice, he approved the appropriation of trivial objects as souvenirs. Ransacking the President's ceremonial office, he settled on Madison's leather-bound copy of a printed summary of the Treasury's expenditures, which he would later pass on to his elder brother, James, 9th baronet of Langton and governor of Bermuda.[212] Inspecting the president's mansion accompanied by local book dealer Roger Chew Weightman, he settled upon what the *National Intelligencer* called "sundry articles of trifling value"—perhaps a hat belonging to Madison and a cushion from Dolley Madison's chair—and proceeded to exhibit these prizes in the streets with "a gross levity of manner."[213] This selection encouraged the soldiers to behave in a similar fashion, snagging minor pieces for themselves and pitching major ones on the pyre. There were exceptions to this practice, however. Lieutenant Beauchamp Colclough Urquhart made off with a ceremonial sword.[214] Physician James Ewell, whose house was requisitioned by the British for their headquarters, was informed by a servant that soldiers had plundered "some of my furniture, apparel and plate."[215] According to Bermuda

[212] Latimer, *1812: War with America*, 317, states that the book was inscribed *An Account of the Receipts and Expenditure of the United States for the Year 1810* and was taken for no other reason than to prove that Cockburn had been in the president's office; the book can be found on the Library Congress Website at https://www.loc.gov/item/myloc1/.

[213] Lord, *The Dawn's Early Light*, 168; Pack, *The Man Who Burned the White House*, 19. *National Intelligencer*, 31 August 1814, 1, in Readex: America's Historical Newspapers (accessed 3 October 2017); also see Seale, *The President's House*, 1: 135; Hickey, *The War of 1812: A Forgotten Conflict*, 208; *Philadelphia Aurora*, 27 and 30 August 1814; Margaret Bayard Smith to Jane Kirkpatrick, 30 August 1814, in Bayard Smith, *The First Forty Years of Washington Society, Portrayed by the Family Letters of Mrs. Samuel Harrison Smith (Margaret Bayard)*, ed. Gaillard Hunt (New York: C. Scribner's Sons, 1906), 113; George, *Terror on the Chesapeake*, 109; Latimer, *1812: War with America*, 319.

[214] Lord, *The Dawn's Early Light*, 168.

[215] James Ewell, *The Medical Companion . . . A Dispensatory and Glossary. . .A Concise and Impartial History of the Capture of Washington* (Philadelphia: Anderson and Meehan, 1816), 637–638, 652; Anon., *The Washington Guide*, 2nd ed. (Washington, D.C.: S. A. Elliot, 1826), 50, in "Works of Art Destroyed by Fire: Portraits of Louis XVI and Marie-Antoinette" file, Curatorial Department, Office of the Architect of the Capitol, Washington, D.C., noted: "Several houses were plundered by the [British] soldiers and negroes, amongst which were—Mr. A. McCormick's, Mr. D. Rapine's, Mr. W. Elliot's . . ." George, *Terror on the Chesapeake*, 110, states that Ross ordered a number of enlisted men to be flogged for looting. On 17 September 1814, a property owner who styled himself "Omega" wrote a letter to the editor of the *National Intelligencer* (20 September 1814), p. 1, in which he deplored not only Cockburn's torching the Capitol and President's House but also the theft of "private or public property," which he was unable to recover despite *"my very humble solicitations"*; despite finding "one of the British officers (a Lt. Mitchell of the Royal Artillery)" in possession of my property, he "would not even afford me the trifling satisfaction of informing me *to whom I was indebted for the loss.*"

military tradition, Cockburn impounded two pairs of state portraits of George III and Charlotte from "some warehouse" in Washington, D.C., placed them on his southeast bound flagship *Euryalus*, and presented them to the Corporations of St. George and Hamilton in Bermuda.[216] Although the account has not been substantiated by an original document (e.g., rear-admiral's report, ship's manifest), one pair of the Ramsay type were presented to the Corporation of Hamilton (though by George's elder brother, Sir James Cockburn, at the end of his tenure as Governor of Bermuda in 1819) and one pair of the Reynolds type currently hang in the Assembly at Hamilton.[217]

But the chief purpose of taking the public buildings, as Ross wrote to the Earl Bathurst some days after, was to burn them "with the least possible delay so that the Army might retire" to the boats.[218] Lieutenant George de Lacey Evans organized the labor, and Lieutenant George Pratt engineered the ignition of the two stone blocks.[219] Historians have suggested that citizens who lived nearby persuaded Ross to burn rather than blow up the structure so that the debris would not injure their own habitations.[220] He seems to have accommodated them, for in a letter to Jefferson, Latrobe stated that the occupiers initially set their sights on the House of Representatives but had so much difficulty igniting it by firing rockets through the roof that "at last they made a great pile in the center of the room of the furniture [i.e. desks, tables, and chairs] and retiring set fire via rockets to [fired rockets into] a large quantity of rocket stuff [powder mixed with a viscous binder] in the middle."[221] The result of this ignition was a blaze so intense that the glass lights were melted, the colonnade and entablature abraded, and the freestone and sandstone walls cracked, though the arches and vaults held.[222]

[216] Thomas Melville Dill, "Bermuda and the War of 1812," *Bermuda Historical Quarterly*, 1, 3 (July–Sept 1944): 145, commented on the veracity of the rumor that George Cockburn discovered two pairs of life-size portraits of George III and Charlotte in Washington, D.C., "I give this account of the works of art with some diffidence as I cannot vouch for the correctness of my memory, or for the truth of the story. . . ." Scott, *Recollections of a Naval Life*, 3: 103 footnote, suggests that burning warehouses—including Mr. Stump's warehouse at Havre de Grace on 8 May 1813—was a typical activity for British troops in the Chesapeake.

[217] Smart, *Allan Ramsay*, 119 (no. 192ea), observes that Sir James Cockburn presented (undated) Ramsay portraits of the king and queen to the Corporation of Hamilton at the end of his tenure as governor of Bermuda in 1819; the Assembly at Hamilton currently displays a Reynolds pair of uncertain origins.

[218] Robert Ross to Henry Bathurst, 30 August 1814, in Dudley and Crawford, eds., *The Naval War of 1812*, 224.

[219] Latimer, *1812: War with America*, 317.

[220] George, *Terror on the Chesapeake*, 107.

[221] Benjamin Henry Latrobe to Thomas Jefferson, 12 July 1815, in "Works of Art Destroyed by Fire: Portraits of Louis XVI and Marie-Antoinette" file, Curatorial Department, Office of the Architect of the Capitol, Washington, D.C.; also see Margaret Bayard Smith to Jane Bayard Kirkpatrick, August 1814, in Bayard Smith, *The First Forty Years of Washington Society*, 102.

[222] Margaret Bayard Smith to Jane Bayard Kirkpatrick, August 1814, in Bayard Smith, *The First Forty Years of Washington Society*, 109, stated: "The poor capitol! nothing but its blacken'd walls remained!. . . . Those beautiful pillars in the Representatives Hall were crack'd and broken, the roof, that noble dome, painted and carved with such beauty and skill, lay in ashes in the cellars beneath the smouldering [sic] ruins, were yet smoking."

The troops then crossed the 100-foot wooden bridge.[223] Tinged with regret, Gleig contributed to a similar incendiary effort in the Senate chamber. Latrobe would find the marble columns there "burnt to lime" and toppled over, though the elliptical walls still supported the ceiling.[224] Even with this damage, both chambers were better off than the Library, whose old wooden framework and combustible volumes burned intensely, fanned by a storm with hurricane force winds that appeared out of nowhere. There are no descriptions of the condition of the rooms adjoining the Senate Chamber, particularly the large committee room in the north or the small rectangular room in the northeast, but they must have been as hot as an oven.

The devastation could be seen from afar. Ewell wrote, "Never shall I forget my tortured feelings, when I beheld that noble edifice wrapped in flames, which, bursting through the windows and mounting far above its summits, with a noise like thunder, filled all the saddened night with a dismal gloom."[225] Cockburn, already compared to "Satan in his cloud" at Havre de Grace, was credited for the conflagration in London: for the Royal Academy exhibition of 1817, John James Halls represented the rear-admiral at full length wearing a plain uniform consisting of bicorn hat, dark navy coat with matching breeches, and hessian boots and standing resolutely on the road leading out of Washington, D.C., his sword sheathed and balanced like a walking stick to indicate a mission accomplished, and the Capitol and other public buildings issuing great flames and smokey plumes in the background (figure 23).[226] There is a strange disjunction between the resolute figure which bespeaks law and order and the burning monuments which conjure up mob rule and chaos. Comparison with Callet's portrait of Louis XVI in robes of state is

[223] Wilhelmus Bogart Bryan, *A History of the National Capital from Its Foundation through the Period of the Adoption of the Organic Act*, 2 vols. (New York: The Macmillan Company, 1914), 1: 454, observed that "After the year 1810 no further appropriations were made for the capitol building, and the two wings, practically completed and connected by a wooden covered way, were left until the return of more peaceful times and an improvement in the public finances, which were being drained to supply the army and the navy and to resist the growing encroachments of England"; Hazelton, *The National Capitol*, 32, stated that in 1811 the two wings were connected by means of a wooden bridge 100 feet in length.

[224] Report of Benjamin Henry Latrobe, n.d., in *Documentary History of the Capitol*, 1: 191–192, in "Works of Art Destroyed by Fire: Portraits of Louis XVI and Marie-Antoinette" file, Curatorial Department, Office of the Architect of the Capitol, Washington, D.C.; Latrobe, Report of 28 November 1816, 427–428, in "Works of Art Destroyed by Fire: Portraits of Louis XVI and Marie-Antoinette" file, Curatorial Department, Office of the Architect of the Capitol, Washington, D.C., communicated: "The north wing of the Capitol was left after the fire in a much more ruinous state than the south wing. The whole interior of the west side having been constructed of timber, and the old shingle roof still remaining over the greatest part of the wing, an intensity of heat was produced which burnt the walls most exposed to it, and, being driven by the wind into the Senate chamber, burnt the marble columns to lime, cracked everything that was of free-stone, and, finding vent through the windows and up the private stairs, damaged the exterior of the wing very materially ... Of the Senate chamber no parts were injured but such as were of marble or free-stone. The vault was entire [i.e., preserved in its entirety], and required no repair whatever."

[225] Ewell, *The Medical Companion*, 637.

[226] John O'Neil to unidentified friend in Baltimore, 22 May 1813, quoted in Scott, *Recollections of a Naval Life*, 3: 107.

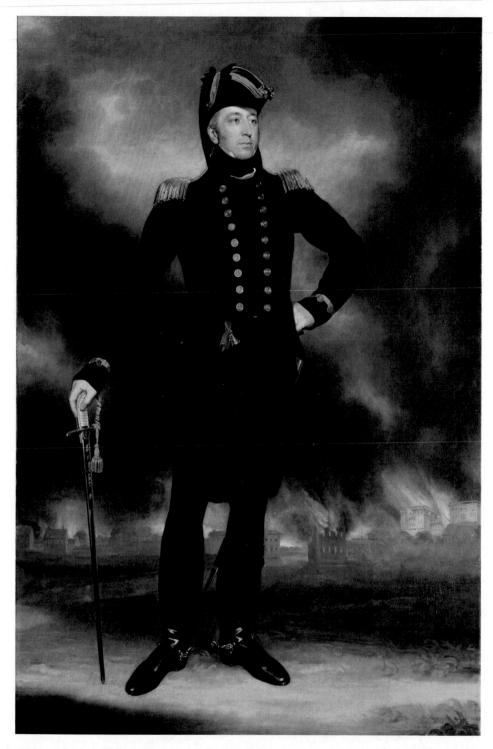

Figure 23. John James Halls, *Rear-Admiral George Cockburn*, 1817. Oil on canvas, 239 × 148.5 cm. National Maritime Museum, Greenwich, London. The History Collection / Alamy Stock Photo.

instructive: although both men have a proud bearing with their right hands balanced on a support and feet firmly planted, the French canvas employs monarchical pomp and symbols of justice and dominion to lend weight to American claims to sovereignty while the British canvas employs military might and signs of pillaging and burning to suggest the eradication of American self-governance. With the French king/portrait gone, there is nobody to protect the American people against the encroachment of the vengeful British admiral/portrait.

What the Ambassador Heard,
What the Justice of the Peace Saw

What happened to Congress' portraits of Louis XVI and Marie-Antoinette? The events that transpired prior to and following de Lacey Evans and Pratt's ignition of combustibles in the Senate Chamber are difficult to establish. It is certain that the royal images were hanging in a committee room—presumably the larger one, possibly the smaller—on the main floor at the time of conflagration and that only the gilded borders remained the day after the British had withdrawn from the city.

This is established on the basis of one Senate motion and two Treasury receipts. On 1 August 1813, Rufus King of New York had made a motion in the Senate to direct sergeant-at-arms Mountjoy Bayly "to remove the portraits of the King and Queen of France from the apartment in which they are now placed [presumably the Senate Chamber or contiguous recess], and to put them up in one of the committee rooms of the Senate, causing the portraits to be first cleaned and repaired by a person skillful in such business."[227] The motion was carried and Bayly apparently followed through, for there is a 25 September record of payment in the amount of $6.00 to one Alban Clarke for "painting under the King & Queen [of] France," which could refer to treatment of the discolored wall or wainscot against which the portraits formerly hung, the newly paneled chamber where they were about to hang, or, more daringly (through an accidental conflation of "over" and "under") filling in the pictures' abraded surfaces.[228] Pennsylvania Representative Charles Jared Ingersoll recalled that the royal portraits were located "in a room adjoining the Senate Chamber" at the time of the British storming of the Capitol.[229] On 28 September 1814, three days after the structure was burned, Thomas Munroe, superintendent of the City of Washington, noted a total payment of $11.00 for costs incurred by Bayly in arranging for Tobias (Simpson?) and eight men to remove "the frames of the pictures of the King & Queen of France"

[227] Senate Proceedings, 1 August 1813, *Journal of the Senate of the United States*, 1820–74, 5: 365.

[228] Mountjoy Bayly to Alban Clarke, 25 September 1813, Miscellaneous Treasury Accounts, General Accounting Office, Account of Expenditures on the Capitol #30,743 #39, Record Group 217, National Archives, Washington, D.C.

[229] Ingersoll, *Historical Sketch of the Second War*, 2: 185.

from Capitol Hill (presumably so that architect Benjamin Latrobe could get on with rebuilding the north wing).[230]

What happened to the canvases? Analysis of extant accounts of the British occupation of the capital and the forty-eight hours that followed as the Americans regained control of it suggest two possible fates: that they were either destroyed or stolen.

The case for destruction by the British is based on the dispatches of Sérurier, who was one of a few government officials to express concern that Washington was vulnerable to sacking and to remain at his embassy two blocks southwest of the Executive Mansion during occupation. On 26 August, he dispatched a letter to Talleyrand in which he confessed to shock and confusion about the sight of the public buildings aflame:

> to my great astonishment the capitol and the navy-yard and the fort of the point [i.e., the arsenal at Greenleaf Point] appeared to be on fire. It was impossible at first, with the flames darting about, to tell whether it was a general fire or only that of a public edifice. I never saw, Your Grace, a Scene at once more terrible and more magnificent. Y[our] H[ighness], knowing the picturesqueness and grandeur of the setting, can form an idea of it. A profound darkness reigned in the part of the city that I occupy and we were left to conjectures and to the lying reports of Negroes as to what was passing in the quarter illuminated by this frightful fire.[231]

The ambassador was clearly frustrated by a lack of information about the invaders' intentions. His distrust of African American accounts may spring from a variety of causes, including a deep-seated ambivalence about the status of slavery abolished under the French Directory in 1794 and revived under the Consulate in 1802 and suspicion that the British were emancipating (or promising to emancipate) slaves in order to render them effective informers or mis-informers, guides or soldiers to use against their former owners or overseers.[232] In the absence of official communiques, he may also have distrusted rumors from frightened citizenry, freedmen, and slaves who remained behind.[233] At last, Sérurier managed to send

[230] United States (Thomas Munroe) to Mountjoy Bayly, Record of payment, 28 September 1814, Miscellaneous Treasury Accounts, General Accounting Office, Account of Expenditures on the Capitol #30,743 #29, Record Group 217, National Archives, Washington, D.C.

[231] Louis Barbe Charles Sérurier to Charles Maurice de Talleyrand, 22–26 August 1814, 39CP: Correspondance Politique États-Unis, vol. 71, pages 162 verso and 163, Archives du Ministère des affaires étrangères, La Courneuve; Bryan, *A History of the National Capital*, 1: 627.

[232] George, *Terror on the Chesapeake*, 85, suggests that whites with British sympathies, intent on preserving local real estate holdings, or riven with poverty or infirmity, may have worked with Cockburn to identify important buildings or hidden valuables. Smith, *The Autobiography of Lieutenant-General Sir Harry Smith*, 1: 205, told of one occasion on which a slave carried a note between a British officer and an American informant. The *National Intelligencer*, 2 September 1814, 2, fed American readers with the conspiracy that insiders or moles facilitated the enemy's entry into Washington, D.C.

[233] Pack, *The Man Who Burned the White House*, 187, states that a Washington census conducted a few years after the British attack estimated the city population at 13,247—comprised of 9,607 white, 1,696 free blacks, and 1,944 slaves, while the total population of the District Columbia barely reached 33,000.

a representation to Ross and to secure a guarantee of diplomatic immunity for his residence as a manifestation of Louis XVIII's government.[234]

As the months passed, the ambassador came to accept African American accounts. In late December, he penned a letter to Talleyrand in which he declared that he was convinced that British officers had entered one of the minor rooms and vandalized one of the portraits:

> A hundred times I have witnessed among the misfortunes of the Bourbons, the emotion and the memories of gratitude which the portraits of Louis XVI and of the Queen sent as a present to Congress by His Majesty at the time of the war of independence and placed by him [sic, placed by Congress] in the Capitol [in 1800]. The Americans do not know this Prince by a name other than that of the first friend of the United States. A fact that says much undoubtedly, and which I did not report to Your highness in my letters of September, because I doubted it then but of which I have since discovered the authenticity, took place here on 24 August during the occupation of the Residence [of Congress] by the army Corps of G[ene]r[a]l Ross. The Portrait of His Majesty [Louis XVI] had been moved to a Room not yet furnished which the fire did not reach; At the time of the Army's departure it was still in this Room; but the excessive heat which had penetrated the walls melted the colors. It was found pierced with several Sabre thrusts, which the negroes attest to having seen carried out by English officers. I certify this fact to Your Highness . . .[235]

The last observation—that British officers took the opportunity during occupation of the Senate wing to run the French king's portrait through with a sword (or swords)—is significant, suggesting a determination to attack and disfigure a Catholic, male ruler regarded as partly responsible for facilitating American independence and alliance with France. Lauren Lessing, Nina Roth-Wells, and Terri Sabatos have usefully examined incidents of British officers attacking and disfiguring the portraits of prominent Americans whom they suspected of sewing revolution in March 1775; quartered in the homes of prominent Bostonians, these officers took the liberty of stabbing portraits of Reverend Samuel Cooper and Elizabeth Goldthwaite Bacon at strategic points along the body; in this way, they were able to appropriate the images of rebels and transform them through violent acts, thus asserting domination of their enemies both symbolically and militarily.[236] The difference is that whereas the Boston patriots were very much alive (and thus could be offended by the vandalism), the Bourbon monarch had been dead for more than twenty years (and could not). To offend American

[234] Louis Barbe Charles Sérurier to Charles Maurice de Talleyrand, 22–26 August 1814, 39CP: Correspondance Politique États-Unis, vol. 71, page 163, Archives du Ministère des affaires étrangères, La Courneuve; Miriam Greenblatt, *War of 1812* (New York: Facts on File, 2003), 7, states that "A few fortunate individuals managed to store their valuables in the house of French minister Louis Serurier, who held diplomatic immunity" and they were thereby preserved from theft or destruction.

[235] Louis Barbe Charles Sérurier to Charles-Maurice de Talleyrand-Périgord, 28 December 1814, 39CP: Correspondance Politique États-Unis, pages 309 verso – 310 verso, Archives du Ministère des affaires étrangères, La Courneuve.

[236] Lessing, Roth-Wells, and Sabatos, "Body Politics," 32, 34, 36.

political sensibilities in the Democrat-Republican era, the British invaders would have to strike at the image of a founder no less revered than George Washington, and the First lady had ensured that the Stuart portrait had been spirited away.[237] Sérurier's decision to omit mention of the queen's portrait and/or violence done to it may be explained not by its absence from the committee room or the north wing but by the author's epistolary strategy: in highlighting the loss of the king's portrait, Sérurier hoped to secure a "replacement" image of Louis XVIII for his own office (rather than an image of Louis XVI for the Senate assembly or committee room), presumably to signify the Bourbons' abiding interest in the welfare of the United States through their appointed ambassador.[238]

The royal portraits were evidently beyond repair; reports of a gashed canvas and melted pigments together with singed but intact frames indicate to me less the room's rising temperature as flames engulfed the entire structure than the soldiers' improvisation in converting all manner of ornament into fire starter. Might the British invaders have found it expedient to destroy the building by setting fires in each of the committee rooms as well? The effect of extreme levels of heat on oil paintings can be disastrous: discoloring of the surface with smoke and bubbling and cracking of layers of pigment. Although such damage can be "conserved" and "restored" today by a technician skilled at resewing tears, reattaching pigment, and

[237] Because blacks and whites had worked to preserve the nation's heritage prior to the British invasion, whether packing up Congress' books and papers at the Capitol or the President's silver service and state portrait at the Executive Mansion, it seems likely that efforts to preserve public property at the President's House were better organized than those at the legislature prior to invasion and that preservation efforts at both buildings were impossible during occupation. Record of compensation for Tobias Simpson, in SEN 13A-D2 Memoranda of Bills and Resolutions Examined, Presented and Approved, Records of the U.S. Senate 13th Congress, RG 46, box 10, National Archives, Washington, D.C., reveal the amount of $200.00 was dispensed "for his exertions to save the public property in the Capitol both before and after the destruction thereof by the enemy." Dolley Madison to Lucy Payne Washington Todd, 23 August 1814, in Donald R. Hickey, ed., *The War of 1812: Writings from America's Second War of Independence* (New York: Literary Classics of the United States, 2013), 507, stated that she took it upon herself to save Gilbert Stuart's "large picture of Gen. Washington," ordering "the frame to be broken, and the canvass [sic] taken out" and "placed in the hands of two gentlemen of New York, for safekeeping"; Paul Jennings, *A Colored Man's Reminiscences of James Madison*, in Hickey, ed., *The War of 1812: Writings*, 510, identified the men who provided the labor: "John Susé (a Frenchman, then door-keeper, and still living) and Magraw, the President's gardener, took it [the portrait of Washington] down and sent it off on a wagon, with some large silver urns and such other valuables as could be hastily got hold of."

[238] See Louis Barbe Charles Sérurier to Charles Maurice de Talleyrand, 22–26 August 1814, 39CP: Correspondance Politique États-Unis, vol. 71, page 164 verso, Archives du Ministère des affaires étrangères, La Courneuve, wherein he states his intention to leave Washington, D.C., for Philadelphia for a month, relinquishing the French legation (the Octagon House) to President and Mrs. Madison. In an odd formulation, Sérurier wrote to Talleyrand, 28 December 1814, 39CP: Correspondance Politique États-Unis, vol. 71, pages 309 recto and 309 verso, Archives du Ministère des affaires étrangères, La Courneuve, as follows: "The custom being that the portrait of the king is sent to his ambassadors and ministers, I have the honor of requesting one from you for this [diplomatic] mission. I am certain of the interest with which it will be regarded in this country." Sérurier's letter can be seen as a strategy to endear himself to the Bourbons, to remind them of his years of difficult service in the American wilds, and the need to come to terms with Congress in order to pave the way for relinquishing the post and returning to France. See Chevalier, *Notice biographique sur feu M. le comte de Serurier*, 30.

filling in separations with matching color, this would have presented a real challenge to early American artists. If the reports were credible, the portraits would have had to be thrown out with the rest of the debris.

Sérurier's observation that "English officers" had run through Louis XVI's portrait with their swords raises the question of whether this constituted an act of iconoclasm, generated by a belief that a threatening force was somehow vested in the idealized human which had to be effaced or destroyed. Exhausted from the day's march and skirmish at Bladensburg and traumatized by the recent sniper fire, Cockburn and Ross may well have found breaking and entering the massive stone structure in the dead of night and encountering life-size portraits of (unknown?) persons beyond their reach startling and sought release of pent-up fear and anger. David Freedberg evokes something like this moment of confrontation: "Imagine the consequences of fusion [between the sign, signified and referent]. The body in the image loses its status as representation; image is the body itself. Arousal ensues, positive or negative. . . . the iconoclast dramatizes these issues. He sees the image before him. It represents a body to which, for whatever reason, he is hostile. Either he sees it as living, or he treats it as living. Or—perhaps frighteningly—what should be absent (or unknown) is present (or known). In either event, it is on these bases that he feels he can somehow diminish the power of the represented by destroying the representation or by mutilating it."[239] What did the English officers feel or say as they went about their work? Was it the king's challenging stare, his engulfing figure, or even the relief of a sinister ship patrolling a coast in the background that made them feel vulnerable? To address these questions, it would certainly help to have testimony from those who assailed the picture, saw it being assailed, and examined evidence of actual damage done to the picture. Unfortunately, nobody appears to have claimed responsibility for the deed in dispatch or newsprint.

What can be affirmed is that iconoclasm often implies a degree of competition in the political realm.[240] In times of national upheaval, for example, people have assailed images traditionally used to express, impose, and legitimize power over the state in order to challenge, reject, and delegitimize that claim.[241] It follows that in times of international conflict, doing physical violence to images traditionally used to express dominion, kinship, friendship, or alliance might be thought to forestall, defame, or undermine that pretension. Louis XVI had provided substantial aid to the moderate Republican government during the War of Independence from Britain, and thus could be viewed as having paved the way for the radical Republicans' alliance with France, albeit one that was imperiled by Napoleon I's

[239] David Freedberg, *The Power of Images: Studies in the History and Theory of Response* (Chicago: University of Chicago Press, 1989), 406.

[240] Dario Gamboni, *The Destruction of Art: Iconoclasm and Vandalism since the French Revolution* (New Haven: Yale University Press, 1997), 27.

[241] Gamboni, *The Destruction of Art*, 27. Freedberg, *The Power of Images*, 390, observes, "On other occasions [of iconoclasm] . . . the motivation seems much more clearly political. The aim is to pull down whatever symbolizes—stands for—the old and usually repressive order, the order which one wishes to replace with a new and better one. . . . To pull down the images of a rejected order or an authoritarian and hated one is to wipe the slate clean and inaugurate the promise of utopia."

intractable nature.[242] Louis XVI was also known to have built up the French ports
and fleet in order to restore the balance of powers in Europe, a military readiness
that Napoleon I attempted to expand with the aid of Spanish forces. By doing away
with what had passed from a symbolic to a commemorative presence, Cockburn
and company may have wished to turn back the clock to the seemingly ideal pe-
riod prior to the American Revolution when only the English monarch's portrait
was displayed in government houses. Eradication of Louis XVI's image from the
Senate chamber would have followed the ancient process of *Damnatio Memoriae*,
or exclusion of a man condemned for treason from public view and the historical
record; the former Bourbon monarch had betrayed his superior caste and absolut-
ist principles by helping an English colony throw off its Hanoverian sovereign and
heavy-handed cabinet so that it could institute a republic; now it was time to sup-
port the new Bourbon monarch in his pledge to make France a peaceable nation
within the dominant imperial order.

Iconoclasm can also imply a disturbance of gender relations. A man who ap-
proaches a woman of great power or influence might feel subconsciously threat-
ened that she has the ability to lessen or limit his own power or initiative. This
irritation might be exacerbated by rumors that the woman in question is a stron-
ger personality than her husband, spends extravagantly, keeps a lover on the
side, and meddles in appointments, legislation, and foreign policy. The American
women who gathered at the Executive Mansion, the House of Representatives,
and the Supreme Court in Washington, D.C., to socialize, debate, and learn were
beginning to realize their power as sources of political patronage and facilitators
of political alliance.[243] For them, Marie-Antoinette may have served as a model
because she had Louis XVI's ear and knew when and how to approach him.
Sérurier's decision to omit Marie-Antoinette's portrait from his account could be
taken to imply that the British officers did not assault it because they did not per-
ceive it to be threatening. The queen appears in an elaborate ceremonial dress,
but she turns her head to direct her gaze elsewhere, so that her presence becomes
both a spectacle of courtly femininity and magnificence and a statement of practi-
cal judgment and independent point of view. The invaders may have believed that

[242] Freedberg, *The Power of Images*, 392, formulates this relation between the image and the
referent as follows: "Could it be that by assailing the dead images, getting rid of them, one was
assailing the very men and women they represented? And if so, were they there in the images,
or did the hostile act somehow carry over to the signified by a kind of magical transference or
contagion?. . . . The underlying idea is always the same: that in so far as an image is similar to the
original, it is *equal, identical* with it. . . . The implications for iconoclasm are clear: if the similar
image is perceived as identical, and if hostility to what it represents is sufficient, then the mo-
tion to mutilate, destroy, ruin, or cripple is likely to come to the fore." Freedberg, *The Power of
Images*, 412–413, develops this idea in discussions of portraits of Ferdinand Marcos and Princess
Diana of Wales: "this kind of hostility is simply visited on images of those who are successful in
general; and once again, as with images of political leaders, we deal with the feeling, unexpressed
though it may be, that by damaging the representation one damages the person whom it rep-
resents. At the very least, something of the disgrace of mutilation or destruction is felt to pass on
to the person represented. . . . The young man knew perfectly well that by attacking the image of
Princess Diana somehow the dishonor would accrue to her as well, that public response to this act
would have at least as much to do with who was represented as with the damage to an expensive
object in a public place."

[243] Branson, *These Fiery Frenchified Dames*, 148–149.

Marie-Antoinette had been against the War of American Independence, antici-pating her lady-in-waiting's published opinion that "the queen expressed her-self more openly on the part which France played in the independence of the American colonies and was steadfastly opposed to it" not because she foresaw that their revolution could spread to France but because "she found only too little generosity in the means that France had chosen to undermine English power."[244] Sparing the portrait of a queen who had nonetheless gone along with her hus-band's foreign policy would have contradicted established British practice of as-sailing images of women in the colonies.[245] Indeed, they may have been content to witness it go up in flames along with the rest of the artifacts related to the nation's founding.

Iconoclasm may serve as an indication of racial tension. Perhaps a few hun-dred slaves managed to escape their oppressors and make their way to British vessels and ultimately to freedom, but many more were tied more tightly to their duties under the watchful eye of the white overseer and found opportunities to rebel against the furnishings and chores in his absence. Jennifer Van Horn raises the possibility that African Americans committed "ideologically motivated acts of iconoclasm" rather than emotionally driven acts of vandalism in the interval be-tween the master's desertion of the plantation and the Union Army's liberation of it during the Civil War, which included destroying, disfiguring, and hiding portraits as if to neutralize the symbolic threat posed by the referent's presence or power.[246] The advantage accruing to those servicing the Capitol under British occupation is readily apparent. On a practical level, the exceptionally large and cumbersome French pictures could be made to disappear from the north wing, thus ensuring that no servant would ever again have to move or dust them. On an ideological level, the representations of Europeans of apparently superior wealth and breeding, of preeminent political and social standing could be eliminated and thus eradicate a superfluous claim to ownership. It is even possible that British officers encouraged black laborers to wretch the canvases from their honorific po-sitions and toss them on the bonfire as a gesture of liberation.

British officers may have desired the notoriety arising from such a deed, expanding their reputation as a cruel and vengeful adversary. As Freedberg ob-serves, "All iconoclasts are aware of the greater or lesser publicity that will accrue from their acts. They know of the financial and cultural and symbolic value of the work they assault. The work has been adored and fetishized [in a public place]."[247] Cockburn and Ross burned the Capitol to a shell and reduced the pictures to a set of frames so that Americans would not forget the power of the British military and

[244] Jeanne Louis Henriette Genet Campan, *Mémoires de Madame Campan, première femme de chamber de Marie-Antoinette*, ed. Jean Chalon with notes by Carlos de Angulo (Paris: Mercure de France, 1988), 153.

[245] Lessing, Roth-Wells, and Sabatos, "Body Politics," 34, have observed that while American patriots avoided damaging portraits of women possibly for reasons of chivalry or political irrelevance, British occupiers had no qualms about damaging portraits of women possibly due to religious bias.

[246] Jennifer Van Horn, "'The Dark Iconoclast': African Americans' Artistic Resistance in the Civil War South," *Art Bulletin* 99 (December 2017): 135–136, 140–142.

[247] Freedberg, *The Power of Images*, 409.

the humiliation dealt to states who wished to thrive outside the British empire. Still, there were those British for whom this was not enough, as Smith recalled, "Neither our Admirals nor the Government at home were satisfied that we had not allowed the work of destruction to progress [beyond the public buildings], as it was considered the total annihilation of Washington would have removed the seat of government to New York [City], and [sic, because] the Northern and Federal States were adverse to war with England."[248] This constituency had to be appeased with a resounding and humiliating defeat.

The case for theft of the portraits is based on the recollection of the first architect of the Capitol and Superintendent of the Patent Office William Thornton, who fled Washington hours before the British invasion but who returned the next day to negotiate the preservation of the Patent Office and the day after that to reestablish order in the city. Accused by less timely and diligent public servants of aiding the enemy through direct negotiation, Thornton published a lengthy defense of his conduct in the *National Intelligencer*. In it he recounted his exertions to remove all the books and papers from the Patent Office (the former Blodgett's Hotel on Seventh and E Streets, NW) and to transport them to his farm in Bethesda.[249] With the approach of British troops on the afternoon of 24 August, he and his wife Anna Maria fled their home on F Street and sought refuge in the Georgetown heights; taken in by Martha Custis Peter, they had a commanding view of the devastation as it unfolded.[250] As the British retreated in the direction of their ships the evening of the 25th, Americans finally cracked their doors, and some of them headed toward the ruins to pillage what remained of government property. It was not until the following morning that Thornton, asserting his authority as the only justice of the peace in the area, placed guards at the Capitol, the Executive Mansion, Secretary of State-War-Marine Offices, and Navy Yard "to prevent plunderers who were carrying off articles to the amount of thousands of dollars."[251]

[248] Smith, *The Autobiography of Lieutenant-General Sir Harry Smith*, 1: 201.

[249] William Thornton, Public Announcement, 30 August 1814, in *National Intelligencer*, 14, 2179 (8 September 1814): 1, accessed 23 February 2016, https://repositories.lib.utexas.edu/handle/2152/13227; George W. Paulson, *William Thornton, M.D.: Gentleman of the Enlightenment* (Columbus, OH: George W. Paulson, 2007), 249; Gordon S. Brown, *Incidental Architect: William Thornton and the Cultural Life of Early Washington, D.C., 1794–1828* (Athens, OH: Ohio University Press, 2009), 79.

[250] Anthony S. Pitch, *The Burning of Washington: The British Invasion of 1814* (Annapolis, MD: Naval Institute Press, 1998), 95–96, 111; Thornton, Public Announcement, 30 August 1814, in *National Intelligencer*, 14, 2179 (8 September 1814): 1, recalled: "I removed with my family in the retreating army from the City, and beheld in deep regret, that night, the tremendous conflagrations of our public buildings, &c."; Anna Maria Thornton noted in her diary, quoted in Pitch, *The Burning of Washington*, 111, "We stayed all night at Mrs. Peter's (Mrs. Cutting with us) and there witnessed the conflagration of our poor undefended and devoted city."

[251] William Thornton, Public Announcement, 30 August 1814, in *National Intelligencer*, 14, 2179 (8 September 1814): 1. "Com. Tingly's Report, 27 August 1814," *National Intelligencer*, 12 September 1814, p. 1, squares with Thornton's as regards the plunder of state property: "Having landed in the [Navy] yard, I soon ascertained that the enemy had left the city. . . . Finding it impenetrable to stop the scene of plunder that had commenced, I determined instantly on repossessing the yard, with all the force at my command; repairing therefore immediately to Alexandria. Lieut. Haraden, the ordinary men and the few marines there were ordered directly up, following myself, and got full possession again at evening."

However, this measure proved inadequate to keeping away looters in the long term, as he recalled:

> I placed a Guard at the Navy Yard over the various materials that were subject to Plunderers, & turned out by force about fifty persons who were carrying them off. I placed a Guard over the Books & other property of the public at the Capitol, & if the Guard had been relieved, not only thousands of Books, but other Property, among which were the pictures of the King & Queen of France, would have been preserved. I placed a Guard also over the property at the Offices, but none of the Guards were relieved, by order of the Mayor, & thus the whole was plundered & carried off.[252]

Thornton was frustrated with the task of keeping locals away from the federal buildings and compounds; he suggests that "the pictures" (i.e., portraits and frames) were in good or salvageable condition, which made them attractive to thieves. Thornton hated having his measures for preservation questioned and being blamed for property loss, as he continued: "For these exertions, which I thought myself bound to make as a citizen & a magistrate, I received only contumelious language."[253] He points instead to Mayor James Blake, who had fled the city on the night of the 24th and who had upon his return the afternoon of the 26th not only neglected to relieve the guards but also cancelled Thornton's joint American–British maneuvers designed to locate incapacitated or stray soldiers and to have disparaged Thornton's idea of sending a deputation to the British squadron to prevent more sailors from disembarking and molesting the citizenry.[254] It was an extension of the vituperative back-and-forth between pro-British Federalists (with whom Thornton identified) and pro-French Republicans (Blake) that punctuated the national government.[255] The official responsible for the Capitol and its contents, Surveyor of Public Buildings Benjamin Latrobe, had withdrawn to Pittsburg

[252] William Thornton, letter of 15 February 1825, William Thornton Papers, Vol. VI, in "Architects of the Capitol: William Thornton" file, Curatorial Department, Office of the Architect of the Capitol, Washington, D.C., and in "Portraits of Louis XVI and Marie-Antoinette" dossier, December 1960, National Archives, Washington, D.C.

[253] William Thornton, letter of 15 February 1825, William Thornton Papers, Vol. VI, in "Architects of the Capitol: William Thornton" file, Curatorial Department, Office of the Architect of the Capitol, Washington, D.C., and in "Portraits of Louis XVI and Marie-Antoinette" dossier, December 1960, National Archives, Washington, D.C.

[254] Pitch, *The Burning of Washington*, 150; William Thornton, Public Announcement, 30 August 1814, in *National Intelligencer* 14, no. 2179 (8 September 1814): 1; Rear Admiral Edward Codrington, General Memo to Captains, 25 August 1814, in Dudley and Crawford, eds., *The Naval War of 1812*, 230, acknowledged that "great outrages" were "committed upon the Houses and property of Inhabitants in this Neighbourhood [i.e., Benedict] who have remained peaceably in their Houses by persons belonging to the Fleet, unaccompanied by any Officer to restrain and regulate their conduct" and ordered that stewards and servants be permitted to venture on land only if accompanied by an officer. Even so, outrages were repeated at Drum Point.

[255] Brown, *Incidental Architect*, 79, identifies the root of Thornton's and Blake's mutual distrust as follows: "Mayor James Blake . . . seemed to believe that Thornton had charged him with cowardice for fleeing the city. Blake countered with insinuations that Thornton had been too friendly with the occupiers and overly lenient toward British prisoners." For accusations and counter-accusations between James Blake and William Thornton following the retreat of the British from Washington, see *Daily National Intelligencer*, 9, 12, 14, 22, and 23 September 1814.

in 1813 due to presidential disfavor and lack of congressional appropriations and therefore escaped censure.

Thornton's account raises the possibility that the portraits of Louis XVI and Marie-Antoinette were neither pierced nor melted but cut from their frames, rolled, and carried away. In his recollections of the war, Representative Ingersoll admitted that he was at a loss to describe what occurred at the Capitol on the night of the conflagration, but the sequence in which he laid out the events suggests that he, like Thornton, recognized that the royal portraits had survived the fire only to be purloined. As he stated,

> the mock resolution [to burn the Capitol] was executed by rockets and other combustibles applied to the chairs and furniture heaped in the centre [sic], and fired wherever there was a fit place. The temporary wooden structure connecting the two wings, readily kindled. Doors, chairs, consumable parts, the library and its contents, in an upper room of the Senate wing, everything that would take fire, soon disappeared in sheets of flame. In a room adjoining the Senate Chamber, portraits of the King and Queen of France, Louis the Sixteenth, and his wife, were cut from the frames, by whom has never appeared. The frames were scorched, but not burned, and probably some pilferer snatched those pictures from destruction to steal them.[256]

The last phrase is significant: he leaves open the possibility that the portraits, having escaped the worst effects of the fire in a peripheral room, were cut from their frames by person or persons unknown: "The particulars of the destruction of the Capitol it is almost impossible to obtain. After diligent inquiry, I can find no one within sight, such was the terror of all."[257] Evidently he did not have access to reports on the ground as events were unfolding; he might well have suspected African American informants of inventing the "slash and burn" story as a ruse designed to avoid suspicion that they had actually stolen the pictures and intended to keep them.[258] But if he had thought through his account of the theft more carefully, he would have had to acknowledge that cutting canvases with a knife, rolling them into a compact tube, and carrying them over a distance would have presented many occasions for damage and detection. In place of reliable information, he could only speculate about how the caper was managed, where the canvases had been taken, and what purpose they served.[259]

Suppose a British straggler had managed to remove the portraits or, more interesting still, a British officer had taken them. Instructed to fill their knapsacks with food, British troops departed Washington at 9 p.m. on 25 August, retracing their steps northeast and discarding cumbersome or weighty items along the way.[260]

[256] Ingersoll, *Historical Sketch of the Second War*, 2: 185; also see Ewell, *The Medical Companion*, 634–635, 637.

[257] Ingersoll, *Historical Sketch of the Second War*, 2: 185.

[258] Van Horn, "'The Dark Iconoclast,'" 150, considers that former slaves' appropriation of their former master's portraits may have served as an opportunity to own, ogle, alter, or sell a white body figuratively, thus reversing the "usual power dynamic of a white owner and a black body."

[259] See Jean Louis Fernagus to comte Élie Decazes, 17 March 1816, in *L'Intermédiaire des chercheurs et curieux*, 57, 1183 (10 May 1908): 717–718.

[260] See Smith, *The Autobiography of Lieutenant-General Sir Harry Smith*, 1: 202.

Reaching Bladensburg twenty-four hours later, the men then headed south to Benedict and began to re-embark the ships the evening of the 29th so that the squadron could weigh anchor on the morning of the 31st and reach Tangier Island by 7 September.[261] What were the odds that canvases, heavier with each step, or jumbled and dented on a horse or cart, could have survived such a trek? The gunpowder explosion at Greenleaf's Point had mangled seventy-four British and a severe storm had flattened several houses, creating an apocalyptic environment that motivated Ross to pull out of the city early.[262] Thornton, Ewell, and others promised to look after the wounded, but they might cede the portraits to Cockburn, Ross, or another officer as a gesture of good faith.[263] What were the odds that they—any more than documents, books, and nick knacks taken—would be returned?

As has been discussed, British and French authorities considered that public works of art and cultural relics were the legitimate property of the victor, to be pocketed as souvenirs and paraded through the streets as booty.[264] Napoleon's conquest of the Italian States, the consequent extraction of works of art, triumphal parade on the Champ-de-Mars, and display at the Musée Central des Arts (Musée Napoleon from 1803) is the most flagrant example.[265] The British respected the sovereignty of the United States, they said, by paying for meat and stores taken from local residents and by sparing towns that agreed to render information and assistance to them, but they also disdained the duly elected Madison administration and Republican Congress, they demonstrated, by taking from it signs of legitimacy as an independent nation—navigation of the waters, allegiance of seamen; military fortifications, stores, and vessels; and public buildings, political culture, and portraits. This was more than a war-time lesson in military inexperience or unpreparedness: it was a bitter reminder that no aspirant nation should ever challenge the hegemony of a mighty empire. The British officers who entered the Capitol, astonished at the splendor of republican space, fixtures, and implements,

[261] Arthur Brooke, 6 September 1814, in George, "The Family Papers of Maj. Gen. Robert Ross," 305.

[262] Scott, *Recollections of a Naval Life*, 3: 312–313; Latimer, *1812: War with America*, 321.

[263] Robert Ross to Elizabeth Ross, 1 September 1814, in George, "The Family Papers of Maj. Gen. Robert Ross," 308, wrote: "we were forced to leave the wounded who could not be moved at Bladensburg"; Smith, *The Autobiography of Lieutenant-General Sir Harry Smith*, 1: 204, remarked, "We made arrangements for the care and provisioning of the wounded we had left at Bladensburg, and the attention and care they received from the Americans became the character of a civilized nation"; Ewell, *The Medical Companion*, 648–649, offered to care for those injured at Greenleaf Point. Cockburn was accustomed to granting requests for prisoner exchanges: George Cockburn to Alexander Cochrane, 21 October 1814, p. 2, The Papers of George Cockburn, ms. 17,576, reel 6, Manuscript Division, Library of Congress, Washington, D.C., wrote that he intended "all the Prisoners of War who have been brought here [to Bermuda] taken either during our recent Expedition against Washington or operation before Baltimore" to be exchanged for British prisoners; Cockburn to Rear Admiral Pulteney Malcolm, 25 October 1814, p. 2, wrote that he was prepared "to carry into Effect the agreement of Exchange" with the Americans.

[264] See Jeanette Greenfield, "'The Spoils of War,'" in Elizabeth Simpson, ed., *The Spoils of War: World War II and Its Aftermath: The Loss, Reappearance, and Recovery of Cultural Property* (New York: Harry N. Abrams, Inc., Publishers and The Bard Graduate Center for Studies in the Decorative Arts, 1997), 34–38.

[265] See Gould, *Trophy of Conquest*, 42–66, and Andrew McClellan, *The Art Museum from Boullée to Bilbao* (Berkeley: University of California Press, 2008), 235–245; Greenfield, "'The Spoils of War,'" 35.

wished to ascribe it to the Parliament of London or the government buildings at York. Accordingly, they scanned in disbelief, grabbed what they could, and burned the rest, determined that republican political culture would be a fleeting trend and that royal political culture would remain an enduring tradition. In so doing, they unwittingly struck at the American people's sense of identity, continuity, and cohesion as a nation.

Alternatively, suppose an unscrupulous servant, entrepreneur, or business-man had managed to sneak the portraits out of the Capitol or, more pointedly, that a Federalist or counter-Republican critical of Madison and the Republicans' break with Britain or inept conduct of the war had removed them in protest or punishment. At the time, the British blockade of the East Coast was tighter than ever, which ruined fishing, shipping, and mercantile industries that depended on constant access to the sea lanes, leading to unemployment and vagrancy. As early as 1807, Latrobe warned Congress that free access of citizens to the Capitol was a major cause of the defacement of walls and the theft of articles, and this would have expanded with the flight of clerks and guards, the breaking of doors and windows by the soldiers.[266] Historian Anthony Pitch has observed that the morn-ing after the British departed looting of public buildings took place on a massive scale: "hordes of citizens swarmed over the remains of the President's House, the Capitol, and the Navy Yard . . . Like vultures, they descended on the open ruins to pick and pluck at random. . . ."[267] Among these salvagers were surely those who viewed the portraits with an eye for squeezing value from them as French luxury goods but also those who thought of stealing from the Capitol as a form of political protest. Pitch has gleaned from the testimony of Dr. William Marshall several new instances of graffiti appearing on the walls of the Capitol—"Armstrong sold the city for 5000 dollars" and "James Madison is a rascal, a coward and a fool," together with sketches of Winder hanging from a tree and the president fleeing without hat or wig—that give an indication of public outrage at the administration.[268] This was a base form of communication, but it highlighted the recourse those of lower social and economic status were driven to when their governments refused to listen to or redress their grievances. This spirit of discontent sometimes reverberated to or corresponded with that of the ruling class, as Hickey points out, a Virginia Re-publican declared, "The whole administration is blamed for the late occurrences at Washington" while a New York Federalist reported, "Without money, without

[266] Benjamin Latrobe, Report on the Hall of Representatives, 27 October 1807, in Latrobe, *The Correspondence and Miscellaneous Papers of Benjamin Henry Latrobe*, eds. John C. Van Horne and Lee W. Formwalt, 3 vols. (New Haven: Yale University Press, 1984–1988), 2: 492, stated "idle and dissolute persons ranged the whole building. The walls were defaced by obscenity and by libels. The public furniture and utensils of the house were considered as fair objects of depradation [sic] . . ."

[267] Pitch, *The Burning of Washington*, 150. Reports in the *National Intelligencer*, 31 August 1814, quoted in John S. Williams, *History of the Invasion and Capture of Washington and of the Events Which Preceded and Followed* (New York: Harper and Brothers, Publishers, 1857), 266, confirm this: "No houses were half as much plundered by the enemy as by the knavish wretches about the town who profited by the general distress." Thomas Tingey, "Extracts of a letter from Com. Tingey to the Secretary of the Navy," 27 August 1814, in *National Intelligencer*, 12 September 1814, 1, described his efforts to secure the Navy Yard from plunder on 26 August.

[268] Dr. William Marshall testimony quoted in Pitch, *The Burning of Washington*, 163.

soldiers & without courage, the President and his Cabinet are the objects of very general execration."[269]

But theft also implies a desire to obtain something for oneself surreptitiously without thought of the financial, material, or symbolic cost to others. The purveyor of stolen wares and the collector of rare or beautiful objects exist on a continuum of exchange seemingly at odds with that of the street peddler and popular consumer. Jean Louis Fernagus, a French anti-Bonapartist novelist and bookseller who had taken refuge in Philadelphia, thought he had uncovered a sordid chain of events linking commoner and aristocrat. He wrote to comte Élie Decazes, Louis XVIII's chief of police in Paris, that (he had heard that?) within a few days of the burning of Washington, D.C. "a Federalist of George-Town" remarked "that the magnificent portrait of the August Marie-Antoinette. . .had been devoured by flames, but that the portrait of the King, relegated to another wing of the Capitol, had remained intact" only to be "adroitly cut with a penknife from the frame and carried off like a piece of oil cloth."[270] The Federalist, he continued, placed a notice in a gazette in which he invited the guilty party to surrender the portrait to him in exchange for $1,200 so that it could be restored to Congress, and this measure failing, the only clue to the picture's whereabouts was a rumor that an American collector had sold it to a wealthy Englishman who intended to make a present of it to Louis XVIII! Although the account is unverifiable and contradicts the information of parties and documents on site, it does suggest two additional functions for the king's portrait—namely, to be snapped up by a local collector to be incorporated into his art gallery as an example of the French school and to be carried off by a common salvager to be put to use as a protective tarp for trunk, cart, or roof during the rainy season. In the absence of government and law enforcement, neither the art dealer nor the street peddler would have wanted to miss out on his share of the spoils, and with order restored might have resorted to ingenious devices to repurpose them for sale or use.

In laying out two scenarios for the loss of the royal portraits, I want to emphasize the unlikelihood that they are both correct—that is, that the canvases were pierced by officers and melted by fire and that they were cut from their frames and carried away by thieves. Because Sérurier was in the capital on the night of 24–25 August and had a particular interest in the preservation of diplomatic gifts at the Capitol, while Thornton arrived to survey damage to government buildings on 26 August and had his hands full attempting to preserve state property at several locations, I am inclined to think that the canvases were pierced and torched in conformity with Cockburn's practice of destroying state buildings and valuables as a matter of revenge and deterrence. The circumstance that Cockburn was acquainted with imperial portraits as a member of the officer corps and colonial gentry, combined with his predilection for seizing and destroying towns in the Chesapeake and his desire to be portrayed at full-length burning the most strategic one upon his return to London, surely makes him the obvious suspect. However, the fragmentary

[269] George Hay to James Monroe, 10 September 1814, and Rufus King to Jeremiah Mason, 2 September 1814, quoted in Hickey, *The War of 1812: A Forgotten Conflict*, 240.

[270] Jean Louis Fernagus to comte Élie de Cazes, 17 March 1816, in *L'Intermédiaire des chercheurs et curieux*, 57, 1183 (10 May 1908): 717.

documentation that survives can be interpreted to support ruination or theft scenarios. Indeed, officials most proximate to portraits and interested in their fate expressed in writing unclear ideas about what happened to them, making it unlikely—barring new evidence comes to light—that we will ever know for certain. As an argumentative strategy, "the royal portraits" can be marshaled to express the hardship of Americans enduring occupation or managing subsistence in the capital during the war.

Whether to Seek,
to Replace, or to Forget

In light of the severity of the damage to public buildings and the loss of public property, the administration took measures to ensure the return of the legislature's effects and reconstruction of the Capitol. Madison and his cabinet returned to Washington, D.C., on 27 August, the same day that a British naval force under Captain James Gordon began to bombard the defenses of Alexandria ten miles to the south. The mood in the capital was grim; some of the citizens wondered how the president or his war secretary could have fled the area rather than put up a resistance or pay an indemnity to spare the city.[271] Upon Armstrong's return two days later, Madison confronted him about his strategic blindness and lack of preparedness; Monroe suggested Armstrong take a leave of absence, and the latter withdrew to Baltimore, where he published an extensive defense of his conduct in the *Baltimore Patriot* and dispatched a terse letter of resignation to Madison.[272] Armstrong was doubly humiliated by the indifference of the public to his explanation and the appointment of rival Monroe to his post. The administration decided that the appropriate course of action was to organize the nation's militia and bolster the local defenses to withstand further British strikes in the Chesapeake. The population's feeling of helplessness was only increased with news that Gordon had successfully negotiated the surrender of Alexandria and managed to extract twenty-one vessels plus stores of cotton, tar, tobacco, flour, sugar, beef, and wine.[273] Monroe immediately ordered three navy commanders to install batteries along the river to destroy the plunder-laden fleet as it attempted to pass down the Potomac on 2–5 September, and although shots were fired and lives were lost on both sides, Gordon managed to escape with his prizes intact.

Madison tried to calm fears that all three branches of the federal government were homeless and inoperative by issuing a "Proclamation upon British

[271] Hickey, *The War of 1812: A Forgotten Conflict*, 209.

[272] Stagg, *The War of 1812*, 130, states that Armstrong's justification of his conduct was published in the *Baltimore Patriot* on 3 September 2014.

[273] George, *Terror on the Chesapeake*, 122–124; Hickey, *The War of 1812: A Forgotten Conflict*, 208. Benyon, Journal kept during the years 1813–14, n.d., 175–176, Western Reserve Historical Society, Cleveland, noted on 9 September 1814 that "We weighed [anchor] at daylight and at eight saw the Sea Horse and [Eurayalus] with the Bombs, [brigs] Devastation, Meteor, and Aetna coming down [the Potomac] with a great many Prizes . . . taken from Alexandria, the inhabitants were made to load them all with flour, Tobacco and cotton. . . . All the prizes are under our orders for Tangier Island w[h]ere we are to paint the vessels [sic] to resemble transports."

Depredations, Burning of the Capitol" on 1 September.[274] Published three days later in the *National Intelligencer*, the proclamation read in part:

> they [the enemy] wantonly destroyed the public edifices . . .; some of these edifices being also costly monuments of taste and of the arts, and others depositories of the public archives, not only precious to the nation as the memorials of its origin and its early transactions, but interesting to all nations, as contributions to the general stock of historical instruction and political science. . . . We are well aware, that it is not the pecuniary loss to the nation by the late incursion of the enemy which is most to be deprecated. But, as that loss has been greatly overrated in some of the public prints [i.e., gazettes], it may be proper to state that the public property, of every description, cannot be fairly estimated to amount to more than two millions of dollars, perhaps not even so much.[275]

Madison plays down the loss of government buildings and property in order to remind citizens that the principles and laws of republican government survive, that the military forces of the king of England had once again sought to violate their national sovereignty, and that if they wished to remain a free people, they better fight on. In other words, the trappings of office ought not to be invested with greater significance than the ideals that inspired them. One constituency who had never mistaken the magnificent structures for havens of freedom and liberty was the local slave population. In *A Portraiture of Domestic Slavery in the United States* (1817), Jesse Torrey discussed the base living and transporting conditions of slaves, the brutal practice whereby families were separated and freedmen were sold south, and included an engraving of a well-dressed man attempting to reconcile his ideals of liberty and humanity (allegorized in the sky) with the ruined Capitol before him and the coffle of African Americans behind him (figure 24).[276] Divine retribution had been visited upon freedom-loving white residents for their oppression of blacks.

In the same address, Madison made it clear that measures were being taken to convert the General Post and Patent Office (formerly Blodgett's Hotel) into Congress' meeting place in time for its first session on 19 September.[277] An engraving made after an earlier image from the 1820s reveals a three-story structure with a full basement, broken at the center with a triple arched entry surmounted by a recessed porch screened by six columns, entablature, and pediment (figure 25). In anticipation of this convocation, Munroe wrote a column (published in the *National Intelligencer* on 4 September) that entreated and

[274] Stagg, *The War of 1812*, 131. See James Madison, "September 1, 1814: Proclamation upon British Depredations, Burning of the Capitol," Presidential Speeches, Miller Center, University of Virginia, accessed 10 June 2019, https://millercenter.org/the-presidency/presidential-speeches /september-1-1814-proclamation-upon-british-depredations.

[275] James Madison, "A Proclamation," *National Intelligencer*, 3 September 1814, 2–3.

[276] Jesse Torrey, *A Portraiture of Domestic Slavery, in the United States* (Philadelphia: Jesse Torrey and John Bioren, 1817), 30–37, 41–54, 56–58; John Davis, "Eastman Johnson's *Negro Life at the South* and Urban Slavery in Washington, D.C.," *Art Bulletin* 80, 1 (March 1998): 71–72.

[277] James Madison, "A Proclamation," *National Intelligencer*, 3 September 1814, 3.

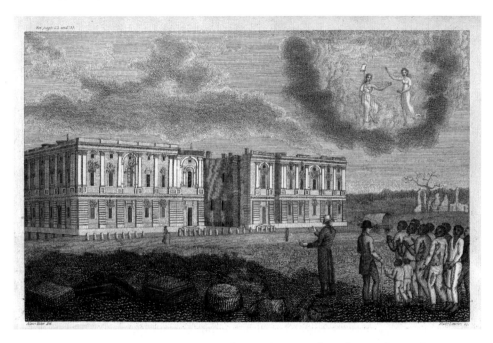

Figure 24. Alexander Lawson (after a drawing by Alexander Rider), *View of the Capitol of the United States after the Conflagration in 1814*, frontispiece from Jesse Torrey, *A Portraiture of Domestic Slavery* . . . (1817). Engraving, 15 × 22 cm. The Library Company of Philadelphia. Public Domain.

Figure 25. Unknown (after an earlier wood engraving), *Blodgett's Hotel, Washington, D.C.*, 1860–1880. Engraving. Prints and Photographs Division, Library of Congress, Washington, D.C. Public Domain.

cajoled locals to cough up any loot—furniture, fixtures, books—that might be useful to the delegates' work:

> Information having been given, that sundry persons (a list of whose names is lodged with the proper authority) are in possession of property to a considerable amount, which was removed from the public buildings on the night of the late conflagration, or subsequently; such persons are hereby requested to make report to this office of the articles in their possession respectively, and to continue their patriotic services, by uniting with the agents of government appointed, for the recovery & preservation thereof. A liberal remuneration for all care, trouble and expence [sic] will be paid, or a certain salvage be given. . .
>
> It is presumed that no person who may have removed, or be in possession of, any of these articles, will hesitate a moment to act as above requested . . . But if there should be any who, misled by ill disposed advisers, or under the pretence [sic] of a gift or tolerated plunder by the enemy, should withhold or fraudulently conceal any thing purloined or removed as above mentioned, the most rigorous prosecutions will be instituted against them, in addition to the property being taken from them...Information against the unprincipled pillager is earnestly invited, and a liberal reward will be paid to the informant for all property recovered on his or her information.[278]

Munroe implies that he knows or is about to know the identity of every scrounger, who would do well to return the article in question or risk being branded a plunderer of public property. Three crucial points emerge: first, that objects were removed prior to and subsequent to the fire; second, that these objects are both well preserved and damaged or incomplete; and third, that the British occupiers may have given objects to citizens or looked the other way as they were plundered. The president avoids mentioning specific items like the royal portraits, perhaps because spotlighting them would encourage the public to appreciate the immensity of losses sustained and blame the administration.

 It was by no means certain that the British were finished wreaking havoc in the Chesapeake. Having conquered Washington, D.C., and intimidated Alexandria into surrender, Cockburn and Ross set their sights on Baltimore, the third largest city in the United States, an important shipyard and commercial hub, and a haven for privateers. From Tangier Island the British sailed north into the far reaches of the Chesapeake Bay and reached the mouth of the Patapsco River on 11 September; following standard procedure, Ross debarked 4,600 men at North Point peninsula, some 14 miles southeast of his target, the following day and proceeded to march them toward Baltimore.[279] This time the

[278] Thomas Munroe, Proclamation, 5 September 1814, in *National Intelligencer* 14, 2178 (6 September 1814): 1, accessed 23 February 2016, https://repositories.lib.utexas.edu/handle /2152/13227; also see the *National Intelligencer*, 1 September 1814, in *Records of the Columbia Historical Society*, 2: 258, in "Works of Art Destroyed by Fire: Portraits of Louis XVI and Marie-Antoinette" file, Curatorial Department, Office of the Architect of the Capitol, Washington, D.C.

[279] Arthur Brooke, 11 and 12 September 1814, in George, "The Family Papers of Maj. Gen. Robert Ross," 310.

American militias under Samuel Smith were prepared. Morriss observes that five miles into the march Cockburn, Ross, and their advance guard lost sight of the main column, and Brigadier General John Stricker's force of 3,200 militia ambushed them at a wooded turn in the road; as Ross turned back to order up more troops, he was hit by a bullet in the chest and died on a stretcher on the way back to North Point.[280] Command of the British army devolved to Colonel Arthur Brooke, who led the artillery in a frontal assault on Stricker's militia, the British taking the field but suffering 340 casualties and the Americans losing 163.[281]

Pressed by Cockburn, Brooke resumed the march to Baltimore, but upon reaching the outer limits on 13 September they found the defenses—batteries of artillery overlooking "a string of palisaded redoubts . . . connected by breastworks"—to be so formidable that they decided to turn back without attacking.[282] Cockburn was of course furious that the expedition had to be called off and blamed the army for wasting precious time to re-provision. Nevertheless, in an event reminiscent of the previous summer British troops inflicted considerable damage on local citizens, ransacking homes and churches in search of booty. *Niles' Register* acerbically proposed that Ross's death be commemorated with a monument dedicated to "The Leader of a Host of Barbarians, who destroyed the Capitol of the United States, at Washington . . . and devoted the Populous City of Baltimore to Rape, Robbery and Conflagration."[283] Disembarking from North Point on 15 September, the British squadron stopped at Tangier Island to re-provision before dividing and pressing on to Halifax and Bermuda, which they reached around 6 October.[284] On the return voyage the British commanders and their regiments recited that the destruction of Washington and the sack of surrounding communities was deserved retribution for the American assault on York and settlements in Canada; this was their way of coming to terms with the horrors they had inflicted as instruments of the colonial administration and imperial war machine. The American commanders complained that although the two armies had been fairly matched along the Great Lakes, Cockburn's assaults in the Chesapeake and along the East Coast were largely unprovoked and thus

[280] Scott, *Recollections of a Naval Life*, 3: 334; Hickey, *The War of 1812: A Forgotten Conflict*, 210–211; Morriss, *Cockburn and the British Navy*, 110–111; also see Arthur Brooke, 12 September 1814, George Cockburn to Reverend Ross, 17 September, in George, "The Family Papers of Maj. Gen. Robert Ross," 310–311, 313.

[281] Arthur Brooke, 12 September 1814, in George, "The Family Papers of Maj. Gen. Robert Ross," 311, estimated the number of casualties at 500 for the Americans; Hickey, *The War of 1812: A Forgotten Conflict*, 211, estimated 215 American and 340 British casualties; Morriss, *Cockburn and the British Navy*, 111, looking at Brooke's figures, estimated 500 American and 302 (army) plus 106 (navy) British casualties.

[282] Morriss, *Cockburn and the British Navy*, 111–112.

[283] *Niles' Register*, n.d., quoted in Scott, *Recollections of a Naval Life*, 3: 335, and Hickey, *The War of 1812: A Forgotten Conflict*, 213.

[284] George Cockburn to Alexander Cochrane, 24 September 1814, Papers of George Cockburn, ms. 17,576, reel no. 6, item no. 46, Library of Congress, Washington, D.C.; Scott, *Recollections of a Naval Life*, 3: 348.

difficult to justify.[285] And there was no reason to think that these outrageous attacks would deescalate the situation along the border with Canada.

When Congress met that autumn, the Republicans were still solidly in the majority, but their mood was grim. All seven states of New England, whose merchants were severely impacted by the blockade of ports and the levying of taxes, had elected Federalist candidates.[286] Harnessing the anti-war sentiment, they opposed conscription of men and formation of a national bank to continue the war and instead supported payment of indemnities and ceding of territories to the British. Many Republicans joined with Federalists in opposing the Madison administration, and their disgust was felt in the election of Langdon Cheves of South Carolina, a known critic of the executive, as Speaker of the House.[287] In his annual message of 20 September, Madison declared his aim to provide for the treasury and to undertake diplomatic initiatives, especially in light of Britain's "spirit of hostility . . . against the rights and prosperity of this Country."[288] He explained that the defeat of France had led to a power vacuum in Europe, which permitted Britain to expand its control of the ocean unchecked, to the detriment of the rest of "the civilized and commercial world."[289] The British, he continued, may fancy the destruction of private property and public buildings in Washington, D.C., a great victory, but they merely "interrupted for a moment . . . the ordinary public business at the seat of Government" at the cost of the violation of the rules of "civilized

[285] James Monroe, "Copy of a Letter from Mr. Monroe to Sir Alex Cochrane, Vice Admiral, &c, &c," 6 September 1814, *National Intelligencer*, 9 September 1814, 1, responded to Cochrane's assertion that the Governor General of the Canadas had called upon him to retaliate against the inhabitants of the United States for the destruction inflicted by their army in Upper Canada: "Without dwelling on the deplorable cruelties committed by the savages in the British ranks, and in British pay, on American prisoners at the River Raisin, which to this day have never been disavowed or atoned, I refer . . . to the wanton desolation that was committed at Havre-de-Grace, and at George Town, early in the Spring 1813. These villages were burnt and ravaged by the naval forces of Great Britain, to the ruin of their unarmed inhabitants, who saw with astonishment that they derived no protection to their property from the laws of war. During the same season, scenes of invasion and pillage, carried on under the same authority, were witnessed all along the waters of the Chesapeake, to an extent inflicting the most serious private distress, and under circumstances that justified the suspicion, that revenge and cupidity, rather than the manly motives that should dictate the hostility of a high minded foe, led to their perpetration. The late destruction of the Houses of the Government in this City is another act which comes necessarily into view. In the wars of modern Europe, no examples of the kind, even among nations the most hostile to each other, can be traced." Monroe then went on to describe the horrors inflicted by British troops upon American towns on the Canadian border and ended by disavowing any comparably "wanton, cruel and unjustifiable warfare," including any unauthorized acts (such as the burning of the government buildings at York) committed by any of its troops. Also see Marcellus, "War," 14 September 1814, in *National Intelligencer*, 16 October 1814, 1–2, who elaborated this position.

[286] Hickey, *The War of 1812: A Forgotten Conflict*, 239–240, 244.

[287] Stagg, *The War of 1812*, 133.

[288] James Madison, Annual Message to Congress, 20 September 1814, Founders Online, National Archives, Washington, D.C., accessed 26 May 2019, https://founders.archives.gov/documents/Madison/03-08-02-0206.

[289] Madison, Annual Message to Congress, 20 September 1814, Founders Online, National Archives, Washington, D.C.

warfare" and "the loss of character with the world."[290] The Americans, in contrast, had acted nobly: the local militia, volunteers, and regulars who defended Baltimore were able to drive the enemy back to their ships quickly; military operations on the Canadian border and in the Tennessee region had resulted in greater discipline among the soldiery, and agreements with Indian tribes promised to make life difficult for the enemy. After enjoining the delegates to bolster the ranks of the army, to supply them regularly, and to appropriate greater sums of money for extended war operations, the president closed with an invocation that members of the legislature "will cheerfully and proudly bear every burden of every kind, which the safety and honor of the Nation demand."[291] The people were certainly in need of this kind of oratorical rallying, but they would respond much better to news of actual military victories on the southern front in the months ahead.

In the meantime, the portraits of Louis XVI and Marie-Antoinette were gone, and Bayly had the giltwood frames removed from the Capitol by the end of September so that Latrobe could get on with rebuilding. An important opportunity to discover what a forensic scientist would have made of fibers or residue clinging to the frames was apparently lost in the haste to clear the premises. The business of unscrewing and dismantling the elaborate gilt borders, placing them in a horse-drawn cart, and delivering them first to the house of Mr. Wrightsman (Weightman?) for cleaning, repair, and packing and then to the Post and Patent Office for long-term storage would have been a delicate operation.[292] The workers must have wondered whether the canvases would ever be located and, if not, whether the frames—as elaborate as they were—were worth preserving as a kind of extended escutcheon of the French–American alliance. What purpose could they serve apart from curiosities?

The Treaty of Ghent signed by the Prince Regent on 24 December 1814 and ratified by the Senate on 17 February 1815 put an end to the war between the United States and Great Britain, reestablished diplomatic relations between the two nations, and reinstated the original borders in North America. For the rebuilding of public edifices in the capital, Munroe turned to James Hoban, the most skilled architect in the city at that time, to oversee work on the executive mansion and offices while Latrobe, who was stagnating in Pittsburgh, wrote Munroe for permission to direct work on the Capitol. Congress made an initial appropriation of $500,000, and work commenced on both buildings in late March.[293] It was from a desire to

[290] Madison, Annual Message to Congress, 20 September 1814, Founders Online, National Archives, Washington, D.C.

[291] Madison, Annual Message to Congress, 20 September 1814, Founders Online, National Archives, Washington, D.C.

[292] United States (Thomas Munroe) to Mountjoy Bayly, Record of payment, 28 September 1814, Miscellaneous Treasury Accounts, General Accounting Office, Account of Expenditures on the Capitol #30,743 #29, Record Group 217, National Archives, Washington, D.C.: "To Cash for the hire of a Cart & 2 horses to remove the public furniture from the Capitol Hill / To Mr Wrightsman's House, thence to Congress hall. . .$3.00 / To Cash p[ai]d 8 Men for removing the frames of the pictures of the King & Queen of France to D[itt]o. . .[$]4 / To Cash p[ai]d Tobias for two days employ removing public property. . .to D[itt]o. . .[$]4 / [Total:] $11.00 / Received this 28th of Sept. 1814 the above [from the] Acct of Thomas Munroe / Mountjoy Bayly."

[293] Seale, *The President's House*, 1: 138–140.

establish continuity with the past that Madison directed the commissioners to rep-
licate the original models, as he wrote John van Ness the following May, "In car-
rying into execution the law for rebuilding the Public Edifices, it will best comport
with its object & its provisions, not to deviate from the models destroyed, farther
than material & manifest conveniency, or general & known opinion, may bring the
alterations within the presumed contemplation of Congress. How far those pro-
posed by Mr. Latrobe for whose judgment & taste I have great respect, are of this
character, I suspend an opinion, untill [sic] I can form one with the advantage of
being on the spot . . ."[294] The president was determined that all traces of British
assault on the fabric of American government should vanish through careful res-
toration and reconstruction. Unfortunately, Latrobe, always more visionary than
diplomatic, attempted to redesign the Capitol in a new classical idiom, incurred
the ire of the commissioners, and was forced to resign in 1817, leaving the work to
Charles Bulfinch, who fulfilled the mandate in time for Congress's sessions of 1819.
Charles W. Burton's watercolor rendering of the legislative building as seen from
the bottom of the hill focuses on the massive west portico and copper-sheathed
dome rather than the reconstructed wings, which are nearly obscured by the trees
lining the avenue (figure 26)—a park for peaceable promenade rather than a field
for hateful incendiarism.

Neither architect showed an interest in locating or replacing the royal por-
traits, perhaps because they had long ceased to be integral to the design, furnish-
ing, or ethos of the Senate chamber, or perhaps because the factional rancor that
had led to them being moved to a committee room had dissipated. Only a year
prior to the British invasion the triumphant Republicans had dismissed them as
outmoded fixtures of the ancien régime and the waning Federalists had preserved
them as resonant signs of diplomatic initiatives and revolutionary extremism. In
the post-war era, the national mood shifted again to one of reconciliation and re-
generation, as if an intuitive understanding took hold of the citizenry that nothing
could be rebuilt politically or economically without cooperation.

The Era of Good Feelings saw Republican James Monroe build national
trust through appointment of qualified professionals regardless of political affil-
iation and travel the length of the nation to sound out public opinion. When he
was elected to a second term without any opposition candidate in late 1820, it
seemed like the Federalists had been swept away and ideological divisions had
subsided in favor of a Republican vision of national cohesion. In his second in-
augural address to Congress of 5 March 1821, Monroe credited earlier presidents
with forming the union so that he could simply guide its future, though he ac-
knowledged that his own "humble pretentions," combined with "powerful causes,"
had enabled him to draw the electorate together without the usual factional rancor,
which gave him every reason to expect that "a like accord" would prevail on "all
questions touching . . . the liberty, prosperity, and happiness of our country."[295] He
then acknowledged the perfectibility of republican government for a virtuous and

[294] James Madison to John Peter van Ness, 23 May 1815, accessed 6 June 2019, https://founders
.archives.gov.

[295] "March 5, 1821: Second Inaugural Address," Presidential Speeches / James Monroe Presi-
dency, Miller Center, University of Virginia, accessed 6 June 2019, https://millercenter.org.

Figure 26. Charles W. Burton, *View of the Capitol*, ca. 1824. Watercolor, pen and black ink, and gum arabic on wove paper, 40.6 × 63 cm. Metropolitan Museum of Art, New York City. Purchase, Joseph Pulitzer Bequest, 1942. Public Domain.

hard-working people: "In our whole system, national and State, we have shunned all the defects which unceasingly preyed on the vitals and destroyed the ancient Republics. In them there were distinct orders, a nobility and a people, or the people governed in one assembly. . . . In this great nation there is but one order, that of the people, whose power, by a peculiarly happy improvement of the representative principle, is transferred from them, without impairing in the slightest degree their sovereignty, to bodies of their own creation, and to persons elected by themselves, in the full extent necessary for all the purposes of free, enlightened and efficient government."[296] The wise people would ensure that qualified delegates were sent to Congress to cooperate in realizing protection and prosperity for all. It was populist hyperbole that for the moment bound the wounds of three generations of citizens, while passing over the plight of the indigenous, slaves, recent immigrants, and women.

And what of America's relations with Britain and France? Would competition over ships, ports, and trade routes also subside in the years ahead? Ingenuity would be more important than ever if the United States was to expand into continental and colonial markets, and weather boom and bust cycles. Several visitors to the Post and Patent Office contemplated models displayed alongside memorabilia

[296] "March 5, 1821: Second Inaugural Address," Presidential Speeches / James Monroe Presidency, Miller Center, University of Virginia, accessed 6 June 2019, https://millercenter.org.

as a measure of the nation's success. Writer Karl Bernhard recollected being shown Butteux's elaborately carved picture surrounds in 1825–26: "They pointed out to me two large gilt frames with the arms of France and Navarre. They hung before the catastrophe of 1814, in the house of the president [sic, the Capitol], and contained full length portraits of Louis XVI and Marie-Antoinette, which were presented [sic, sent] in 1783, by those unfortunate monarchs to the United States, at their especial desire. Both portraits suddenly disappeared, and it is believed that it happened in 1814, when the English made their unexpected visit to Washington, and burnt down the house of the president [sic, the chambers of the delegates]."[297] Bernhard's account suggests that the narrative about what happened on the night of the British invasion became more confused over time. The destruction of the frames in the fire that engulfed the Post and Patent Office in December 1836 made the royal portraits a matter of legend, the bare outlines of which were shaped by letters and documents in the national archives.

[297] Karl Bernhard, *Travels Through North America during the Years 1825 and 1826*, 2 vols. (Philadelphia: Carey, Lea and Carey, 1828), 1: 17. It is intriguing to pursue the question of why Bernhard placed the frames in the Executive Mansion ("house of the President") at the time of the invasion. Bernhard was likely misinformed by an erroneous account or placard. Stuart's portrait of George Washington was placed first in the oval drawing room and then the dining room of the mansion, and the addition of Callet's *Louis XVI* and Vigée Le Brun's *Marie-Antoinette* would have had the effect not only of symbolically reenacting the trans-Atlantic alliance of 1778 dear to Federalists but also of furthering the illusion of monarchical splendor that Jefferson had sought to distance as a Republican president (e.g. refusing to deliver his Annual Message in the Senate Chamber) and that Madison had abhorred (e.g. declining to fill the residence with French furnishings and objects d'art).

Conclusion

This essay has accomplished four major objectives: first, it has analyzed British and French practices of dispatching portraits of reigning monarchs to North America and the Caribbean to demonstrate the strategic nature of Callet's *Louis XVI* and Vigée Le Brun's *Marie-Antoinette* as a diplomatic gift for the U.S. Congress in 1783; second, it has assessed British and American wartime practice of looting and burning forts and towns on the Canadian border to identify Cockburn's motives in extending this brutal tactic to the Chesapeake Bay during the War of 1812; third, it has proposed the destruction of York and incendiary warfare along the Canadian border as pretexts for the British campaign to take Washington, D.C., ransack and burn the Capitol in late August 1814; and fourth, it has offered two plausible explanations for what happened to the royal portraits, together with the development of potent myths about them in their absence.

Ever in the popular imagination, Congress's missing state portraits of Louis XVI and Marie-Antoinette have taken a long route to scholarly appraisal for a few reasons. On one hand, they have escaped notice as art objects because they were standard portrait copies and ostentatious surrounds respectively produced by ateliers at Paris and Versailles and therefore were overlooked in the prioritization of works of the greatest quality and originality. On the other hand, they have been neglected as products of French–American political culture because they were conceived as part of a particular moderate republican diplomatic strategy in the late 1770s and dispensed by Louis XVI's foreign ministry as a sign of royal favor, the significance of which was lost as Convention republicans took control of the revolution in France and Jeffersonian republicans began to dominate the national government in the United States in the early 1800s. Today the royal portraits are sometimes mentioned in political histories and art catalogs, conjuring up the untold splendor of the old court of Versailles and the new court of Washington, D.C., over the thirty-year period between the French Revolution and the Napoleonic Wars. But what makes them worth examining in absentia here is the potential to bring together aspects of the histories of war and art, political and material culture, in an interdisciplinary enterprise that considers eighteenth-century state portraits as highly evocative and politically useful objects that became the locus of competing claims of national representativeness or sovereignty and international dominion or alliance until a collective patriotic ethos and set of laws could be formulated.

Although the pictures were on display for no more than thirty years, those who beheld them must have been struck by the distance they had travelled, from the initial dispatch from the foreign minister's depot at Versailles (1783) and preview at the French embassy in Philadelphia (1784), to installation at Congress's successive meeting places, the City Hall of New York (1785), Congress Hall of Philadelphia (1790), and the Senate wing of the Capitol in Washington (1800). Indeed, during the Revolutionary and Federal Eras they were probably scrutinized

and discussed more than any other state portraits in the United States save those of George III and Charlotte, and George and Martha Washington; incrementally they revealed the abrasions that came from wiping, mending, and retouching the painted surfaces and absorbed observations about the nature of royal iconography, from king's symbolic presence, to founder's memento, to curious ornament; constantly they invited discussion not only about the viability of a strategic alliance with France but also about the potential of women to play a leading role in the nation's political life and the role of raw materials and luxury goods to transform people's work place within the trans-Atlantic trade network. It remains to be seen whether the "return" of original copies of *Louis XVI* and *Marie-Antoinette* to the Senate wing is possible or even desirable given the current trend toward ideological polarization within the legislature and trade tensions among heads of state.

In the meantime, "the pictures" continue to resonate as a notion to which are attached ideas of theft, vandalism, and wreckage. Jan Pruszynski, who has surveyed the range of objects taken from Poland during World War II, suggests that research of objects in absentia certainly sheds light on ways they could have been lost or appropriated in war, but it should primarily awaken people's consciousness of their history and cultural heritage, contributing to a sense of continuity with past generations and identity as a modern community in equilibrium or in tension with those of other national communities.[298] Because the royal portraits were material witnesses to American political history, they continue—even as scholarly discourse or popular imaginings—to add to our sense of continuity with the past and identity as migrants, settlers, and citizens of the United States both distinct from and in dialogue with those of France and Britain, Canada and the Caribbean.[299]

[298] Jan P. Pruszynski, "Poland: The War Losses, Cultural Heritage, and Cultural Legitimacy," in Simpson, ed., *The Spoils of War*, 49–50.

[299] Pruszynski, "Poland: The War Losses," 49–50.

Bibliography

Adams, Henry. *History of the United States of America during the Administrations of James Madison* (New York: Literary Classics of the United States, 1986).

_____. *The Life of Albert Gallatin* (Philadelphia: J. B. Lippincott and Company, 1879).

Anderson, Dice Robins. *William Branch Giles: A Study in the Politics of Virginia and the Nation from 1790 to 1830* (Gloucester, MA: Peter Smith, 1965).

"Architects of the Capitol: William Thornton" file, Curatorial Department, Office of the Architect of the Capitol, Washington, D.C.

Armitage, David and Michael J. Braddick, eds. *The British Atlantic World, 1500–1800* (Houndmills, England: Palgrave Macmillan, 2002).

Arthur, Eric Ross. *Toronto, No Mean City* (Toronto: University of Toronto Press, 1964).

"August 1814: Saving Senate Records," United States Senate Website, https://www.senate .gov/artandhistory/history/common/generic/Origins_SavingSenateRecords1814 .htm#:~:text=When%20British%20forces%20attacked%20the,Senate%20messenger %20named%20Tobias%20Simpson (accessed 15 September 2015).

Baillio, Joseph. "Marie-Antoinette et ses enfants par Mme Vigée Le Brun (Deuxième Partie)," *L'Oeil*, 310 (May 1981): 52–61, 90–91.

Bailyn, Bernard, Robert Dallek, David Brion Davis, David Herbert Donald, John L. Thomas, and Gordon S. Wood. *The Great Republic: A History of the American People*, 4th ed. (Lexington, MA: D. C. Heath and Company, 1992).

Baulez, Christian. "Souvenirs of an Embassy: The comte d'Adhémar in London, 1783–87," *The Burlington Magazine*, 151, 1275 (June 2009): 372–81.

Benyon, Benjamin G. Journal kept during the years 1813-14 by Lieut. Benyon, Royal Marines, serving on board H. M. S. Menelaus on the American Station during the War of 1812, n.d., Western Reserve Historical Society, Cleveland.

Bérenger, Jean, and Jean Meyer. *La France dans le monde au XVIIIe siècle* (Paris: Sedes, 1993).

Bernhard, Karl. *Travels Through North America during the Years 1825 and 1826*, 2 vols. (Philadelphia: Carey, Lea and Carey, 1828).

Bordes, Philippe. *Jacques-Louis David: Empire to Exile* (New Haven: Yale University Press, 2005).

Branson, Susan. *These Fiery Frenchified Dames: Women and Political Culture in Early National Philadelphia* (Philadelphia: University of Pennsylvania Press, 2001).

Brenton, Edward Pelham. *The Naval History of Great Britain from the Year MDCCLXXXIII to MDCCCXXII*, 5 vols. (London: C. Rice, 1823–25).

Brown, Gordon S. *Incidental Architect: William Thornton and the Cultural Life of Early Washington, D.C., 1794–1828* (Athens, OH: Ohio University Press, 2009).

Bryan, Wilhelmus Bogart. *A History of the National Capital from Its Foundation through the Period of the Adoption of the Organic Act*, 2 vols. (New York: The Macmillan Company, 1914).

Buel, Richard. *America on the Brink: How the Political Struggle Over the War of 1812 Almost Destroyed the Young Republic* (New York: Palgrave MacMillan, 2005).

Burk, Kathleen. *Old World, New World: Great Britain and America from the Beginning* (New York: Atlantic Monthly Press, 2007).

"Burning of the Capitol" file, Office of the Architect of the Capitol, Washington, D.C.

Campan, Jeanne Louis Henriette Genet. *Mémoires de Madame Campan, première femme de chamber de Marie-Antoinette*, ed. Jean Chalon with notes by Carlos de Angulo (Paris: Mercure de France, 1988).

Cheney, Paul. *Cul de Sac: Patrimony, Capitalism, and Slavery in French Saint-Domingue* (Chicago: University of Chicago Press, 2017).

Chevalier, Michel. *Notice biographique sur feu M. le comte de Serurier, pair de France et minister plénipotentiaire* (Paris: Librairie de Firmin Didot Frères, 1862).

Clarfield, Gerard H. *Timothy Pickering and the American Republic* (Pittsburgh: University of Pittsburgh Press, 1980).

"Com. Tingly's Report, 27 August 1814," *National Intelligencer*, 12 September 1814, p. 1.

Cormack, Malcolm. "The Ledgers of Sir Joshua Reynolds," *The Volume of the Walpole Society*, 42 (1968–70): 105–69.

Correspondance politique: États-Unis, 1791–1792, 39CP35 and 39CP36 (microfilms P5982 and P12121), Archives du ministère des affaires étrangères, La Courneuve.

Cruikshank, E. A., ed. *Documentary History of the Campaigns upon the Niagara Frontier in 1812–1814*, 9 vols. (Welland, Ontario: Tribune Press, 1896–1908).

Daily National Intelligencer, 9, 12, 14, 22, and 23 September 1814.

Daly, Gavin. *The British Soldier in the Peninsular War: Encounters with Spain and Portugal, 1808–1814* (New York: Palgrave Macmillan, 2013).

Davis, John. "Eastman Johnson's *Negro Life at the South* and Urban Slavery in Washington, D.C.," *Art Bulletin*, 80, 1 (March 1998): 67–92.

Davis, William Howard. *Gouverneur Morris: An Independent Life* (New Haven: Yale University Press, 2003).

The Debates and Proceedings in the Congress of the United States, 1789–1824 (Washington, D.C.: Gales and Seaton, 1854) in "Annals of Congress: Debates and Proceedings, 1789–1824," Library of Congress, https://memory.loc.gov/ammem/amlaw/lwac.html (accessed 11 November 2015).

Dill, Thomas Melville. "Bermuda and the War of 1812," *Bermuda Historical Quarterly*, 1, 3 (July–Sept 1944): 137–50.

Dudley, William S., and Michael J. Crawford, eds., *The Naval War of 1812: A Documentary History*, 3 vols. (Washington, D.C.: Naval Historical Center, Department of the Navy, 1985–2002).

Egerton, H. E. "The System of British Colonial Administration of the Crown Colonies in the Seventeenth and Eighteenth Centuries Compared with the System Prevailing in

the Nineteenth Century," *Transactions of the Royal Historical Society*, Vol. 1 (1918): 190–217.

Engerand, Fernand, ed. *Inventaire des tableaux commandés et achetés par la direction des Bâtiments du roi (1709–1792)* (Paris: Ernest Leroux, 1901).

Erickson, Mark St. John. "War of 1812: British Raiders Pillage Hampton," 22 June 2018, *Daily Press* Website, http://www.dailypress.com/features/history/war-of-1812/dp-nws-war-of-1812-hampton-20130622-story.html (accessed 20 September 2018).

Ernst, Robert. *Rufus King: American Federalist* (Chapel Hill: University of North Carolina Press, 1968).

Ewell, James. *The Medical Companion. . .A Dispensatory and Glossary . . . A Concise and Impartial History of the Capture of Washington* (Philadelphia: Anderson and Meehan, 1816).

"Extrait des bons du roy du 22 mars 1768," Cahiers d'extraits de bons du roi, 1764–1774, O 1 1063, Archives nationales de France, Paris.

"Extraits" from the Bâtiments bons du roy de 1746 à 1766, O 1 1062, Archives nationales de France, Paris.

Fairman, Charles E. *Art and Artists of the Capitol of the United States of America* (Washington, D.C.: Government Printing Office, 1927).

Fernagus, Jean Louis. Letter to comte Élie Decazes, 17 March 1816, in *L'Intermédiaire des chercheurs et curieux*, 57, 1183 (10 May 1908): 716–19.

Forster, George. "Extrait de *Voyage philosophique et pittoresque sur les rêves du Rhin, à Liége, dans la Flandre, le Brabant, la Hollande, etc.*," in *La Décade Philosophique, littéraire et politique*, t. 3 (1 October 1794), 278–88, https://gallica.bnf.fr/ark:/12148/bpt6k423971p/f286.item (accessed 13 October 2020).

Freedberg, David. *The Power of Images: Studies in the History and Theory of Response* (Chicago: University of Chicago Press, 1989).

Furstenberg, François. *When the United States Spoke French: Five Refugees Who Shaped a Nation* (New York: The Penguin Press, 2014).

Gamboni, Dario. *The Destruction of Art: Iconoclasm and Vandalism since the French Revolution* (New Haven: Yale University Press, 1997).

George, Christopher T. "The Family Papers of Maj. Gen. Robert Ross, the Diary of Col. Arthur Brooke, and the British Attacks on Washington and Baltimore of 1814," *Maryland Historical Magazine*, 88, 3 (Fall 1993): 300–16.

_____. *Terror on the Chesapeake: The War of 1812 on the Bay* (Shippensburg, PA: White Mane Books, 2000).

Gilks, David. "Attitudes to the Displacement of Cultural Property in the Wars of the French Revolution and Napoleon," *The Historical Journal*, 56, 1 (2013): 113–43.

Gleig, George Robert. *A Narrative of the Campaigns of the British Army at Washington and New Orleans Under Generals Ross, Pakenham, and Lambert in the Years 1814 and 1815 with Some Account of the Countries Visited*, 2nd ed. (London: John Murray, 1821).

Gould, Cecil. *Trophy of Conquest: The Musée Napoléon and the Creation of the Louvre* (London: Faber and Faber, 1965).

Greenblatt, Miriam. *War of 1812* (New York: Facts on File, 2003).

Greene, Jack P. *Evaluating Empire and Confronting Colonialism in Eighteenth-Century Britain* (Cambridge: Cambridge University Press, 2013).

Grenouilleau, Olivier. *Fortunes de mer, sirens colonials: Économie maritime, colonies et développement: la France, vers 1660–1914* (Paris: CNRS Éditions, 2019).

Halpenny, Francess G., and Jean Hamelin, eds. *Dictionary of Canadian Biography*, 14 vols. (Toronto: University of Toronto/ Université Laval, 1966–82), University of Toronto / Université Laval Website, http://www.biographi.ca/en/bio/pilkington_robert_6E.html (accessed 28 June 2019).

Hardman, John. *French Politics 1774–1789: From the Accession of Louis XVI to the Fall of the Bastille* (London: Longman, 1995).

Hayworth, Jordan R. *Revolutionary France's War of Conquest in the Rhineland: Conquering the Natural Frontier, 1792–1797* (Cambridge: Cambridge University Press, 2019).

Hazelton, George C. *The National Capitol: Its Architecture, Art and History* (New York: J. F. Taylor and Company, 1897).

Hickey, Donald R. *The War of 1812: A Forgotten Conflict* (Urbana, IL: University of Illinois Press, 2012).

Hickey, Donald R., ed. *The War of 1812: Writings from America's Second War of Independence* (New York: Literary Classics of the United States, 2013).

Hodge, Carl Cavanagh, ed. *Encyclopedia of the Age of Imperialism, 1800–1914*, 2 vols. (Westport, CT: Greenwood Press, 2008).

Hood, Graham. *The Governor's Palace in Williamsburg: A Cultural Study* (Williamsburg, VA: The Colonial Williamsburg Foundation, 1991).

Horn, Jeff. *Economic Development in Early Modern France: The Privilege of Liberty, 1650–1820* (Cambridge: Cambridge University Press, 2015).

Howard, Seymour. "Thomas Jefferson's Art Gallery for Monticello," *The Art Bulletin*, 59, 4 (1977): 583–600.

Idzerda, Stanley J. "Iconoclasm during the French Revolution," *American Historical Review*, 60, 1 (October 1954): 13–26.

Ingersoll, Charles J. *Historical Sketch of the Second War between the United States of America and Great Britain Declared by Act of Congress, the 18th of June 1812 and Concluded by Peace, the 15th of February 1815*, 2 vols. (Philadelphia: Lea and Blanchard, 1845–49).

Irwin, Ray W. "The Capture of Washington in 1814 as Described by Mordecai Booth, with Introduction and Notes," *Americana* (January 1934): 7–27.

"Joint Resolution," 16 June 1934, Statutes at Large, 73rd Congress, Session 2, Chapter 559, p. 978, Library of Congress, Washington, D.C., Library of Congress Website, https://www.loc.gov/law/help/statutes-at-large/73rd-congress/session-2/c73s2ch559.pdf (accessed 10 June 2019).

Journal of the House of Representatives of the United States, 75 vols. (Washington, D.C.: Gales and Seaton, Thomas Allen, Blair and Rives, Ritchie and Heiss, A. Boyd Hamilton, Cornelius Wendell, James B. Steedman, Government Printing Office, 1825–75), in "A Century of Lawmaking for a New Nation: U.S. Congressional Documents and Debates, 1775–1875," Library of Congress, http://memory.loc.gov/ammem/amlaw/lwhjlink.html#anchor13 (accessed 11 November 2015).

Journal of the Senate of the United States of America, 70 vols. (Washington: Gales and Seaton, Ritchie and Heiss, Government Printing Office, 1820–74), "A Century of Lawmaking for a New Nation: U.S. Congressional Documents and Debates, 1774–1875," Library of Congress, http://memory.loc.gov/cgi-bin/query/r?ammem/hlaw:@field (DOCID+@lit(sj004446)) (accessed 11 November 2015).

Kantorowicz, Ernst H. *The King's Two Bodies: A Study in Medieval Political Theology* (Princeton: Princeton University Press, 1957).

Larkin, Todd Lawrence. "A "Gift" Strategically Solicited and Magnanimously Conferred: The American Congress, the French Monarchy, and the State Portraits of Louis XVI and Marie-Antoinette," *Winterthur Portfolio,* 44, 1 (Spring 2010): 31–75.

————. *Marie-Antoinette and Her Portraits: The Politics of Queenly Self-Imaging in Late Eighteenth-Century France,* Ph.D. dissertation, 2 vols., University of California, Santa Barbara, 2000.

————. "Observations on the Cabinet des Tableaux du Roi at Versailles, ca. 1774–1792," *Notes on Early Modern Art,* 4, 2 (2017): 47–70.

————. "The U.S. Congress's State Portraits of Louis XVI and Marie-Antoinette: The Politics of Display and Displacement at the Capitol, 1800–1814," in *Politics & Portraits in the United States & France during the Age of Revolution,* ed. Larkin (Washington, D.C.: Smithsonian Institution Scholarly Press, 2019), 21–38.

Latimer, Jon. *1812: War with America* (Cambridge, Massachusetts: Belknap Press, 2007).

Latrobe, Benjamin. *The Correspondence and Miscellaneous Papers of Benjamin Henry Latrobe,* eds. John C. Van Horne and Lee W. Formwalt, 3 vols. (New Haven: Yale University Press, 1984–88).

Lord, Walter. *The Dawn's Early Light* (New York: W. W. Norton and Company, 1972).

"Louis Seize, Roi des Français, Restaurateur de la Liberté," Mount Vernon Collections, Mount Vernon Website, https://www.mountvernon.org/preservation/collections-holdings /browse-the-museum-collections/object/w-767a-b/ (accessed 15 June 2019).

Lovell, Margaretta. *Art in a Season of Revolution: Painters, Artisans, and Patrons in Early America* (Philadelphia: University of Pennsylvania Press, 2005).

Madison, James. Annual Message to Congress, 29 November 1809, transcript, Miller Center, University of Virginia, Charlottesville, http://millercenter.org/president/madison /speeches/speech-3608 (accessed 21 August 2015).

————. Annual Message to Congress, 5 November 1811, transcript, Miller Center, University of Virginia, Charlottesville, http://millercenter.org/president/madison/speeches /speech-3613 (accessed 14 September 2015).

————. Annual Message to Congress, 20 September 1814, Founders Online, National Archives, Washington, D.C., https://founders.archives.gov/documents/Madison /03-08-02-0206 (accessed 26 May 2019).

————. "A Proclamation," *National Intelligencer,* 3 September 1814, 2–3.

————. Letter to John Peter van Ness, 23 May 1815, https://founders.archives.gov (accessed 6 June 2019).

————. "September 1, 1814: Proclamation upon British Depredations, Burning of the Capitol," Presidential Speeches, Miller Center, University of Virginia, https://miller center.org/the-presidency/presidential-speeches/september-1-1814-proclamation -upon-british-depredations (accessed 10 June 2019).

Madison, James, and James Monroe. "A Proclamation," in *National Intelligencer*, 3 September 1814, 2–3.

Marcellus, "War," 14 September 1814, in *National Intelligencer*, 16 October 1814, 1–2.

"March 5, 1821: Second Inaugural Address," Presidential Speeches / James Monroe Presidency, Miller Center, University of Virginia, https://millercenter.org (accessed 6 June 2019).

Marin, Louis. *Portrait of the King*, trans. Martha M. Houle (Minneapolis: University of Minnesota Press, 1988).

Marks, Arthur S. "The Statue of King George III in New York and the Iconology of Regicide," *American Art Journal*, 13, 3 (Summer 1981): 61–82.

McClellan, Andrew. *The Art Museum from Boullée to Bilbao* (Berkeley: University of California Press, 2008).

_____. *Inventing the Louvre: Art, Politics, and the Origins of the Modern Museum in Eighteenth-Century Paris* (Berkeley: University of California Press, 1999).

McConville, Brendan. *The King's Three Faces: The Rise and Fall of Royal America, 1688–1776* (Chapel Hill: University of North Carolina Press, 2007).

Medlam, Sarah. "Callet's Portrait of Louis XVI: A Picture Frame as Diplomatic Tool," *Furniture History*, 43 (2007): 143–54.

Meigs, William M. *The Life of Charles Jared Ingersoll* (Philadelphia: J. B. Lippincott Company, 1897).

"Memoire des portraits du Roy qui sont ordonnés au Sr. Jeaurat garde des tableaux de sa Majesté à la surintendance de ses Bâtimens à Versailles," 2 October 1773, O 1 1912, Archives Nationales de France, Paris.

Memorandum of Armand Marc de Montmorin, 22 January 1791, Folder "1789–1793: Revolution," Carton "Présents et pierreries 1783–1830," 750SUP220.70, Archives du ministère des affaires étrangères, La Courneuve.

Menz, Katherine B. *Historic Furnishings Report, Hamilton Grange National Monument, New York, New York* (Harpers Ferry Center, WV: National Park Service, U.S. Department of the Interior, 1986).

Miller, Marla. *Betsy Ross and the Making of America* (New York: Henry Holt and Company, 2010).

Miscellaneous Treasury Accounts, General Accounting Office, Account of Expenditures on the Capitol #30,743 #29, Record Group 217, National Archives, Washington, D.C.

Monroe, James. "Copy of a Letter from Mr. Monroe to Sir Alex Cochrane, Vice Admiral, &c, &c," 6 September 1814, *National Intelligencer*, 9 September 1814, 1.

Morriss, Roger. *Cockburn and the British Navy in Transition: Admiral Sir George Cockburn 1772–1853* (Columbia, SC: University of South Carolina Press, 1997).

Munroe, Thomas. Proclamation, 5 September 1814, in *National Intelligencer*, 14, 2178 (6 September 1814): 1, https://repositories.lib.utexas.edu/handle/2152/13227 (accessed 23 February 2016).

National Intelligencer, 31 August 1814, 1, in Readex: America's Historical Newspapers (accessed 3 October 2017).

Niven, John. *John C. Calhoun and the Price of Union: A Biography* (Baton Rouge, LA: Louisiana State University Press, 1988).

The Oxford History of the British Empire, Vol. 2: The Eighteenth Century, eds. P. J. Marshall and Alaine Low (Oxford: Oxford University Press, 1998).

Pack, James. *The Man Who Burned the White House* (Annapolis: Naval Institute Press, 1987).

The Papers of George Cockburn, Manuscript 17,576, Reel no. 6, Manuscript Division, Library of Congress, Washington, D.C.

Paulson, George W. *William Thornton, M.D.: Gentleman of the Enlightenment* (Columbus, OH: George W. Paulson, 2007).

Penny, Nicholas, ed. *Reynolds* (London: Royal Academy of Arts and Weidenfeld and Nicolson, 1986).

Peterson, Merrill D. *The Great Triumvirate: Webster, Clay, and Calhoun* (New York: Oxford University Press, 1987).

Philadelphia Aurora, 27 and 30 August 1814.

Pitch, Anthony S. *The Burning of Washington: The British Invasion of 1814* (Annapolis, MD: Naval Institute Press, 1998).

Porter, Andrew, and Alaine Low, eds. *The Oxford History of the British Empire, Volume 3: The Nineteenth Century* (Oxford: Oxford University Press, 1999).

"Portrait, Affaires Generales, 17 March 1759," Bons du roi: portraits, O 1 1074, Archives nationales de France, Paris.

"Portraits of Louis XVI and Marie-Antoinette" dossier, December 1960, National Archives, Washington, D.C.

Prentiss, Hervey Putnam. *Timothy Pickering as the Leader of New England Federalism, 1800–1815* (New York: Da Capo Press, 1972; originally published 1933–34).

Reaves, Wendy Wick. "The Prints," *Magazine Antiques*, 135, 2 (February 1989): 502–11.

Reaves, Wendy Wick, ed. *Beyond the Face: New Perspectives on Portraiture* (Washington, DC: National Portrait Gallery, London: D. Giles Limited, 2018).

Record of compensation for Tobias Simpson, in SEN 13A-D2 Memoranda of Bills and Resolutions Examined, Presented and Approved, Records of the United States Senate 13th Congress, RG 46, box 10, National Archives, Washington, D.C.

Registre du dépôt des bijoux et autres effets destines pour les présens du roi dans le Département des affaires étrangères, Année 1783, Année 1787, Archives du Ministère des affaires étrangères, La Courneuve, Mémoirs et Documents France, Neuilly-sur-Marne, Société d'Ingenierie et de Microfilmage, 1991, vol. 2088 (1783), vol. 2092 (1787).

Saint-Méry, Médéric Louis Elie Moreau de. *Loix et constitutions des colonies Françoises de l'Amérique sous le vent*, 6 vols. (Paris: Chez l'Auteur, Moutard, and Mequignon Jeune, 1784), 1:xxix, xxxv, https://books.google.com/books?id=IMRFAAAAcAAJ&pg=PR29#v=onepage&q&f=false (accessed 17 June 2019).

Saunders, Richard H., and Ellen G. Miles, eds. *American Colonial Portraits 1770–1776* (Washington, D.C.: Smithsonian Institution Press, 1987).

Scott, James. *Recollections of a Naval Life*, 3 vols. (London: Richard Bentley, 1834).

Seale, William. *The President's House: A History*, 2 vols (Washington, DC: White House Historical Association, 1986).

Sérurier, Louis Barbe Charles. Letters to Charles Maurice de Talleyrand, 22–26 August, 28 December 1814, 39CP: Correspondance Politique États-Unis, vol. 71, 158–64, 309 verso–310 verso, Archives du Ministère des affaires étrangères, La Courneuve.

Sheppard, George. *Plunder, Profit, and Paroles: A Social History of the War of 1812 in Upper Canada* (Montreal and Kingston: McGill-Queen's University Press, 1994).

Shomette, Donald G. *Flotilla: Battle for the Patuxent* (Solomons, MD: Calvert Marine Museum Press, 1981).

Simon, Jacob. "Frame Studies II. Allan Ramsay and Picture Frames," *The Burlington Magazine*, 136, 1096 (July 1994): 444–55.

Simpson, Elizabeth, ed. *The Spoils of War: World War II and Its Aftermath: The Loss, Reappearance, and Recovery of Cultural Property* (New York: Harry N. Abrams, Inc., Publishers and The Bard Graduate Center for Studies in the Decorative Arts, 1997).

Smart, Alastair. *Allan Ramsay: A Complete Catalogue of His Paintings*, ed. John Ingamells (New Haven and London: Yale University Press, 1999).

Smith, Harry. *The Autobiography of Lieutenant-General Sir Harry Smith Baronet of Aliwal on the Sutlej*, ed. G. C. Moore Smith, 2 vols. (London: John Murray, 1901).

Smith, Margaret Bayard. *The First Forty Years of Washington Society, Portrayed by the Family Letters of Mrs. Samuel Harrison Smith (Margaret Bayard)*, ed. Gaillard Hunt (New York: C. Scribner's Sons, 1906).

Sofaer, Abraham D. *War, Foreign Affairs and Constitutional Power: The Origins* (Cambridge, MA: Ballinger Publishing Company, 1976).

Stagg, J. C. A. *Mr. Madison's War: Politics, Diplomacy, and Warfare in the Early American Republic, 1783–1830* (Princeton: Princeton University Press, 1983).

————. *The War of 1812: Conflict for a Continent* (Cambridge: Cambridge University Press, 2012).

Taylor, Alan. *The Civil War of 1812: American Citizens, British Subjects, Irish Rebels, & Indian Allies* (New York: Alfred A. Knopf, 2010).

Thornton, William. Public Announcement, 30 August 1814, in *National Intelligencer*, 14, 2179 (8 September 1814): 1, https://repositories.lib.utexas.edu/handle/2152/13227 (accessed 23 February 2016)

Tingey, Thomas. "Extracts of a letter from Com. Tingey to the Secretary of the Navy," 27 August 1814, in *National Intelligencer*, 12 September 1814, 1.

Tompkins, Arthur. *Plundering Beauty: A History of Art Crime during War* (London: Lund Humphries, 2018).

Torrey, Jesse. *A Portraiture of Domestic Slavery in the United States* (Philadelphia: Jesse Torrey and John Bioren, 1817).

Treue, Wilhelm. *Art Plunder: The Fate of Works of Art in War and Unrest*, trans. Basil Creighton (New York: The John Day Company, 1961).

Ulrich, Laurel Thatcher. *The Age of Homespun: Objects and Stories in the Creation of an American Myth* (New York: Alfred A. Knopf, 2002).

Van Horn, Jennifer. "'The Dark Iconoclast': African Americans' Artistic Resistance in the Civil War South," *Art Bulletin*, 99 (December 2017): 133–67.

Warren, Charles. "What Has Become of the Portraits of Louis XVI and Marie Antoinette, Belonging to Congress?" *Massachusetts Historical Society Proceedings*, 59 (October 1925–June 1926): 45–85.

Washington, George. *Writings of George Washington*, ed. John C. Fitzpatrick, 41 vols. (Washington D.C.: U.S. Government Printing Office, 1931–44).

Whitney, Frank. *Jean Ternant and the Age of Revolutions: A Soldier and Diplomat (1751–1833) in the American, French, Dutch and Belgian Uprisings* (Jefferson, NC: McFarland and Company, Inc., 2015).

Williams, John S. *History of the Invasion and Capture of Washington and of the Events Which Preceded and Followed* (New York: Harper and Brothers, Publishers, 1857).

Wiltse, Charles M. *John C. Calhoun: Nationalist, 1782–1828* (New York: Russell and Russell, 1968 re-issue of 1944 ed.).

"Works of Art Destroyed by Fire: Portraits of Louis XVI and Marie-Antoinette" file, Curatorial Department, Office of the Architect of the Capitol, Washington, D.C.

Index